Cameron: Her Work and Career

D1242565

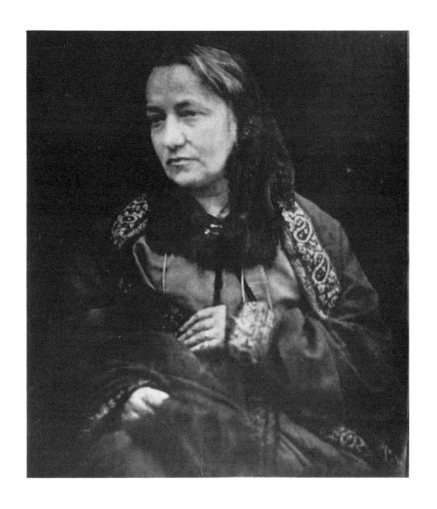

Julia Margaret Cameron

J o a n n e L u k i t s h

International Museum of Photography at George Eastman House

Contents

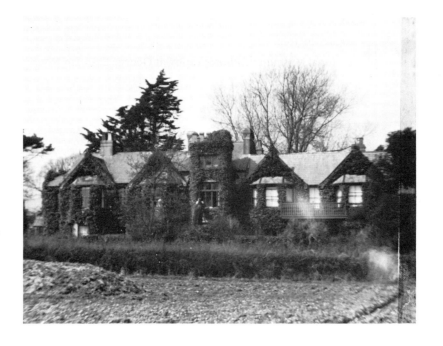

(Cameron's home, "Dimbola," Freshwater, Isle of Wight)
Alvin Langdon Coburn
c. 1920 (Modern enlargement by Michael Hager, 1985)
Bequest of Alvin Langdon Coburn

Acknowledgements

AMERON: HER WORK AND CAREER" evolved from a project to research and catalogue the Julia Margaret Cameron photographs in the collection of the International Museum of Photography at George Eastman House. The project was undertaken to fulfill the terms of the grant from the Andrew W. Mellon Foundation which supported my employment: to promote research and publications on the Museum's collection. As my work progressed, the definition of the word "collection" necessarily expanded beyond the Print Archive, Library, and Information File to include the Technology and Negative Collections, the expertise of the Conservation Department, the knowledge and interest of the staff, the legacies of former employees and, finally, the thirty-six year historical perspective provided by the Eastman House itself. The Eastman House collection is the foundation of this exhibition and gives it its context.

Robert A. Mayer, Director of the Museum, gave strong and instrumental support for this exhibition, as did Robert Sobieszek, Director of the Department of Photographic Collections; I would like to thank Mr. Sobieszek in particular for his work in the editing of the catalogue essay. In the Department of Photographic Collections, David Wooters brought the Print Archive to life for me, and Heather Alberts, Marianne Fulton, Janet Buerger, and especially Carolee Aber gave important advice. I would like to thank Pat Byrne, formerly of the Cataloging Department; Ann McCabe, Registrar, and James Conlin, Assistant Registrar; Norma Feld, formerly Serials Librarian; Barbara Puorro Galasso, Photographic Services; Pamela Schultz, Departmental Secretary; Susan Kramarsky, Marketing Services, and Delbert Zogg, Senior Cataloguer, for assistance above and beyond the call of duty. Susan Canton, Word Processing Operator, deserves special note for her careful and patient typing of this manuscript.

This project drew upon the resources of many departments. Grant Romer, Conservator, contributed a valuable essay to this catalogue on the implications of Cameron's use of albumen paper, in addition to directing an extensive survey of the conditions of the Cameron photographs; my thanks to Elizabeth Frey, formerly Conservation Assistant, and to Interns Constance McCabe, Hiroko Arai, and Silvia Berselli. My thanks to: Dr. Rudolf Kingslake, Special Advisor to the Technology Collection; Morgan Wesson, Assistant Curator, Technology/Film; Michael Hager, Negative Archivist; Katharine Ritter, Negative Cataloguer, who brought Alvin Langdon Coburn's negatives of Dimbola to my attention; Rachel Stuhlman, Head Librarian; Barbara Hall, Public Relations; Sarah McDonald, Secretary to the Director; Rebecca Simmons, Serials Librarian; Andrew Eskind, Interdepartmental Services; and former

Rebecca Simmons, Serials Librarian; Andrew Eskind, Interdepartmental Services; and former employees Joan Pedzich and Linda McCausland.

This exhibition and its catalogue were supported by the National Endowment for the Arts. Funding for the development and realization of the exhibition was provided by the New York State Council for the Arts.

A lecture series, "Ideal Lives/Ideal Loves: Julia Margaret Cameron and the Victorian Family Lifestyle," organized by Kathleen Wolkowicz, Director, Education Department, was held in conjunction with this exhibition. The lecture series was funded by a grant from the New York Council for the Humanities. My thanks to Ms. Wolkowicz and her staff, C. Lynn Reynolds and Marianne Kroon, for their efforts. Marion Simon, Director of Development, gave special support for this project. Chief Preparator, Rick Hock and assistants James Via and Carolyn Zaft did their customary excellent job with the installation of this exhibition. Seymour Nusbaum, Building Services Manager, and his staff made many things possible.

I would like to express my appreciation to: P. M. Doran, Arthur Gill, Anne Hammond, Mark Haworth-Booth, Anne Hewat, Richard Jefferies, John Norman, T. R. Padfield, Terrence Pepper, Pamela G. Roberts, and Mike Weaver for assisting me with my research in England; Isobel Crombie and Alan Davies for researching Cameron's activities in Australia; Terrence Abbott, Patricia Anderson, Rafael Fernandez, Lee Marks, Pamela G. Roberts, and Patricia Swenson for assistance with many aspects of this exhibition. Special acknowledgement is due my predecessors in the study of Cameron's photography, Helmut Gernsheim, Anita Ventura Mozley, Colin Ford, and Mike Weaver, for information and analyses.

Reinhold Heller, Beaumont Newhall, O. J. Rothrock, and Joel Snyder contributed to my understanding of Cameron; Lorraine Kenny and Joan Coke gave valuable advice and example. David Harris deserves special thanks for his patient and exacting review of several drafts of this manuscript.

The humor and support of Robert and Mary Margaret Lukitsh, Carol and Steven Yahoodik, and Nancy Lukitsh sustained me through this project: this work is theirs.

Joanne Lukitsh
Rochester, 1986

Introduction

ULIA MARGARET CAMERON (1815-1879) is one of the most prominent figures in the history of photography, recognized primarily for her accomplishments as a portraitist of Victorian men of mark, including Alfred Tennyson, Thomas Carlyle, John Herschel and Henry Wadsworth Longfellow. The turn of the century fine art photography movement recognized Cameron for her expressive use of focus and, as a result, Cameron came to be considered as a precursor of the modernist movement in artistic photography. Consideration of Cameron's photographs along these terms, however, is at the expense of Cameron's own intentions and the place of her work in its context.

One indication of Cameron's intentions for her photography is given in an article published in January, 1886 (seven years after Cameron's death), in the English journal, *Photographic News,* "A Reminiscence of Mrs. Cameron by a Lady Amateur." According to the "Lady Amateur" (who had posed for several Cameron photographs), Cameron:

> *had a notion that she was going to revolutionize photography and make money. To some extent she did the first, if to be discussed for a twelve month or more in every photographic circle means a revolution; but the second she never succeded in doing.* [1]

Cameron's ambition "to revolutionize photography and make money" is also present in her own writings from the early years of her photographic work. This ambition indicates that Cameron's photographic work was directly connected to contemporary photography and intended to be financially successful as well.

The arrangement of the photographs in the exhibition, "Cameron: Her Work and Career," presents Cameron's photography as an expansion of the activities of the family photographer. The connection between the family photographer and the photographer with revolutionary ambitions was the "out of focus" form of Cameron's photographs. Cameron's use of "out of focus" was not simply an artistic device to blunt the sharpness of the photographic lens, but a representation which symbolized a superior practice of photography. This superior practice of photography was developed in response to dissatisfactions with contemporary photographic representation, one aspect of a larger cultural reaction of the English upper classes away from the conflicts and problems of mid-Victorian modernization into a timeless realm of the ideal. Cameron's photographs commemorate this timeless realm as embodied by the lives and activities of Cameron's family and circle. Cameron believed her family photographs would be a source of public uplift and inspiration; the fortunes of this belief, and of her extensive efforts to promote her photographs, pertained to the applicability

1. Unsigned, "A Reminiscence of Mrs. Cameron by a Lady Amateur," *The Photographic News* 30 (January 1, 1886): 2-4.

of Cameron's superior practice to photography in general. The course of Cameron's promotion of her photographs and her "out of focus" representation indicate that Cameron's superior practice of photography pleased a particular audience, but didn't alter the course of contemporary industrialization of photography.

The majority of the photographs in the exhibition are from the collection of the International Museum of Photography at George Eastman House, including the Watts Album, the earliest known Cameron album extant, and the two volumes of *Julia Margaret Cameron's Illustrations to Tennyson's "Idylls of the King" and Other Poems*. The *Illustrations* are particularly important, because they preserve not only photographs, but evidence of Cameron's intentions in the arrangement of images and use of supporting textual material. The exhibition opens with a selection of photographs of Cameron's family, to introduce the insular and emotional dimensions of Cameron's photography and her audience. The second section presents Cameron's photographic idealization of the family in images of Madonnas and cherubs. The third section presents Cameron's illustrations of subjects from history, religion and literature. The portrait section includes photographs of many of the prominent men (and a few of the women) from Cameron's circle, and features several different photographs of the two men Cameron photographed most frequently: Alfred Tennyson and Henry Taylor. The second, third and fourth sections are each arranged chronologically, to show the development of Cameron's representational approaches. The last major photographic project of Cameron's career, her *Illustrations to Tennyson's "Idylls of the King" and Other Poems* has its own section. The exhibition closes with a selection of the reprints of Cameron photographs produced during the fine art photography period of the late 19th-early 20th century; several Cameron albumen prints are compared with their turn of the century reprints.

Ideal Nature and Family Photography

ULIA MARGARET CAMERON'S obituary in the *Athenaeum* concluded with the sentence, "She was a woman of taste, accomplishments and unusual energy."[1] Photography was one of the achievements which merited Cameron notice in the *Athenaeum,* the journal of the Victorian literary establishment. Julia Margaret Pattle was born in Calcutta in 1815, one of ten children of Adeline de l'Etang, a descendant of the French aristocracy, and James Pattle, an official of the East India Company. Julia Pattle was educated in Europe; she returned to Calcutta, where she married Charles Hay Cameron in 1838. Charles Cameron, a widower twenty years her senior, was a distinguished jurist, follower of the Utilitarian philosophy of Jeremy Bentham, and member of the Indian Law Commission, the Council of India, and the Council of Education for Bengal. The Camerons were prominent in Anglo-Indian society and they assumed a comparable position when they returned to England in 1848, upon Charles Cameron's retirement. They had six children, a daughter and five sons.[2]

Cameron was active in philanthropic and artistic activities, in addition to her family responsibilities. In India Cameron raised thousands of pounds for Irish famine relief and on Freshwater, Isle of Wight, she donated a reading room to the library. Cameron and her family moved to Freshwater in 1860, where they lived next door to close friends Alfred and Emily Tennyson. Cameron was a member of the Society for Promoting Knowledge of Art; she published a translation of G. A. Bürger's *Leonore* in 1847, wrote and published her own poetry, and apparently attempted a novel. The *Atheneaum* obituary described Cameron as "well-known and highly esteemed" by visitors to the distinguished salon at Little Holland House (conducted by Cameron's sister, Sara Pattle Prinsep), where Cameron enjoyed the company of some of the most prominent literary and artistic figures of mid-Victorian England.[3]

Cameron was related by blood, friendship, and social associations to many influential people in Victorian society. When she began to work in photography, these individuals coalesced into a network of advice and support. The distinguished scientist and astronomer, Sir John Herschel, was a close friend of Cameron's from the 1830s; after Cameron took up

1. Unsigned, "Mrs. Julia Margaret Cameron," *Athenaeum,* March 8, 1879, p. 320.

2. The standard biographical sources for Cameron are: Helmut Gernsheim, *Julia Margaret Cameron: Her Life and Photographic Work,* revised edition, (Millerton, NY, 1975); Julia Margaret Cameron, *Victorian Photographs of Famous Men and Fair Women,* Introductions by Virginia Woolf and Roger Fry, expanded and revised edition edited by Tristram Powell, (Boston, 1973); Colin Ford, *The Cameron Collection: An Album of Photographs by Julia Margaret Cameron Presented to Sir John Herschel,* (Wokingham, England, 1975); Brian Hill, *Julia Margaret Cameron: A Victorian Family Portrait,* (New York, 1973).

3. Gernsheim, *Cameron,* p. 20-27; Mike Weaver, *Julia Margaret Cameron, 1815-1879,* (New York, 1984), p. 38; Hill, *Cameron: Victorian Family Portrait,* p. 83-99.

photography, Herschel posed for portraits and gave Cameron technical advice. Cameron was a great admirer of the painter George Watts, the "artist-in-residence" at Little Holland House; Watts became Cameron's artistic advisor and the recipient of her first album of photographs. Sara Prinsep's son, Valentine, was an artist (later Royal Academician), one of the young men who painted the frescos of the Oxford Union in the company of Dante Gabriel Rossetti in 1857; Cameron was a friend of the Rossetti family, giving her photographs to Dante Gabriel and photographing William Michael (and possibly Christina) Rossetti. William Michael Rossetti wrote admiringly of Cameron's photographs. Minnie and Anne Thackeray, daughters of the novelist William Makepeace Thackeray, stayed with Cameron after their father's death in 1863. Anne Thackeray later wrote an article about Cameron's photographs, and persuaded her friend Henry Cole, the director of the South Kensington Museum, to accept Cameron's photographs into the Museum's collection.[4]

8

Minnie Thackeray married Leslie Stephen and, after her death, Stephen married Cameron's niece, Julia Jackson Duckworth, who had been photographed by Cameron. Julia Stephen wrote the entry for Julia Cameron for the *Dictionary of National Biography,* which Leslie Stephen edited. Virginia Woolf, daughter of Leslie and Julia Stephen, compiled a collection of her great aunt's photographs for the Hogarth Press, published in 1926, *Victorian Photographs of Famous Men and Fair Women*; Woolf also wrote a family theatrical, "Freshwater," about life in the Cameron household. Charles Cameron's classmate from Eton, Samuel Jones Loyd, later Lord Overstone, was the recipient of an album of Cameron photographs and one of Her Majesty's Commissioners for the London International Exposition of 1871, in which Cameron exhibited. Overstone loaned the Cameron family money in the 1850s and 1860s; these financial matters were handled by Cameron's son-in-law, Charles Norman, the son of Lord Overstone's friend George Warde Norman. Cameron was a close friend of Sir Henry Taylor, poet and dramatist, who posed for numerous portraits and *tableaux vivant* photographs. John Ruskin was an acquaintance with whom Cameron apparently corresponded about photography; William Allingham, another acquaintance, reviewed Cameron's photographs in the *Pall Mall Gazette*.[5] This list of associations and their interrelations could be expanded; Cameron's photography was intertwined on many levels with her other activities.

4. For Cameron's friendship with Sir John Herschel, see Ford, *The Cameron Collection,* p. 5-7, 15-16, 140-142; for Cameron's friendship with George Watts, see Mary S. Watts, *George Frederick Watts: The Annals of an Artist's Life,* 3 vols., (New York, 1912), I, p. 94, 143, 203-209.

For information on Val Prinsep, see Hill, *Cameron: Family Portrait,* 175-76; for Cameron's association with the Rossetti family, see W. M. Rossetti, compiler, *Rossetti Papers, 1862-1870,* (London, 1903), p. 201-202; Cameron's seven photographs to Dante Gabriel Rossetti are in the Gernsheim Collection, Harry Ransom Humanities Research Center, University of Texas at Austin; for Cameron's portrait of William Michael Rossetti, see p. 43; William Michael Rossetti discussed Cameron's photography in his article, "Mr. Palgrave and Unprofessional Criticisms of Art," from the *Fine Arts Quarterly Review,* 1866 reprinted in *Fine Art, Chiefly Contemporary: Notices Reprinted with Revisions,* (London, 1867), p. 324-34.

Cameron's friendships with Anne and Minnie Thackeray are discussed in Winifred Gérin, *Anne Thackeray Ritchie, A Biography*: (Oxford and London, 1981), p. 130, 145, 148, 151, 185; Anne Thackeray's intercession on Cameron's behalf with Henry Cole is recounted in Charles and Frances Brookfield, *Mrs. Brookfield and her Circle,* 2 vols., (London, 1905), 2, p. 515. Anne Thackeray's review of Cameron's photography, "A Book of Photographs," was published in *Toilers and Spinners and Other Essays,* (London, 1874), p. 224-29.

5. Noel Annan, *Leslie Stephen: The Godless Victorian,* (New York, 1984), p. 76-81, 83-8; the *Dictionary of National Biography* entry on Julia Cameron is reproduced in Stanford, CA, "*Mrs. Cameron's Photographs from the Life,*" Stanford University Museum of Art, p. 49; Julia Margaret Cameron, *Victorian Photographs of Famous Men and Fair Women,* Introductions by Virginia Woolf and Roger Fry, (London, 1926); Virginia Woolf, *Freshwater: A Comedy,* edited and with a preface by Lucio P. Ruotolo, (New York, 1976); Val Williams, "Only Connecting: Julia Margaret Cameron and Bloomsbury," *The Photographic Collector* 4 (1983): 40-89.

For information on Lord Overstone, see D. P. O'Brian, ed., *The Correspondence of Lord Overstone,* 3 vols., (Cambridge, 1971); information on the Cameron family finances is from manuscripts in the Overstone Collection, University of London Library, MS. 804/1848 and /1850; information on the 1871 London International Exposition is from the *Official Catalogue: Fine Arts Department,* 3rd rev., (London, 1871).

Henry Taylor's discussion of the Cameron family is from his *Autobiography of Henry Taylor 1800-1875,* 2 vols., (New York, 1885), 2, p. 41-47, 153-7, 208-09. Ruskin's letter to Cameron of

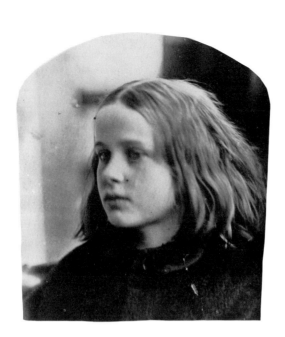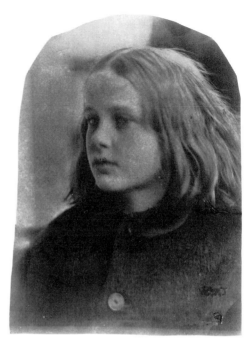

(Annie Philpot)
From G.F. Watts Album, 1864
Museum collection

Annie Philpot
From G.F. Watts Album, 1864
Museum collection

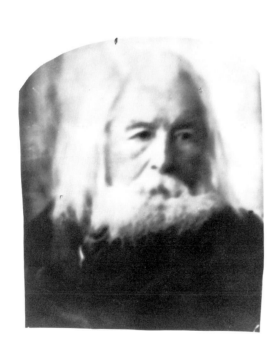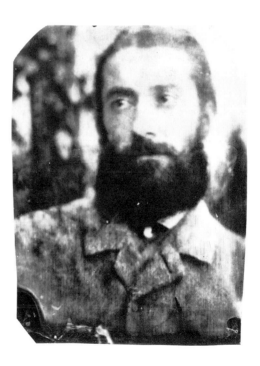

(Charles Cameron)
From G.F. Watts Album, 1864
Museum collection

(Charles Norman)
From G.F. Watts Album, 1864
Museum collection

10

(Charlotte Norman)
From G.F. Watts Album, 1864
Museum collection

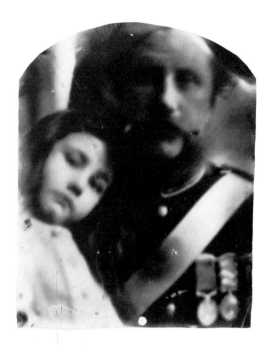

Katey Kuhn & her Father
From G.F. Watts Album, 1864
Museum collection

Pietet Baby
From G.F. Watts Album, 1864
Museum collection

**(Mary Hillier as Madonna with
two children)**
From G.F. Watts Album, 1864
Museum collection

Hallam Tennyson
From G.F. Watts Album, 1864
Museum collection

(Julia and Charlotte Norman)
From G.F. Watts Album, 1864
Museum collection

(Julia and Charlotte Norman)
(1864)
Museum collection

Cameron began to photograph at the age of forty-nine in early 1864. Her daughter and son-in-law, Julia and Charles Norman, gave her a camera basically as a distraction while her husband and sons visited the family coffee plantations in Ceylon (now Sri Lanka).[6] Two prints (p. 9) from what Cameron later described as her "first negative," a portrait of a young girl, Annie Philpot, are arranged on facing pages as the first images in an album of photographs which Cameron gave to George Watts on February 22, 1864. (This album of 39 photographs is the earliest known Cameron album.) Only one of the two prints of Annie Philpot was titled by Cameron and it differs from its untitled counterpart in the cropping, reduction of contrast by toning, and retouching of the print on the highlights of the hair. In comparison with the untitled version, the forms of "Annie Philpot" are softer and more generalized. The photographs which follow in the album suggest that Cameron's conception of photography went beyond merely achieving the softened forms of "Annie Philpot."

The Watts Album photographs encompass nearly every means of producing a photographic image on a wet-collodion negative and printing it on albumen paper. In the photograph of Hallam Tennyson (p. 11) the flattened forms of the face loom as an apparition out of a dark, indeterminate space. The portrait of Charles Cameron (p. 9) was taken against a light background, but a similar compression and simplification of form, obtained by manipulation of the lens, is seen here and in the portrait of Charles Norman, Cameron's son-in-law (p. 9). "Katey Kuhn & her Father" (p. 10), an image of dark shadows and light shapes, appears to have been made by separating the negative from the photographic paper in printing, as does the portrait of Cameron's granddaughter, Charlotte Norman (p. 10). The photograph of Mary Hillier (p. 10) (a maid in the Cameron household), veiled and posed as a Madonna with two children, has a halo painted onto the negative emulsion, and Cameron's signature and the phrase "From Life" painted on the negative. Lest the appearance of these photographs be attributed to Cameron's physiological incapacity to focus a lens, the photograph "Pietet Baby" (p. 10) is a clear and fairly detailed image of an infant. Cameron's early experimentation included manipulation of subject lighting, focus, and depth of field, and ranged from retouching the negative to manipulating it during printing, from toning the photographic paper, to cropping the print itself, as in the photograph of Julia Norman and Charlotte (Cameron's daughter and granddaughter) (p. 11). The forms of these photographs are not so much softened and blurred, as manipulated and distorted in space. In the Watts Album images Cameron extended photographic representation to the borders of legibility, using multiple aspects of the photographic process to bring form to an unformed nature.

However, for their blurriness, distortions, and technical eccentricities, the Watts Album photographs were all produced through the exposure of light on the photographic emulsion of a negative, and the transmission, by light, of this exposure to the photo-

February 23, 1868, is reprinted in E. T. Cook and Alexander Wedderburn, *The Works of John Ruskin,* 39 vols., (London, 1912), 37, p. 734; the significance of Ruskin's letter to Cameron in relation to his changing attitudes towards photography is discussed in R. N. Watson, "Art, Photography and John Ruskin," *British Journal of Photography* 91 (March 10, 24, and April 7, 1949): 82-83; 100-101; 118-19, and Abigail Solomon-Godeau, "Photography and Industrialization: John Ruskin and the Moral Dimensions of Photography," *Exposure* 21 (2): 10-14; *William Allingham's Diary,* introduction by Geoffrey Grigson, (London, 1967), p. 161, 171.

6. Julia Margaret Cameron, "Annals of My Glass House," in *Photography: Essays and Images,* edited by Beaumont Newhall, (New York, 1980), p. 135-39. The "Annals" were unpublished in Cameron's lifetime; Newhall cites its publication in the *Photo Beacon* (Chicago) 2 (1890): 157-60 as the first, from a publication in England, identified by Weston Naef, *The Collection of Alfred Stieglitz: Fifty Pioneers of Modern Photography,* (New York, 1978), p. 295 as the catalogue of the 1889 Cameron and Smith exhibition at 106, New Bond Street, London. The manuscript of the "Annals" is in the collection of the Royal Photographic Society of Great Britain, Bath, England.

Colin Ford, "Rediscovering Mrs. Cameron and Her First Photograph," *Camera* (May, 1979): 4, 13, 23-25; Ford discovered a Cameron manuscript giving January 29, 1864 as the date of "Annie Philpot." In the Overstone Album Cameron inscribed, "*Every* Photograph taken from the Life and *printed* as well as taken by Julia Margaret Cameron fm (sic) January 1, 1864 to July 1865."

graphic paper. The fidelity to the physical action of light in the production of the photographic image is sustained even to the application of Cameron's signature and the phrase "From Life" onto the negative with an opaque substance and the physical painting of Hillier's Madonna halo onto the negative's emulsion. The Watts Album photographs are "From Life" in their preservation of the material trace of the action of light on the photographic paper; the print retouching (i.e., painting the surface of the photograph with a pigmented substance) of "Annie Philpot" does not reappear. The extensive technical manipulation of the Watts Album photographs is an example of an extreme as a case in type; "out of focus" imagery possessed a particular meaning in its context, and in order to understand this meaning it is necessary to consider the reception to photographs (nearly contemporaneous with the Watts Album) by the English painter David Wilkie Wynfield.

Cameron wrote to the art critic William Michael Rossetti in February, 1866, "to my feeling about his [Wynfield's] beautiful Photography I owed *all* my attempts and indeed consequently all my success."[7] Cameron received photographic instruction from Wynfield, and their photographs were compared in several reviews in the photographic and non-photographic press in 1864-65.[8] In the March 19, 1864, "Fine Arts" column of the *Illustrated London News* was a review of a portfolio of photographs by Wynfield, recently published by Messrs. Hering and Company, London. Wynfield's photographs provoked the reviewer to discuss the limitations of contemporary photographic representation:

> *To the eye of the artist the rigid sharpness and stark precision of photography (especially when it pervades every part of a photograph) is its greatest artistic defect. It is true that if we regard a photograph merely as a production of optical and chemical science, definiteness of detail throughout is the measure of success. But this is not what persons of artistic feeling want or require in most cases, especially in representations of the face. Nevertheless, photographers persist in giving to portraits a deathlike stillness and a universal distinctness beyond the power of fevered vision to realize. A photographer's grand aim is to get everything into an "artificial focus," which is widely different from that of the human eye—or, rather, eyes, for it is owing to the phenomena of binocular vision that we derive so much softer and more agreeable an impression from Nature than photography gives us. Everyone must recollect how charming are some early photographs, and many by amateurs. Well, this is because of what some professional photographists call their "focal distortion," but which same distortion artists think consonant with certain eternal laws, both of nature and art. It seemed to require that an artist should be the first to work in photography upon such principles as we have indicated. And at last we find that an artist—Mr. Wynfield—has actually produced a set of photographs which are intentionally and confessedly "out of focus." To attempt to describe these photographs we will not; but we must maintain that, if they do not, they ought to revolutionize photographic portraiture, if not other branches of the art. The series consists of a set of large bust portraits of popular artists, such as Phillip, Faed, Calderon &c.; and each artist is dressed after the manner of the subjects of the great portrait painters, Italian and Flemish. The result is a set of photographs which resemble copies from very choice portraits by Titian, Rembrandt, Vandyke and other old masters, but which possess greater softness, lifelike animation, apparent power of movement, and breadth of light and shade than any photographic copies of pictures and studies from life we have even seen. [9]*

7. Letter from Julia Margaret Cameron to William Michael Rossetti, January 23, 1866, in the Gernsheim Collection, Harry Ransom Humanities Research Center, University of Texas at Austin, reprinted in Gernsheim, *Cameron,* p. 34-35.

8. Cameron's instruction from Wynfield: Ford, *The Cameron Collection,* p. 20, quote from Cameron letter to Herschel of February 26, 1864, in the collection of the Library of the Royal Society of London. Affinities between work noted by reviewers: Unsigned, "Photographic Exhibition," *Photographic Journal* 11 (August 15, 1864): 86-88, and Unsigned, "The Photographic Exhibition: Portraiture," *Photographic News* 8 (July 15, 1864): 339-40.

9. Unsigned, "Fine Arts," *Illustrated London News* 44 (March 19, 1864): 275; ten Wynfield photographs were registered for copyright on December 8, 1863. The sitters were J. F. Hodgoon, E. B. Jones, F. Leighton, V. Prinsep, W. F. Yeames, H. S. Marks, G. F. Watts, P. H. Calderon, J. Phillip, and T. Faed, each described as dressed in costume (i.e., Elizabethan, medieval, Holbein).

To photograph "out of focus" was not an expressive act, but a restorative one, which established continuity with "some early photographs and many by amateurs," healed the estrangement of "artificial focus" from human vision, and placed photography in consonance with "certain eternal laws, both of nature and art." The impressive accomplishments charged to such a comparatively simple action pertained less to the particular merits of Wynfield's photographs than to the desire for a representation of nature in photography unavailable in commercial photographs. The acclaim for Wynfield's modest series of portrait photographs indicated the strength of the desire to put photography in this relationship with nature and art.

Wynfield's portraits were in the tradition of fancy dress activities: different forms of play-acting (often in costumes and poses in imitation of famous paintings) which were

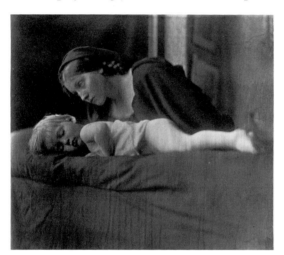 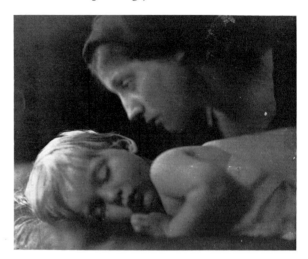

recreations of the affluent in the 18th and 19th centuries. Fancy dress theatrics, including *tableaux vivants,* provided opportunities for make-believe and the imaginative projection of one's personality into different historical and literary characters.[10] The "Fine Arts" critic did not identify Wynfield's photographs with fancy dress activities, but with the canon of artistic achievement represented by the paintings of the old master artists. Old master paintings often served as prototypes for fancy dress activities and the easy interchange between fancy dress and old master paintings in Wynfield's photographs relates to the use of these activities as components of a way of life superior to the common activities of mid-Victorian England, with its unfancy dress, its challenges to the artistic canon, and the "deathlike stillness" of its photography.

On July 15, 1865 (seventeen months after the review of Wynfield's work cited above), the "Fine Arts" column of the *Illustrated London News* praised Cameron for achieving the promise given in Wynfield's photographs:

> ... *it was reserved for a lady—Mrs. Cameron—to fully demonstrate the marvellously various and noble results which follow the application of the principles of fine art to the practice of photography.*[11]

Cameron's photographs "gave a scientific demonstration from Nature herself of the truth of the principles of the old masters," enabling their viewers to "recognize the sources in nature"

10. Richard D. Altick, *The Shows of London,* (Cambridge, MA, 1978), p. 342-49; Kirsten Gram Holström, *Monodrama, Attitudes and Tableaux Vivants: Studies on some Trends of Theatrical Fashions: 1770-1815,* (Stockholm, 1967), p. 191-97; Edinburgh, *Van Dyck in Check Trousers: Fancy Dress in Art and Life, 1700-1900,* Scottish National Portrait Gallery, 1978, p. 1-3, 19-30, 45-63.

11. Unsigned, "Fine Arts: Art in Photography," *Illustrated London News* 47 (July 15, 1865): 50.

in the accomplishments of Michelangelo, Phidias, Leonardo, Correggio, Rembrandt, Velasquez, Raphael, Reynolds, Gainsborough, Titian and the early Italians. This great array of traditional achievement pertained less to the artistry of any Cameron photograph than to the values her photographs confirmed: the existence of ideal nature, possessing transcendent qualities of beauty and truth, which were of all time—and available in the present, proved through a "scientific demonstration from Nature herself."[12]

The "Fine Arts" critic, allowing that Cameron's photographs, "may almost be adduced to prove, in opposition to the theory of the schools, that the Real and the Ideal are but one," observed that a painter could "hope to maintain his proper supremacy" to Cameron's photographs "only by dramatic invention, by color and by the evidences of mental operations in his handiwork;" the critic's humility before the ideal nature demonstrated in Cameron's

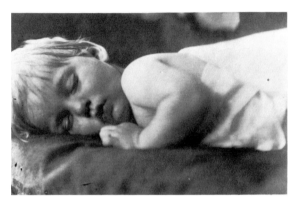

My grandchild Archie aged 2 years & 3 months
(1865)
Gift of Eastman Kodak Company: ex-collection Gabriel Cromer

For Signor my chef d'oeuvre My grand child age 2 years & 3 months
Born at Barbados May 1863
(1865)
Gift of Eastman Kodak Company: ex-collection Gabriel Cromer

My grandchild my chef d' oeuvre
(1865)
Gift of Eastman Kodak Company: ex-collection Gabriel Cromer

15

photographs (echoed in Watts's inscription on a Cameron photograph, "I wish I could paint such a picture as this")[13] indicated that the authority of Cameron's "scientific demonstration" was a consequence of the values it substantiated. As Watts wrote in an 1867 essay, the ideal nature of the old master paintings pointed to the existence of an ideal life:

> ... That the harmonious and glowing effect produced by the old masters possess a degree of truth and power rarely or never found in modern Art is not surprising, as they were in fact copies of reality, not seen now and then and upon great occasions, but as often as the artist left his painting room.[14]

The glories of old master paintings were the glories of reality. The relation of the old master artist to nature was that of copiest, but, if only a copiest, at least the life was a pleasant one. Watts's old master artist—and potentially the modern artist—had only to stroll outside the studio to see reality in its truth and power. In her photographic work, Cameron lived Watts's dream of artistic fulfillment.

The models of the Watts Album photographs were members of Cameron's family, her friends, the household maid, and the children of her next-door neighbor (in this case, Lionel and Hallam Tennyson, Alfred Tennyson's sons), and nearly every type of subject matter Cameron used in her photography—portraiture, illustrations from literature, Madonna subjects and allegorical studies—is present in the Watts Album. The Watts Album is an album of family photographs and Cameron was a family photographer, whose photographs commemorated the lives and values of her family and friends. Cameron was distinguished from the

12. Ibid.

13. Gernsheim, *Cameron,* p. 67.

14. Tom Taylor, ed., *The Autobiography and Memoirs of Benjamin Robert Haydon, 1786-1846,* 2 vols. (Edinburgh, 1957), 2 p. 832-33.

typical family photographer by her belief that those lives and values would be an inspiration to those outside of her circle. Within the family setting Cameron possessed ample opportunities for the fancy dress and imaginative play necessary for her illustrative and allegorical subjects; extend the "family" setting to include friends and associates, and Cameron possessed the opportunities to photograph some of the most prominent members of mid-Victorian society.

The interplay of artistic values, family activities, and ideal nature is described in a series of letters and published articles pertaining to Cameron's last major photographic project, the 1874-75 production of the photographic illustrations for two gift books, *Julia Margaret Cameron's Illustrations to Tennyson's "Idylls of the King" and Other Poems* (the project is discussed in detail later in this essay). Cameron wrote to Sir Edward Ryan, a family friend, about the models for two characters from the *Idylls of the King*, Merlin (portrayed by

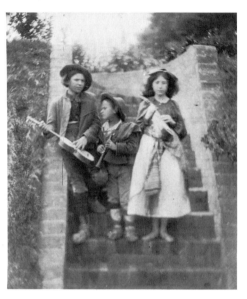

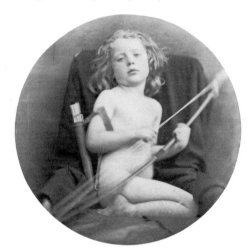

Cameron's husband Charles) and Vivien (portrayed by "Miss Agnes", who, under the *nom de plume* "Lady Amateur," wrote the reminiscence of Cameron discussed in the *"Introduction"*). Cameron wrote to Ryan, who knew the models for Merlin and Vivien (p. 18):

> *My husband is exceedingly well thank god. He appears in character!! in his book. Can you guess his character—you ought to know his tendency!! He sends you his love and so do I. Your gifts of the cabinet photo looks to me from the mantle piece as much as to say, I will help with your success. A notice in the Times for Xmas would sell all my books.* [15]

Cameron also wrote of Vivien," . . . she is not wicked eno' for she is a sweet girl, but she is lissome and graceful and piquante I think."[16] These characterizations would have been available only to Cameron's immediate circle, but, in one sense, the photographs made a dimension of their characters available to the public. Even the less-than-enthusiastic participation of her models didn't undermine the seriousness of Cameron's enterprise. The "Lady Amateur" wrote of her experience as a model:

> *. . . I very much objected to this because Vivien did not seem to be a very nice character to assume, but when Mrs. Cameron said a thing was to be done, it had to be done and so my objections were overruled. My troubles however were not over, for in addition to my having to portray the objectionable Vivien, I discovered, to my dismay, that she had designed her husband*

15. Julia Margaret Cameron to Sir Edward Ryan, November 29, 1875. The letters from Cameron to Ryan quoted here are in the collection of the Gilman Paper Company, New York City, and re-printed with their permission. Portions of the Cameron/Ryan correspondence are reprinted in Gernsheim, *Cameron,* p. 44-48.

16. Cameron to Ryan, December 6, 1874, Gilman Paper Company Collection.

for Merlin. As for Mr. Cameron, with his silvery hair and long white beard, being an admirable representative of the partriarch there could not be a shadow of a doubt; but would he laugh?—the point was soon settled, laugh he did and most heartily...[17]

In the photograph of Vivien imprisoning Merlin in the oak tree, Merlin stands before the tree. Apparently Cameron wanted Merlin to sit on the tree trunk, but this pose presented problems for the exposure of the negative. The "Lady Amateur" continued:

...It was more than mortal could stand to see the oak beginning gently to vibrate and know that the extraordinary phenomenon was produced by the suppressed chuckling of Merlin ... Well, with all the latitude Mrs. Cameron allowed herself in the way of 'out of focus' and 'sketchiness' Merlin had moved far too much, there were at least fifty Merlins to be seen [on the negative]...[18]

(Gypsy Children)
(c.1867)
University of Nebraska Art
 Galleries,Sheldon Memorial Art
 Gallery, Gift of Robert Schoelkopf

Love in Idleness
(c. 1866)
Gift of Eastman Kodak Company:
 ex-collection Gabriel Cromer

King Arthur
(Undated reproduction of 1874
 subject)
Courtesy, Museum of Fine Arts,
 Boston.

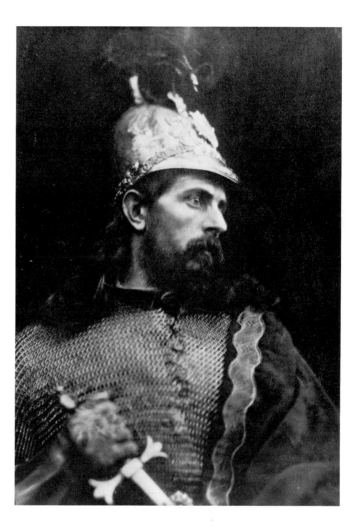

17

In a letter of December 15, 1874, Cameron wrote, "Tennyson himself is very much pleased with this ideal representation of his *Idylls*;"[19] the mundane exposure problems of a chuckling husband did not affect the final, ideal representation.

For Cameron and her circle, dressing-up and acting in scenes, activities willingly (or unwillingly) undertaken for photographs intended for publication, sale, exhibition, and review in the daily press, were expressions and extensions of their own characters. The

17. "A Reminiscence of Mrs. Cameron by a Lady Amateur," *The Photographic News*, 2-4.
18. Ibid.
19. This letter is reproduced in full in Gernsheim, *Cameron*, p. 48; the letter is with the copy of the *Illustrations* in the collection of the Metropolitan Museum of Art, New York City.

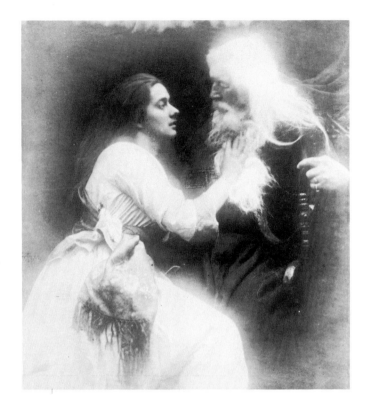

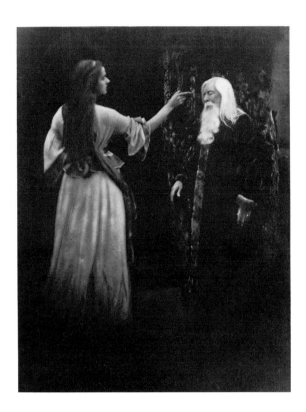

18

Merlin and Vivien
(1874)
Library of Congress

Merlin and Vivien
(Undated reproduction of 1874
subject
Collection of the Royal Photographic
Society of Great Britain

high aspirations and sense of self-congratulation of Cameron and her circle are revealed in a passage from a letter of Cameron to Ryan, in which she explained how Tennyson:

> *approved of my King Arthur (p. 17) greatly. He always says that his Arthur is an embodiment or I might say Incarnation of Conscience. That he was 'principle of conscience moving among his knights' and certainly my King Arthur has eyes that search into one and is mythical and spiritual in the highest degree. I must not detain you with details altho' I know you take a lively interest in matters great and small concerning your friends—* [20]

Ryan apparently did not know William Warder, the Freshwater, Isle of Wight porter who portrayed King Arthur, so there was no speculation as to whether Warder had appeared "in character!!" as the "Incarnation of Conscience." Cameron's imposition of characterizations upon her models was also consistent with the closed network of shared assumptions in which she photographed and lived.

Wynfield's and Cameron's "out of focus" was not a device applied for artistic effect, but a form which symbolized for its audience a superior practice of photography. Old master subjects provided compositional prototypes, but the ideality of Wynfield's and Cameron's photographs resided in the form, not the costume. Cameron gave the Watts Album, the

20. Cameron to Ryan, December 4, 1874, Gilman Paper Company Collection.

G.F. Watts R.A.
(1864)
Museum purchase

Love in Idleness
(c. 1866)
Gift of Eastman Kodak Company:
 ex-collection Gabriel Cromer

album of family photographs, to the artist George Watts. Watts used at least one of the Album photographs, "Lovlos Kuhn" as a study for a painting; several Cameron photographs apparently served as studies for Watts's portraits.[21] With the representation of ideal nature available in her photograph, Cameron was not only able to provide Watts with studies, but to apply Watts's "High Art" aspirations to photography. High Art was academic art, distinguished by serious and exemplary content, which Watts and others hoped would serve as England's national art. Implicit in the High Art movement was the possibility art offered to influence and improve society; Cameron sought to bring this improvement to photography. Cameron discussed her photographic ambitions with Sir John Herschel in a letter of December 31, 1864, in which she contrasted her photography to:

> *mere conventional topographic Photography—map making & skeleton rendering of feature & form without that roundness & fulness [sic] of force & feature that modelling of flesh & limb which the focus I use only can give tho' called & condemned as "out of focus." My aspirations are to ennoble Photography and to secure for it the character and uses of High Art by combining the real & Ideal and sacrificing nothing of Truth by all possible devotion to Poetry and beauty.[22]*

Cameron differed from Wynfield, whom she characterized as the "Great Amateur," in her aspiration to ennoble photography and use it for the purposes of High Art. Cameron ambitiously pursued photography and sought the acclaim which her accomplishments would merit. Cameron hoped the sale of her images would pay the expenses for the education of her sons (and recoup the costs of her photographic supplies). These motivations explain her considerable efforts to gain recognition and sales of her photographs and her interest in having her photographs in the collections of such cultural institutions as the British Museum and the South Kensington Museum.[23]

21. London, National Portrait Gallery, *G. F. Watts: The Hall of Fame, Portraits of His Famous Contemporaries,* 1975, p. 20 "Thomas Carlyle," and p. 24, "Henry Taylor." The Carlyle head is similar to Cameron's "Carlyle," (p. 61), the Taylor to a Coburn reprint of a Cameron photograph of Taylor (p. 79); the Lovlos Kuhn photograph served as a study for "Little Red Riding Hood," an oil study in the collection of the Ashmolean Museum, Oxford.

22. Julia Margaret Cameron to Sir John Herschel, December 31, 1864, collection of the Royal Society of London, quoted in full in Ford, *The Cameron Collection*, p. 140-45.

23. See Appendix I: Exhibitions, Donations and Purchases of Cameron's Photographs.

Love
1864
Boni Collection, Department of
Special Collections, University
Research Library, University of
California at Los Angeles

(Mother and child)
(c.1864-65)
Paul Walter Collection

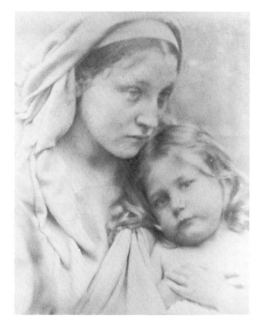

20

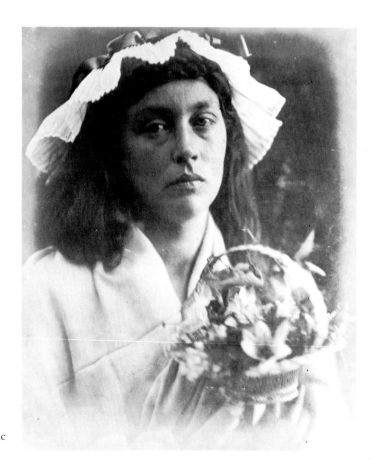

**Madame Reiné (see Village on
the Cliffs)**
1869
Collection of the Royal Photographic
Society of Great Britain

Cherub and Seraph
(1865)
Gift of Eastman Kodak Company:
 ex-collection Gabriel Cromer

Mary Mother
(1867)
Museum purchase

Beatrice
(1866)
Museum purchase

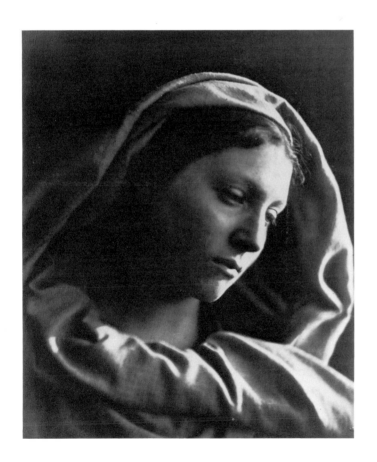

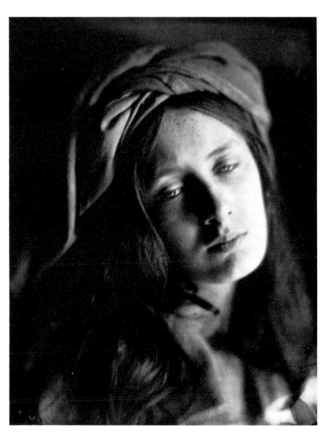

22

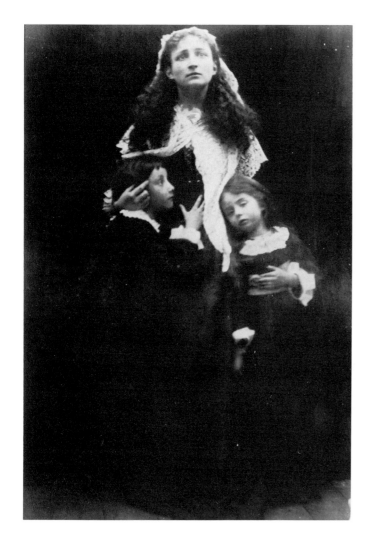

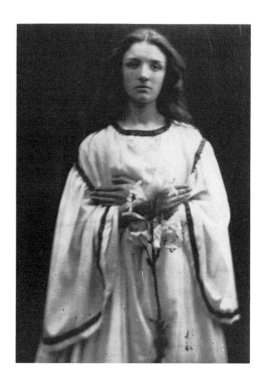

A Flower of Paradise
(1867)
Museum collection

**Queen Henrietta Maria
announcing to her Children the
coming fate of their Father King
Charles the First**
1874
Paul Walter Collection

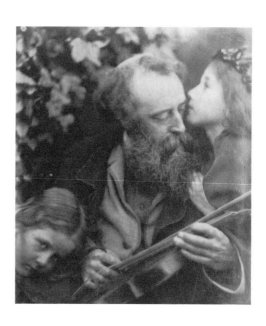

(Whisper of the Muse)
(Modern print by A.L. Coburn,
 c. 1915, from copy negative
 of 1865 print)
Bequest of Alvin Langdon Coburn

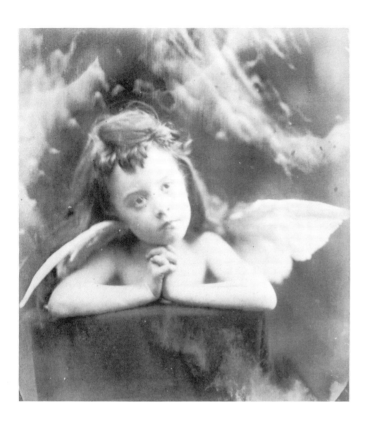

Thy Will be Done
1872
Gift of Eastman Kodak Company:
 ex-collection Gabriel Cromer

Gretchen at the Altar
(Undated reproduction of c.1872
 subject)
Courtesy, Museum of Fine Arts,
 Boston

(Floss and Iolande)
(1865)
Gift of Alden Scott Boyer

Henry Taylor
(1865)
Gift of Eastman Kodak Company:
 ex-collection Gabriel Cromer

The Day Spring
(1865)
Gift of Eastman Kodak Company:
 ex-collection Gabriel Cromer

24

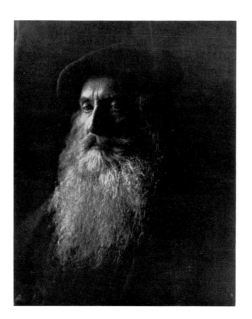

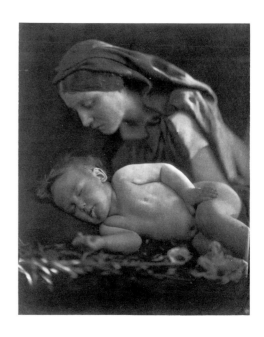

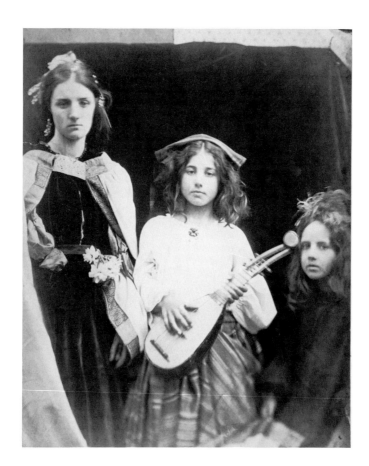

(The Minstrel Group) Study No. 2
(1867)
Museum purchase

(Lord Overstone)
(Undated reproduction of 1865?
 subject)
Collection of the Royal Photographic
 Society of Great Britain, Gift of
 Alvin Langdon Coburn, 1930.

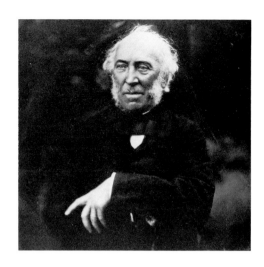

25

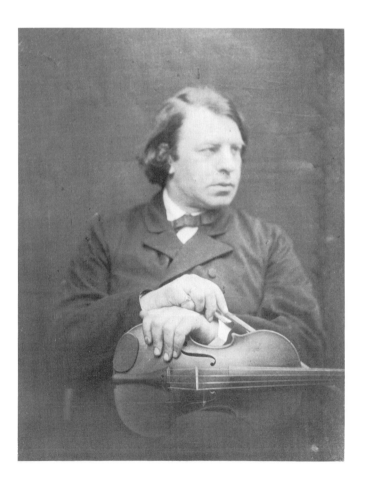

Herr Joachim
1868
Museum purchase

Cameron made her photographs available to artists as studies, and offered her photographs at half-price to artists at her French Gallery exhibition of November, 1865.[24] Cameron's photographs of prominent Victorian "men of mark" were the photographic counterpart to Watts's extended portrait project, "The House of Fame," a pantheon of heroic figures. Cameron's portraits of eminent persons were apparently marketed separately from her illustrative photographs, and satisfied public interest in images of the famous.[25] The major theme of Cameron's non-portrait photographs was the subject of woman. Critics, including Anna Jameson, Coventry Patmore and Lady Elizabeth Eastlake, urged women artists to explore the subjects of women's experiences; Cameron's interest in the subject of woman was held in common with contemporary women artists in other media, indicative of the social expectations governing women's activities during the period. With her High Art aspirations

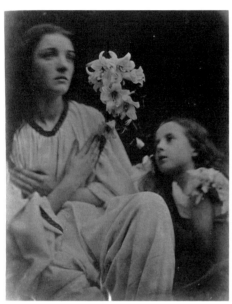
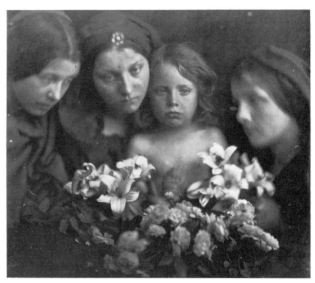

Cameron idealized women's experiences, particularly marriage and maternity, and illustrated inspirational and famous women characters from religion, history, and literature.[26]

In an album presented to Lord Overstone in August, 1865, Cameron assigned three categories, portraits, fancy subjects, and Madonna groups, to her list of titles;[27] each of these categories elaborates upon the combination of old master subjects and fancy dress activities. Cameron's Madonna subjects were related to old master prototypes and epitomize Cameron's idealization of women's domestic experiences. There are coincidences of titles between Cameron's Marian subjects and subjects of Jameson's *Legends of the Madonna as Represented in the Fine Arts.* Jameson praised Mary as the "most perfect moral type" of woman and Cameron celebrated this perfection in such subjects as "La Madonna Riposata" (p. 28) "Mary Mother" (p. 21), "The Day Spring" (p. 24), and "La Madonna" (p. 55).[28] A woman

24. Unsigned, "(Untitled notice)," *Illustrated London News,* 47 (July 22, 1865): 71; "Mrs. Cameron's Exhibition of Photographs," exhibition catalogue in the collection of the National Art Library, Victoria and Albert Museum, London (the month and street address, and the photographs listed, correspond with the French Gallery Exhibition of November, 1865) reads, "All artists are allowed to purchase at half price."

25. Unsigned, "Fine Art Gossip," *Athenaeum,* June 22, 1867, p. 827.

26. Charlotte Yeldham, *Woman Artists in the Nineteenth Century, France and England,* 2 vols., (New York, 1983), 1, p. 379-83.

27. The Overstone Album, presented by Cameron to Lord Overstone on August 5, 1865, of 111 photographs, in the collection of the J. Paul Getty Museum, Malibu, California. Reference photographs and titles for the Overstone Album are in the auction catalogue for Sotheby's Belgravia, June 26, 1975, "Early Photographic Images and Related Material."

28. Anna Jameson, *Legends of the Madonna, as represented in the Fine Arts,* 2nd ed., enlarged, (London, 1857), p. ix; the connection between Cameron and Jameson was made by Mike Weaver, *Julia Margaret Cameron, 1815-1879,* (New York, 1984), p. 18-26.

with either one or two children represented "The Fruits of the Spirit" ("Love" p. 20), a series of nine photographs presented to the British Museum in January, 1865.[29] Cameron's Madonnas are comparable to her studies of children as cherubs, such as "Cherub and Seraph" (p. 21) and "Thy will be done" (p. 23) in the use of old master prototypes to idealize Victorian domestic and religious values. Women were witnesses to the divine in "The Three Marys" (cover), heroines from history and literature, in "Queen Philippa Interceding for the Burghers of Calais" (p. 45), "Queen Henrietta Marie informing her Children of the coming fate of their Father, King Charles the First" (p. 22), "Gretchen at the Altar" (p. 23), and "Beatrice" (p. 21), and figures of beauty in "A Flower of Paradise" (p. 22), "The Mountain Nymph Sweet Liberty" (p. 39), and "Madame Reiné" (p. 20), from Cameron's friend Anne Thackeray's *The Village on the Cliff*.

The Vision
1867
University Art Museum, The University of New Mexico, Albuquerque.

"Wist ye not that Your Father and I sought thee sorrowing?"
(1865)
Gift of Eastman Kodak Company: ex-collection Gabriel Cromer

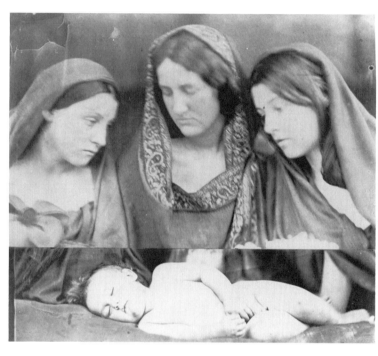

The Adoration
(c.1865)
Museum purchase

The subjects of Cameron's extant Marian subjects and the titles of the copyrighted images are restricted to events in the life of the young Mary: the Incarnation and boyhood of Christ [see "The Vision" (p. 26) and "Wist ye not that Your Father and I sought thee sorrowing?" (p. 26)]. Cameron did not illustrate the later events in the life of the Virgin, also available in Jameson's *Legends of the Madonna*.[30] Cameron's illustration of the young Mary is consistent with her confinement of her representations of women characters to young models. According to Hester Thackeray Fuller (daughter of Anne Thackeray), Cameron said "No woman should ever allow herself to be photographed between the ages of 18 to 80." Perhaps the photography to which Cameron referred was the "mere topographical photography" she disdained, but the statement is consistent with Cameron's infrequent representations of

29. Nine Cameron photographs were accepted into the British Museum in January, 1865. The nine studies are: "The Fruits of the Spirit," Galatians v. 22, "Gentleness," "Meekness," "Joy," "Love," "Long Suffering," "Temperance," "Peace," "Faith," "Goodness."

30. This statement is based upon the information given in the copyright registrations from the period when Cameron was entering her own descriptions and titles. This emphasis upon the youthful Mary is also consistent with Cameron's representation of female beauty—see below.

La Madonna Riposata
1864
Boni Collection, Department of
 Special Collections, University
 Research Library, University of
 California at Los Angeles

The five Wise Virgins
(1864)
Gift of Eastman Kodak Company:
 ex-collection Gabriel Cromer

28

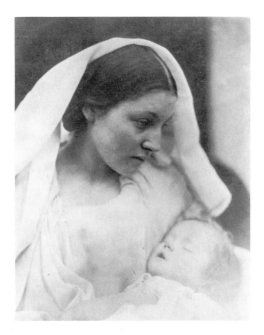 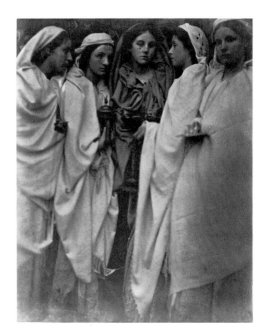

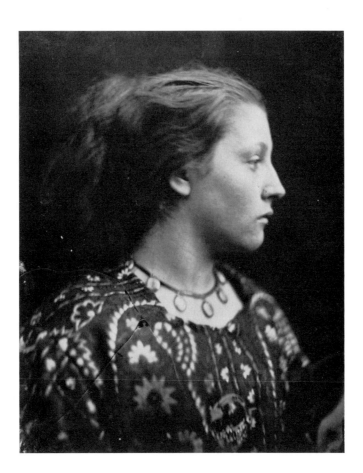

Sappho
(c.1866)
Gift of Eastman Kodak Company:
 ex-collection Gabriel Cromer

middle-aged and older women (in striking contrast to her representations of men) in her photography. The "ideal nature" of Cameron's photography conformed to expectations of the beauty of young women models.[31]

While Cameron's representations of female beauty and subjects of women conformed to conventional Victorian expectations of women, there are indications in Cameron's subjects of the importance, and even power, of women's activities which confound woman's otherwise secondary status. These indications are apparent in the subjects of three sets of photographs which Cameron sold to the South Kensington Museum in the summer of 1865. The subjects of the three sets are nearly identical, and all of the subjects, save one, are exclusively of women: Madonna studies, such as "La Madonna Riposata" (p. 28); women awaiting their bridegroom Christ in "The five Wise Virgins" (p. 28); one woman aiding another, "Floss and Iolande" (p. 23), (a scene from Taylor's *Saint Clement's Eve*); the poetess Sappho (a later version of the subject, with the same model, is p. 28); a scene of two women in contemporary dress, "Yes or No," presumably considering a marriage proposal. The lone man of the group is George Watts, portrayed with two young female muses in "The Whisper of the Muse" (p. 22).[32] The women are mothers, a poetess, and embodiment of nature; they support each other and wait together for their Savior. While the presence of men is implicit in many of the activities, the men are physically absent. In these photographs the conventional, reactive roles of women were honored by their elevation and separation from men. In the last major project of her career, her 1874-75 photographs to the *Idylls of the King,* Cameron illustrated women characters who possessed power and influence, but who did not challenge the order of Arthur's kingdom.

In *Julia Margaret Cameron's Illustrations to Tennyson's "Idylls of the King" and Other Poems,* the subjects of the images all pertain to the women characters of Tennyson's works. The two gift books of the *Illustrations* (the culmination, according to Cameron, of "the experience and labor of the previous ten *years* "),[33] provide a means of analyzing Cameron's intentions in choice of subject, sequencing of images, and use of supporting textual material; in addition, discussion of the project survives in Cameron's letters to friends, providing insights into Cameron's motivations and regard for her work.[34] With the *Illustrations* Cameron joined the artistic activity generated by Tennyson's *Idylls of the King,* one of the most popular and

31. Hester Thackeray Fuller, *Three Freshwater Friends: Tennyson, Watts and Mrs. Cameron,* (Newport, England, 1933), p. 36.
 There are images of women between the ages of 18 and 80 among the extant Cameron photographs: see Overstone, plates 13 and 88, portraits of Lady Elcho; Weaver, *Cameron 1815-1879,* p. 36, "Lady Ritchie and her Nieces;" photographs of Marianne North taken in Ceylon in 1877, Ford, *The Cameron Collection,* p. 21. The characterization is more descriptive than not of her extant photographs.
 For notice of Cameron's representations of female beauty: Unsigned, "Fine Arts," *Illustrated London News* 47 (November 18, 1865): 486; Unsigned, "Fine Arts: Exhibition of the Photographic Society," *Illustrated London News* 51 (November 23, 1867): 574. Fancy picture subjects were associated with images of women, see, Unsigned, "Selected Pictures: Suspense," *Art Journal* n.s., 4 (December, 1865): 336.

32. Purchases and gifts of 93 Cameron photographs are cited in the registration logs of the South Kensington Museum for June and September, 1865. Among these 93 photographs are three sets of 20 titles (save that one set has only 19 of the 20 images); these subjects will be discussed later in the text.
 The twenty titles are: "Resting in Hope," "Kept in the Heart," "Watch Without Ceasing," "Blessing and Blessed," "Grace through Love," "Fervent in Prayer," "Goodness," "Perfect in Peace," (all Madonna subjects) "St. Agnes, eyes open," "St. Agnes, eyes down," "Sappho," "Ioland and Floss," "Spring," "Spring," "Five Wise Virgins," "Five Foolish Virgins," "Yes or No," "Joy," "Whisper of the Muse."

33. Cameron to Ryan, November 29, 1874, Gilman Paper Company Collection; the Cameron letters to Ryan in this Collection are dated November 29, December 4, 6, 8, 12, 1874; other correspondence concerning the first volume of the *Illustrations* is reprinted in Gernsheim, *Cameron,* pp. 44-48.

34. The fullest account of the publication and variant copies of the *Illustrations* is Charles W. Millard, "Julia Margaret Cameron and Tennyson's *Idylls of the King,* " *Harvard Library Bulletin* 21

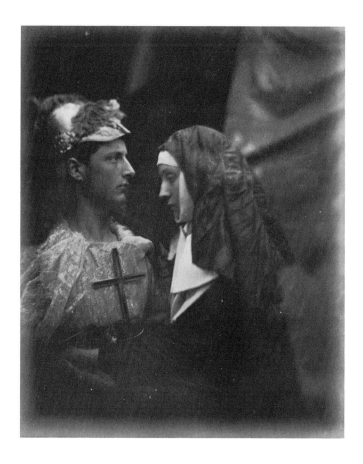

30

(Sir Galahad and the Pale Nun)
(1874)
Lent by The Minneapolis Institute of
 Arts, The Paul J. Schmitt Fund.

important literary works of the period. Tennyson's *Idylls* recast the medieval legend of the ancestral King of Britain for a Victorian audience, and this version of the rise and fall of Arthur and the Order of the Round Table touched deeply upon Victorian idealism and morality; Cameron illustrated Tennyson's Arthurian myth with the experiences of the women of Camelot.

Cameron wrote a series of letters on the production of the first volume of the *Illustrations* to Sir Edward Ryan, a family friend who had connections at the London *Times*. In November 1874, Cameron was furiously finishing her book in time for Christmas giving and asking Ryan to arrange for a review in the London *Times*. She described the project to him in a letter of November 29, 1874.

> *…About three months ago Alfred Tennyson walked into my room saying "Will you think it a trouble to illustrate my Idylls for me?" I answered laughingly "Now you know Alfred that I know that it is immortality to me to be bound up with you that altho' I bully you I have a corner of worship for you in my heart." & so I consented—*
>
> *I have worked for three months putting all my zeal and energy to my high task. But my beautiful large photographs are reduced to cabinet size for his people's edition and the first Illustration is transferred to Wood cut and appears now today when 12000 copies are issued.*

(April 1973): 187-201; an extensive discussion of the *Illustrations* is Gernsheim, *Cameron,* p. 42-50, 178-179.

The titles and sequence of photographs in the two IMP/GEH volumes of the *Illustrations* are listed in Appendix II. References to individual photographs in the *Illustrations* as numbered plates are for ease of identification, as Cameron did not number the subjects. The first volume of the *Illustrations* in the IMP/GEH collection lacks "And Enid Sang"; the plate references to this volume of the *Illustrations,* however, proceed as if this subject were there to give an account which will be accurate for this volume.

Millard, "Cameron and Tennyson's *Idylls of the King:*" p. 194-96, gives a detailed account of the different variations in subjects. Prints are mounted on blue or cream board and the inscriptions on the mounts vary from copy to copy. It is difficult to estimate the number of copies of the *Illustrations* produced; Millard noted that the problem of estimating the publication run is made more difficult by the number of individual photographs which were formerly bound.

Enid
(1874)
Detroit Institute of Arts, Founders
Society Purchase, Joseph M. de
Grimme Memorial Fund.

I do it for friendship not that I would not gladly have consented to profit if profit had been offered. Doré got a fortune for his drawn fancy Illustrations of these Idylls— Now one of my large photographs, the one for instance illustrating Elaine who is May Prinsep (now Hitchens) at her very best would excite more sensation and interest than all the drawings of Doré—and therefore I am producing a volume of these large photographs to illustrate the Idylls, 12 in number all differing (with portrait of Alfred Tennyson) in a handsome half morocco volume priced six guineas—I could not make it under for it to pay at all.[35]

Tennyson wanted illustrations for the forthcoming publication of his collected *Works* by the Henry S. King and Company. Small wood-engraved frontispieces to volumes 6, 7 and 9, illustrating "King Arthur," "Elaine," and "Maud"[36] were poorly reproduced from Cameron's photographs. In light of Cameron's dissatisfaction with the quality of these frontispieces, her own production of a "volume of large photographs" (also published by King and Company) was predictable and, according to Cameron, inspired by Tennyson's suggestion that she publish her photographs, "at their actual size in a big volume at your own risk." Tennyson's endorsement of the project had commercial value and Cameron wanted to make money from the *Illustrations*. She wrote to Ryan, "I *hope* to get one single grain of the momentous mountain heap of profits the poetical part of the album brings to Alfred." Cameron's comparison of her work to that of Gustave Doré, one of the most popular illustrators of the period, indicates her expectations for sales and the high regard in which she held her work.[37]

35. Cameron to Ryan, November 29, 1874, Gilman Paper Company Collection.

36. In a letter from C. Kegan Paul to Cameron of October 30, 1874 (reprinted in Gernsheim, *Cameron,* p. 44), Paul referred to photographs of Elaine, Merlin, Vivien, Gareth and Lynette, and "The Splendid Tear" and requested an illustration of "The Princess." Paul also referred to a photograph of Elaine with a dove and candle unknown to Millard ("Cameron and Tennyson's *Idylls of the King,*" p. 191), and to the author.

37. Cameron to Ryan, November 29, 1874 and December 4, 1874, Gilman Paper Company Collection.

Although the same title is used for both books, the earlier volume, published in January, 1875, was devoted exclusively to the *Idylls of the King,* while the latter volume (published in May, 1875), included the *Idylls* and "Other Poems," "The May Queen," "New Year's Eve," "Conclusion," "The Princess," "Mariana," "The Beggar Maid," and "Maud." The individual volume of the *Illustrations* consists of twelve albumen photographs (and a frontispiece portrait of Tennyson), each preceded by an excerpt from the poem it illustrates.[38] The *Illustrations* photographs were sold individually, and reproduced in carbon. Cameron combined and rearranged the sequence of photographs from both volumes for special presentation copies given to friends, and included *Illustrations* images in a "miniature album" of her photographs, given as a going-away present to her son.[39] The first volume of the *Illustrations* was reviewed in the London *Times* and *The Morning Post,* but not in the English photographic

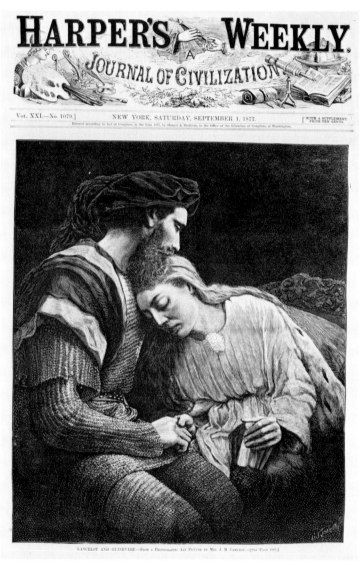

Lancelot and Guinevere
Harper's Weekly 1877
University of Rochester, Rush Rhees
 Library

38. For titles, see Appendix II; Cameron discussed the sale of individual prints in the letter to Ryan of November 29, 1874, Gilman Paper Company Collection; *Harper's Weekly,* September 1, 1877, cover.

39. The contents of a special presentation copy for Anne Thackeray Ritchie are listed in Gernsheim, *Cameron,* pp. 178-9 (this copy is in the Gernsheim Collection, Harry Ransom Humanities Research Center, University of Texas at Austin).
 Cameron produced "miniature editions" of the *Illustrations* (photographs 3″ x 4¼″), combining photographs from both volumes and with two additional illustrations, "The Gardener's Daughter" and "The Childhood of Alice and Effie" identified and illustrated in Millard, "Cameron and Tennyson's *Idylls of the King,*" p. 197, plates VI and VII. The titles of a copy of a miniature edition in the Gernsheim Collection are listed in Gernsheim, *Cameron,* p. 79; *An Album: Julia Margaret Cameron,* a 1975 publication of Lunn Gallery/Graphics International Limited, reproduces the contents of a miniature album Cameron gave to her son Henry Herschel Hay Cameron, presumably after 1874.

press which usually appraised Cameron's exhibition contributions. Less is known about the second volume of the *Illustrations,* apparently published in May, 1875.[40]

The two volumes of the *Illustrations* include fifteen different subjects from the *Idylls of the King* (see Appendix II). Cameron sequenced the *Idylls* subjects in both volumes to follow the course of Camelot, from the springtime and optimism of "Gareth and Lynette" to the winter mysteries of "The Passing of Arthur" (p. 37); as a consequence, Cameron's individual photographs take on the dimensions of Tennyson's narrative. Of the fifteen subjects, eleven are from the idylls of Elaine, Enid, Guinevere, and Vivien, a group which Tennyson had published separately in 1859.[41] In their different virtues and weaknesses Enid, Vivien, Elaine, and Guinevere symbolize the strengths and failings of King Arthur's ideal society. The adulterous love of Queen Guinevere and Lancelot, Arthur's closest friend and finest knight, undermines the integrity of the Round Table and, with it, Camelot itself. Enid, the faithful wife, is suspected by her husband Geraint of being as unfaithful as Guinevere, but Enid's resolute loyalty restores his faith. Vivien seduces Merlin and imprisons him with his own charm, depriving Arthur of his most important advisor. Lancelot's love for Guinevere causes him to reject the pure, innocent Elaine, who goes mad and dies of unrequited love. Cameron illustrated "The Holy Grail" (p. 30) as Sir Galahad inspired by the Pale Nun, "Gareth and Lynette" as a scene of tenderness between these feuding characters, and "The Passing of Arthur" as Arthur leaving Camelot on the mysterious barge.

Cameron's choice of incident and its representation emphasized the experiences of the women of Camelot. Vivien's seduction and imprisonment of Merlin (p. 18) and the Pale Nun's inspiration of Sir Galahad (p. 30) are major events within their idylls, while Lynette's reflections upon the sleeping Gareth and the song of the Little Novice to Guinevere are comparatively minor events. In Cameron's arrangement, however, both Vivien and the Pale Nun become powerful women who influence men's actions, and Lynette's maternal solicitude for the sleeping Gareth takes on the power of "utter peace and love and gentleness" of the world.[42] The women characters of Cameron's *Idylls of the King* are active, the men, passive and reactive: Lynette watches over a sleeping Gareth, Vivien seduces and imprisons Merlin, and the Pale Nun inspires Galahad. Enid's wifely loyalty and beauty are honored (p. 31), but Guinevere's adulterous relationship with Lancelot is described sympathetically, both at her parting from Lancelot (p. 32) and at her remorse at the song of the Little Nun.

This sympathetic interpretation of Guinevere evolved over the course of the production of the *Illustrations.* In an article about Cameron, published at the end of the 19th

33

40. Unsigned review, "Poetry and Photography," London *Times,* February 1, 1875; Unsigned review, "Mrs. Cameron's New Photographs," *The Morning Post,* January 11, 1875, reprinted in Gernsheim, *Cameron,* p. 48-49; by the "photographic press" is meant the *British Journal of Photography,* the *Photographic Journal* and the *Photographic News,* English publications which regularly reviewed Cameron's participation in photographic exhibitions; "Vincus," "From Across the Water," *Anthony's Photographic Bulletin* 6 (April, 1875): 122-7.
On the May, 1875 volume of the *Illustrations,* see Gernsheim, *Cameron,* p. 48, 178 and Millard, "Cameron and Tennyson's *Idylls of the King,*" p. 194-4. Cameron registered four photographs from this May, 1875, volume for copyright on May 1, 1875: the three illustrations of "The May Queen," and "Maud."

41. For a summary of the chronology of the *Idylls of the King* see John D. Rosenberg, *The Fall of Camelot,* (Cambridge, MA, 1973) p. 156-157.

42. The text excerpt for "Gareth and Lynette" is from the idyll of the same title, see *The Poems of Tennyson,* edited by Christopher Ricks, (London, 1969), p. 1521, lines 1240-1257. The final three lines of the text excerpt: "Good Lord, how sweetly smells the honeysuckle/In the hushed night, as if the world were one/Of utter peace, and love, and gentleness!"

Elaine, the Lily Maid of Astolat
(1874)
Museum purchase

century, the model for Guinevere complained about posing all day lying at the foot of the Freshwater porter who played Arthur, clutching his ankle. The event, part of the farewell scene between Guinevere and Arthur, is not illustrated in the extant copies of the *Illustrations,* nor known as an individual print.[43] A photograph of Guinevere standing alone is listed in the copyright registrations of December 8, 1874; a photograph which fits this description is featured in a prototype copy of the *Illustrations,* preceded by a text describing Guinevere as jealous of Lancelot's love for Elaine. By omitting this image of Guinevere from the final version of the *Illustrations,* Cameron minimized Guinevere's role as the rival of the innocent Elaine.[44] This presentation of Guinevere's relationship to Elaine is especially significant because of Elaine's prominence in Cameron's illustrations of the *Idylls of the King.*

Elaine's story received the most extended treatment of any, and was represented from the point-of-view of her fantasy world of love. In the first photograph (p. 34) Elaine gazes at the shield of Lancelot, which he had entrusted to her and which became the focus of her dreams of love. By the following photograph (p. 35) Lancelot has rejected Elaine, claimed his shield, and left her desolate and insane. Her dying request was that her body be taken by barge to Camelot (p. 36) and immortalized at the court; Cameron's final photographs of Elaine illustrate the fulfillment of the request.

43. V. C. Scott O'Connor, "Mrs. Cameron, her Friends, and her Photographs," *Century Magazine,* November, 1897: 10.

44. Copyright registrations, Public Record Office, Kew, England. The prototype copy is in the collection of the Metropolitan Museum of Art, New York City; the illustration of the proud and pale Guinevere was also used in a copy of the *Illustrations* in the collection of the Tennyson Research Centre, Lincoln, England, Millard, "Cameron and Tennyson's *Idylls of the King,* " p. 192.
 The illustration of the proud and pale Guinevere is noted in the review in the London *Times,* but Guinevere and the Little Nun is discussed in the *The Morning Post* review. In the Anne Thackeray Ritchie copy of the *Illustration* in the Gernsheim Collection, the proud and pale Guinevere is not used, but is found in the "miniature edition" of the work, also in the Gernsheim Collection, see Gernsheim, *Cameron,* p. 178-79.

Elaine
1874
Collection of the Royal Photographic
Society of Great Britain.

Visual parallels between Cameron's illustrations of Elaine and Arthur elevate Elaine's fantasy of love into one of the major events of Camelot. Arthur and Elaine are the only characters represented in visually continuous, paired sequence, and both are represented on boats, symbolic of their passages into immortality. In Tennyson's text, there are parallels between Arthur and Elaine, establishing an equivalence between Arthur's dream of an ideal society and Elaine's dream of love, but Cameron went beyond this equivalence in her illustrations of Elaine. Cameron's sequencing of the photographs in the *Illustrations* is strongly oriented around the heroic figure of Arthur, who concludes the *Idylls of the King* photographs in both volumes of the *Illustrations*. These final (and virtually only) images of Arthur visit his presence retrospectively upon all the events of his kingdom; this sequencing prevents Elaine from becoming Arthur's equal, and mitigating his majesterial role. But also because Elaine was not Arthur's equal, she could be an important figure in her own right, the creator of her own immortality. Cameron's Elaine is a powerful figure, who transforms the conditions of men without altering the course of the narrative.

It is instructive to compare Cameron's women subjects in the *Idylls of the King* with those of the "Other Poems:" the fallen and redeemed woman in "The May Queen" (p. 69); the heroine, "The Princess"; the woman transformed by man's love in "The Beggar Maid" and "Mariana"; the beautiful "Maud." "The May Queen" and "The Princess" are illustrated with three photographs sequenced to follow the respective Tennyson texts. Cameron's illustrations of the three poems of "The May Queen" describe the redemption of the fallen May Queen through her death and devotion to her Savior; the three illustrations of "The Princess" do not give an indication of the course of the text.[45] It is interesting to speculate whether this

45. "The May Queen" and "New Year's Eve" were published in 1832 and "Conclusion" added in 1842. See Ricks, *Tennyson*, pp. 418-22. The first and third of Cameron's three illustrations to "The May Queen" were of the May Queen herself. In the first she looks at the viewer, in the second she looks heavenwards with her hands clasped to her breast. Between these two photographs was an

36

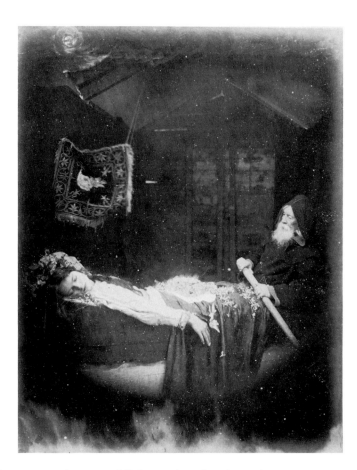

Elaine
(1874-75)
Museum purchase

treatment of the course of events of "The Princess" indicated Cameron's dissatisfaction with the conclusion of the poem, but the absence of a connection between her photographs and the Tennyson text does not allow for the analysis possible with Cameron's illustrations to the *Idylls of the King*. The women characters of the "Other Poems" are generally reactive, not active, as the women characters from the *Idylls of the King*; perhaps the dimensions of an ideal society allowed Cameron possibilities otherwise unavailable.

Cameron's inspirational High Art subjects reflect the interplay of her artistic and family values, and their confirmation of the Victorian conventions governing woman's physical attractiveness, appropriate activities, and influences. Cameron's elevation of women's roles within these conventions, culminating in the powerful women characters of the *Idylls of the King,* referred to Cameron herself, who exercised a level of authority over the activities of her circle ("when Mrs. Cameron said a thing was to be done, it had to be done"), worked intensively with a complicated photographic process, and avidly pursued the recognition of her photography. The vehemence of Cameron's belief in the sensational commercial success and artistic merit of her photographs elicits, if not complete agreement, respect.

image of the May Queen and Robin at a fence, a Victorian visual convention for a courtship scene. The change in appearance between the first and third illustrations of the May Queen is explained by her encounter with Robin. The photograph of the May Queen and Robin followed the text of "New Year's Eve," although the event was taken from "The May Queen."

"The Princess: A Medley" was published in 1847 and extensively revised through the fifth edition of 1853 (Ricks, *Tennyson,* p. 741). Cameron illustrated text excerpts from the end of section III and the beginning of section IV. The first illustration represented the encounter of the Prince (disguised as a woman) with the majestic Princess; the second illustration a woman playing an instrument to a song interposed between sections III and IV; the third illustration a woman playing an instrument to a song from section IV. In the absence of a connection with the narrative of the poem, the interpretation of Cameron's illustrations becomes even more speculative than that given here for the *Idylls*.

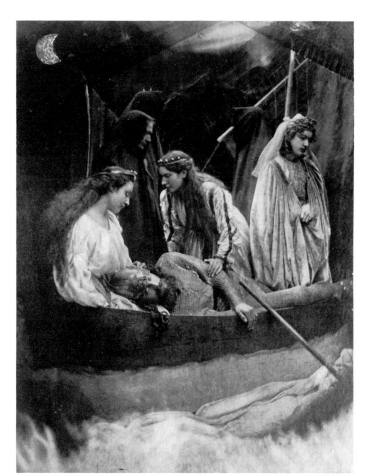

(The Passing of King Arthur)
(Undated reproduction of 1874 subject)
Collection of the Royal Photographic Society of Great Britain.

While there are continuities in context and subject between the photographs in the 1864 Watts Album and the photographs in the 1875 *Julia Margaret Cameron's Illustrations to Tennyson's "Idylls of the King" and Other Poems* there are considerable differences in the appearances of the images. The technical experimentation and expressive distortion of form of the Watts Album photographs are not evident in the 1875 photographs. Figures are no longer realized in space and light no longer creates form; instead, figures and backgrounds are illuminated in a specific, shallow space. These differences are indicative of a change in the meaning of "out of focus" representation which evolved between 1864 and 1875.

In her December, 1864 letter to Herschel (quoted earlier) Cameron distinguished her work from "conventional topographic photography" by its "roundness & fulness *(sic)* of force & feature, that modeling of flesh and limb":[46] the "out of focus" form of Cameron's photography pertained to the representation of space. In Wynfield's bust portraits the use of a lens with a shallow depth of field (and the subsequent change in the quality of focus) represents volumes in spatial recession; Cameron took this representation to an even greater degree. In "The Mountain Nymph Sweet Liberty" (p. 39), the model's head is forward of her neck and shoulders, and the distinctness of focus of her eyes contrasts with the obscurity of her garment and the hair on her shoulders. Herschel praised "The Mountain Nymph Sweet Liberty" as "a most *astonishing* piece of high relief—She is absolutely *alive* and thrusting out her head from the paper into the air."[47] The illusion of relief is one aspect of a plastic and animated form in space characteristic of Cameron's photography through the early 1870s.

46. Quoted in Ford, *The Cameron Collection*, p. 140-41.

47. Ford, *The Cameron Collection*, p. 142, letter from Herschel to Cameron of September 25, 1866, collection of the Royal Society of London.

38

A. Tennyson
(c.1865-66)
Museum collection

(Charles Cameron)
From G.F. Watts Album, 1864
Museum collection

In Cameron photographs from 1864-65 the near illegibility and extensive technical experimentation of the Watts Album images was succeeded by less dramatic representations of form. This development is illustrated in a comparison between a Watts Album photograph of Charles Cameron (p. 38) and an 1865-66 portrait of Alfred Tennyson (p. 38). The Tennyson portrait lacks the distortions of features of the Charles Cameron portrait, although the forms are manipulated in space for representational ends in both images. This manipulation renders Tennyson's features in spatial recession, while Charles Cameron's are compressed and distorted; the two images, however, are in a continuum in the use of the lens to represent forms in space. Another continuity between the Watts Album photographs and later work was Cameron's characterization of her photographs as "From Life." On February 22, 1866, Cameron wrote Herschel about a new development in her work, which put her photographs in a stronger relation "to Life":

> *No praise that I have had for my Photography has been so precious to me or so dear as your praise! It fed all my ambition! It seemed to nourish the very core of the heart—more than this it has stimulated me to new efforts and I have just been engaged in doing that which Mr. Watts has always been urging me to do, A Series of Life sized heads—they are not only* from *the Life, but* to *the Life, and startle the eye with wonder and delight—I hope they will astonish the public and reveal more the mystery of this heaven born art—They lose nothing in beauty and gain much in power—* [48]

48. Ford, *The Cameron Collection,* p. 15, letter from Cameron to Herschel of January 28, 1866, collection of the Library of the Royal Society of London.

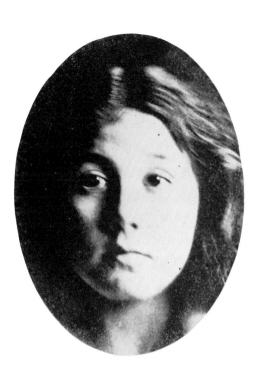

(Woman, full face)
(c.1866-67)
Gift of Alden Scott Boyer

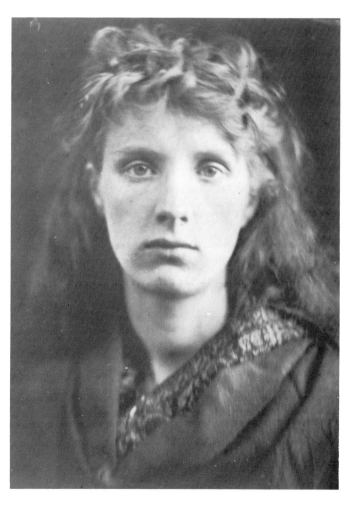

**The Mountain Nymph Sweet
Liberty**
(1866)
Museum collection

Cameron did at least one life-sized head in 1864, a "Mary Madonna" of Mary Hillier; in this photograph the model's face failed to be recorded completely on the 26.7 x 20.7 cm. glass negative. Cameron's switch to a larger lens and negative format, by August, 1865, solved this size problem.[49] Cameron's representation of ideal nature in the manipulation of form in space was sustained in these life-sized heads and the authority of Cameron's demonstration of ideal nature "*from* Life" was carried to its material limits in photographs taken "*to* the Life."

In the ten years of Cameron's photographic career the relation of her "out of focus" photography to commercial photography changed with the increasing specialization of photographic activity and changes in the meaning of the practice of photography. In the following sections Cameron's public promotion of her photographs are reviewed with the reactions of the photographic and non-photographic press to these efforts. In responses to Cameron's photographs different expectations of photographic representation can be evaluated. An analysis of these expectations provides an account of Cameron's aspiration to "ennoble Photography," and suggests reasons for her apparent failure.

49. The photograph of "Mary Madonna" is in the Overstone Album, J. Paul Getty Collection, Malibu, CA; Gernsheim, *Cameron,* p. 69-70; Gernsheim quotes an article by P. H. Emerson, "Mrs. Julia Margaret Cameron," *(Sun Artists* 5 [October, 1890]: 33-41), in which Emerson describes Cameron's first camera as a sliding box type for 11″ x 9″ plates, with a "Jamine" lens, focal length 12″, diameter 3″. Arthur Gill reported in "One Hundred Years Ago," *Photographic Journal* 104 [July, 1964]: 134) that the Cameron camera in the collection of the Royal Photographic Society of Great Britain, an 11″ x 9″ format, has a focus of 14-14½″, not 12″ as Emerson and Gernsehim reported; the discrepancy in focal length measurements could be due to different ways of measuring the focal length, or indicate the existence of another lens.

Cameron worked with a format larger than 11″ x 9″ as early as August, 1865; a photograph in the Victoria and Albert Museum, reproduced in Weaver, *Cameron 1815-1879,* p. 32, is inscribed August, 1865, and measures 10⅝″ x 14¹⁵⁄₁₆″ (27.0 x 36.5 cm). Emerson also described how Cameron purchased an 18″ x 22″ Dallmeyer Rapid Rectilinear lens and used it for 15″ x 12″ plates.

Despite Cameron's interest in photographs "to the life," she did make her work available in *carte-de-visite* and cabinet sizes. See p. 39 and *cartes-de-visite* in the collection of the National Portrait Gallery, London.

Exhibitions and Reactions

Early Recognition: 1864-1865

HE PHOTOGRAPHIC SOCIETY of London in their Journal would have dispirited me very much had I not valued that criticism at its worth. The more lenient and discerning judges gave me large space upon their walls which seemed to invite the irony and spleen of the printed notice.

Julia Margaret Cameron
"Annals of My Glass House," 1874 [1]

Cameron registered 108 photographs for copyright in 1864 and 90 in 1865; the two year total of 198 photographs constitutes more than a third of the total number of registrations made over the ten years of Cameron's career. In 1864-65 the majority of the registered photographs were portraits, including those of artists William Holman Hunt and Richard Doyle, writers Aubrey de Vere, Charles Turner Tennyson, William Michael Rossetti, and Robert Browning, and several portraits each of Tennyson, Taylor, Watts, his wife, the actress Ellen Terry, and the Tennyson children. The other registrations of 1864-65 were predominantly subjects of women: Madonnas and other subjects from literature and the Bible. [2]

Cameron was compared to her mentor David Wilkie Wynfield in reviews of her first exhibition, the tenth Annual Exhibition of the Photographic Society of London (the predecessor of the present Photographic Society of Great Britain) in May, 1864. The Photographic Society of London was one of the foremost photographic societies in Europe and its Annual Exhibition was an opportunity to review important work in contemporary photography. [3] Critical reviews of Cameron's contribution to the 1864 Annual Exhibition present a range of contemporary expectations of photography's artistic capacities. An unsigned review in the *Photographic Journal* (the Photographic Society of London's publication) considered Cameron's photographs as "very good" in their adoption of Wynfield's methods, but inferior to his, because her artistic knowledge was not as great. In this review Cameron's photographs were evaluated as part of the amateur section of the Exhibition. [4] The reviewer in the *Athenaeum* placed Cameron in opposition to professional photographers, characterizing her photographs as, "admirable, expressive, vigorous, but dreadfully opposed to photographic con-

1. Cameron, "Annals," p. 136.

2. All references to copyright registrations are from the registers on file in the Public Record Office, Kew, England.

3. Unsigned, "Fine Arts: Exhibition of the Photographic Society," *Illustrated London News* 51 (November 23, 1867): 574.

4. Unsigned, "Photographic Exhibition," *Photographic Journal* 11 (August 15, 1864): 86-88.

ventionalities and proprieties. They are the more valuable for being so."[5] In a later review the *Athenaeum* elaborated:

So rich are her likenesses in tone and in what is technically styled "color" that they attain, in these respects, the value of works of art. These productions are made "out of focus" as the technical phrase is, and although sadly unconventional in the eyes of photographers, give us hope that something higher than mechanical success is attainable by the camera. Added clearness, the recent aim of operators, will no more give artistic aim to photography than added finish does to a picture, and, as with painters who have sacrificed all to finish, modern photographs are, artistically speaking, little more than diagrams; they are as such, mostly out of scale. [6]

42

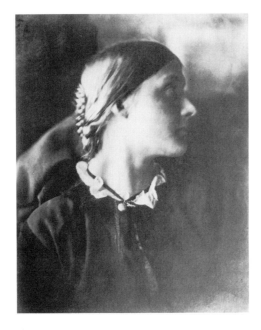 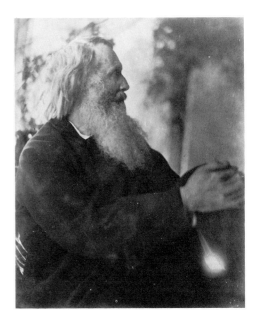

(Julia Jackson)
(Modern print by A.L. Coburn,
 c. 1915, from copy negative
 of 1867 print)
Bequest of Alvin Langdon Coburn

Henry Taylor
(1864)
Museum purchase

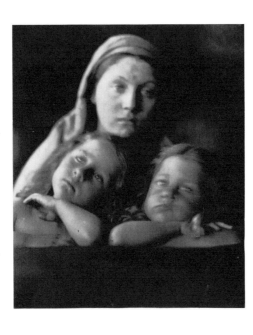 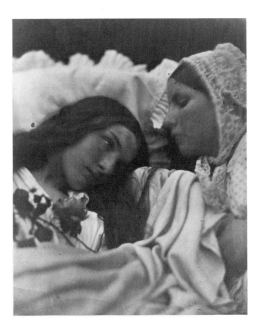

(Woman with two children)
(c.1864-65)
Gift of Eastman Kodak Company:
 ex-collection Gabriel Cromer

The May Queen
(1864)
Museum collection

5. Unsigned, "The Photographic Society," *Athenaeum*, June 4, 1864, p. 779-80.
6. Unsigned, "Out of Focus," *British Journal of Photography* 11 (July 22, 1864): 261.

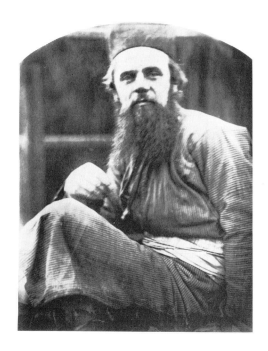

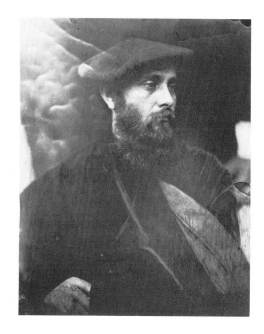

(William Holman Hunt)
(Modern print by A.L. Coburn,
 c. 1915, from copy negative
 of 1864 print)
Bequest of Alvin Langdon Coburn

W.M. Rossetti
(1865)
Gift of Eastman Kodak Company:
 ex-collection Gabriel Cromer

These remarks were reprinted in the *British Journal of Photography,* with the following observation:

> *The art critic of the* Athenaeum *in a recent notice of certain photographic portraits by Mrs. Cameron indulges in some observations, which, seeing the quarter whence they come, are highly complementary to the lady; but we think they will be received with a smile of incredulity by photographers generally. If the critic in question knew anything practically of photography he would not surely insinuate that photographs ought to be "out of focus" in order to be effective. If the principles he seems to advocate be true, surely we have no need of first class opticians to construct our objectives.* [7]

With sarcasm and a patronizing language (this notice was among the many in the *British Journal of Photography* referring to Cameron as "the lady") the reviewer attacked the *Athenaeum* for praising Cameron at the expense of photographers and suppliers. In the same issue of the *British Journal of Photography* her contributions to the Annual Exhibition were reviewed by a critic with the *nom-de-plume,* "Aur Chl.," who described Cameron's portrait photographs as:

> *...of somewhat large size, taken with lens possessing the same photographic qualities as a spectacle eye, or if any kind of sharpness had existed in the negative a contrivance must have been effected for allowing at least a quarter of an inch to intervene between the collodion film and the paper upon which these proofs were printed... with better optical and chemical means Mrs. Cameron will, we doubt not, be enabled to take a higher rank than we can honestly award her at present...* [8]

The technical criticism and concern over Cameron's methods suggest that the audience of the *British Journal of Photography* consisted of photographers and photographic manufacturers with an interest in the appreciation of technical developments in photography. Reviews in the *Photographic News* took a comparatively more flexible view, usually com-

7. Ibid.

8. "Aur Ch1.," "Exhibition of the London Photographic Society," *British Journal of Photography* 11 (July 22, 1864): 260-61.

paring Cameron's photographs with works of art in other media before returning to a standard of photographic artistry based on the camera's capacity to render detail:

> *We have often condemned excessive sharpness in a large head as a vice, but whilst we condemn excessive sharpness we desire to see modeling and form and not the confused image from considerable moving of the sitter and complete absence of definition...in which we find an effect similar to that produced by a painter when he has hastily rubbed in the masses of his subject, without any attempt at detail. The force and sketchiness of the pictures will unquestionably interest, but whilst they exhibit power they fail in that which is the real strength and excellence of photography.* [9]

The challenge of Cameron's work to conventional photographers was recognized by reviewers from her debut exhibition at the Photographic Society of London. The differences between the reviewers of the *British Journal of Photography* and the *Photographic News* indicate varying

44

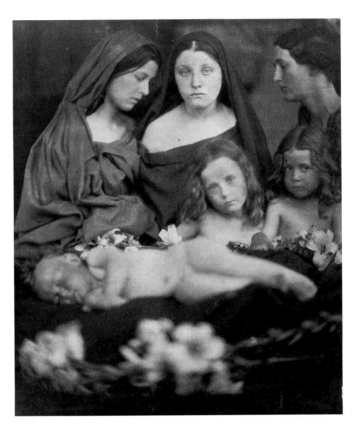

Sister Spirits
(1865 ?)
Gift of Eastman Kodak Company:
ex-collection Gabriel Cromer

levels of defensiveness to Cameron's innovations, but, for both, photographic artistry was predicated upon optimal utilization of photographic equipment.

Expectations for photographic artistry were not, however, confined to the representation of detail. The *Illustrated London News* review of the 1864 Annual Exhibition compared Cameron's work unfavorably to Wynfield's because Cameron "gave no part with sufficient precision, thus satisfying the requirements neither of science nor art;"[10] representations "out of focus" were also subject to expectations of the appropriate "artistic" use of the lens. The *Illustrated London News* differed from the *Photographic News* and the *Athenaeum* by possessing specific "requirements" for photographic artistry: "out of focus" didn't characterize a free play of the lens. According to the *Illustrated London News,* Cameron's contributions to the 1864 Annual Exhibition "gave no part with sufficient precision;" thirteen

9. Unsigned, "The Photographic Exhibition: Portraiture," *Photographic News* 8 (July 15, 1864): 339-40.

10. Unsigned, "Fine Arts: The Photographic Exhibition—Photo Sculpture &c," *Illustrated London News* 44 (June 11, 1864): 575.

months later the *Illustrated London News* declared that Cameron had succeeded in the "application of the principles of fine art to photography." It is impossible to say whether Cameron was responding to the requirements of the *Illustrated London News,* but the change in its judgment gives a context to the change in appearance in Cameron's photography between the Watts Album and 1865. The artistic requirements of the *Illustrated London News* were a particular application of photographic practice to specific ends, an alternative practice of photography. Cameron's extensive technical experimentation in the Watts Album could constitute the extremes of this alternative practice, extremes from which Cameron herself withdrew; by this withdrawal Cameron conformed to expectations about photographic art.[11] For all their differences in outlook, both the *Illustrated London News* and the *British Journal of Photography* evaluated Cameron's photographs in relation to standards of commerical photography.

Decidedly Pre-Raphaellete *(sic)*
(c.1864-65)
Gift of Eastman Kodak Company:
 ex-collection Gabriel Cromer

**Queen Philippa Interceding for
the Burghers of Calais**
(c.1865)
Yale University Art Gallery; Director's
 Discretionary Fund

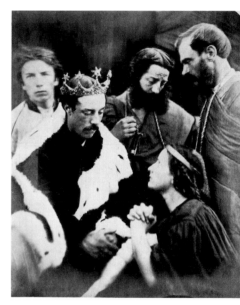

Cameron included non-portrait work among her contributions to the 1865 Annual Exhibition of the Photographic Society of London, the 1864-65 Annual Exhibition of the Photographic Society of Scotland, and the Photographic Section of the 1865 Dublin International Exhibition, but the reviews continued in the same vein. In 1865 the Exhibition Committee of the Photographic Society of London (Cameron had joined the Society in June, 1864) expressed regret that they could not "concur in the lavish praise which has been bestowed upon her productions by the non-photographic press," believing "no sacrifice of pictorial beauty [was] demanded by nice attention to the skillful manipulation and care in the selection of properly adjusted optical instruments."[12] The *British Journal of Photography* complained "good posing does not compensate for sloppiness of manipulation."[13]

Yet for all the hostile criticism in the photographic press, Cameron earned a level of recognition from the photographic community. She received an honorable mention for "grouping and arrangement" at the 1864-65 Annual Exhibition of the Photographic Society of Scotland, and a medal for "Studies" at the 1865 International Photographic Exhibition of the

11. Unsigned, "Fine Arts: Art in Photography," *Illustrated London News* 47 (July 15, 1865): 50.

12. Unsigned, "Report of the Exhibition Committee," *Photographic Journal* 10 (May 15, 1865): 62.

13. Unsigned, "The Photographic Society's Exhibition," *British Journal of Photography* 12 (May 19, 1865): 267-68.

Photographic Society of Berlin.[14] The prominent photographic scientist and educator, Dr. Hermann Wilhelm Vogel, praised Cameron's contributions to the Berlin exhibition for their "fine taste and feeling," despite the technical imperfections of the work.[15] A similar division of opinion was in the Report of the Jurors, Antoine Claudet and Peter le Neve Foster, to the Photographic Section of the 1865 Dublin International Exhibition. Claudet and le Neve Foster went further than Vogel in their praise, describing Cameron as a "true artist" and claiming, "There are no experienced judges who would not prefer these productions, with their manifest imperfections, to many of the best manipulated photographic portraits . . . of the exhibition."[16]

In anticipation of the forthcoming Annual Exhibition of the Photographic Society of London in 1865, the *British Journal of Photography* listed the prominent exhibitors, including, "Bedford, Claudet, Rouch, S. Thomson, Annan, Cooper, Thomas Ross, Blanchard, Joubert, John Pouncy, Dr. Hemphill, Julia Cameron and others."[17] This list of names situates Cameron's photography among many different photographic activities, ranging from the production of commercial landscape views to reproduction processes. The praise of Claudet, Foster, and Vogel, and the awards from the photographic societies indicate a level of appreciation among these heterogeneous activities for Cameron's abilities in composition and her "artistic feeling": Cameron's photographic experimentation had a place among these diverse activities. Developments in the late 1860s would indicate, however, that while the alignment of photographic artistry with photography's technical capacities was not inflexible, the practice of photography was of limited susceptibility to ennoblement.

14. See Appendix I

15. Dr. (Hermann Wilhelm) Vogel, "The International Photographic Exhibition in Berlin," *Photographic News* 9 (June 23, 1865): 291-92.

16. Antoine Claudet and Peter le Neve Foster, "Photography at the Dublin Exhibition: Report and Awards of the Jurors," *Photographic News* 9 (October 6, 1865): 474-77; Unsigned, "Miscellaneous: The Dublin Awards," *Photographic Journal* 10 (November 16, 1865): 199-200 (article reprinted from the *Photographic News)* stated that the praise of Cameron in the report of the jurors did not read as if it were part of the original report, see Gernsheim, *Cameron,* p. 63.

17. Unsigned, "The Photographic Society's Exhibition," *British Journal of Photography* 12 (May 5, 1865): 236.

Reaching the Heights of Accomplishment: 1865-1869

XCEPTIONAL IN THE CRITICAL as in the photographic art are those productions which—like the surprising and magnificent pictorial photographs of Mrs. Cameron to be seen at Colnaghi's—well-nigh re-create a subject; place it in novel, unanticipable lights; aggrandize the fine, suppress or ignore the petty; and transfigure both the subject-matter, and the reproducing process itself, into something almost higher than we knew them to be.

William Michael Rossetti
"Mr. Palgrave and Unprofessional Criticisms on Art," 1866 [1]

Mrs. Cameron has only to persevere, and she will found a school of 'Cameronians,' though not after the fashion of the grim sect so named. Her productions are eminently genial, and from this quality and from their beauty they will find their appropriate resting-places in cultivated homes.

(H.J. Stack)
"Mrs. Cameron's Photographs," 1867 [2]

From February 20, 1866, to August 17, 1871, the copyright registrations for Cameron's photographs were not made by the artist herself, but by two different agents, presumably on behalf of Cameron's publisher, Colnaghi and Company of London.[3] As a result, instead of Cameron's elaborate entries, such as "A Photograph of Mary Hillier full faced with shawl draped over chest border on each side meeting over bosom star on the brow eyes upraised," there are such spare lines as "Photograph of girl's head life size looking down full face;"[4] in addition, most of the agents' entries lack specific titles. Portrait subjects registered during the period include Tennyson, Taylor, Watts, Herschel, Governer Eyre, Jacques Blumenthal, Thomas Carlyle, Valentine Prinsep, Philippa Wodehouse, Herbert Wilson, W. Gifford Palgrave, Charles Darwin, William Henry Longfellow, Sir John Simeon, Dr. Joseph Dalton Hooker, and Sir W. Page Wood.[5] In November, 1865, three photographs were registered of Taylor portraying King Ahasuerus to the model Mary Ryan's Queen Esther, Friar Lawrence to the model Mary Hillier's Juliet, and Prospero to Mary Ryan's Miranda.[6] Other non-portrait subjects registered during the period include, "A Prison Scene," "King Cophetua," (from Tennyson's poem, "The Beggar Maid") "Romeo and Juliet," "The Annunciation after

1. William Michael Rossetti, "Mr. Palgrave and Unprofessional Criticisms on Art," p. 333-34.

2. (H. J. Slack), "Mrs. Cameron's Photographs," *Intellectual Observer Review of Natural History Microscopic Research and Recreative Science* 11 (February, 1867): 30-33; the author is identified in P. H. Emerson, "Mrs. Julia Margaret Cameron," *Sun Artists* 5 (October, 1890): 33-41.

3. Edward W. Howell signed the entries between February 20 and November 22, 1866, and an unnamed person between the latter date and August 17, 1871. Copyright registrations, Public Record Office, Kew, England.

4. Entries for September 25, 1865 and February 20, 1866, Copyright registrations, Public Record Office, Kew, England.

5. Copyright registrations. Public Record Office, Kew, England.

6. These photographs were registered on November 11, 1865.

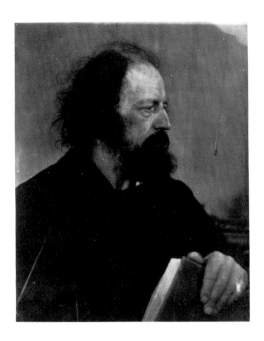

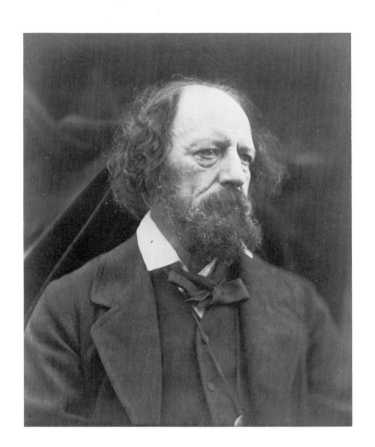

A. Tennyson
(1865)
Museum purchase

A. Tennyson
(1867)
Gift of Alden Scott Boyer

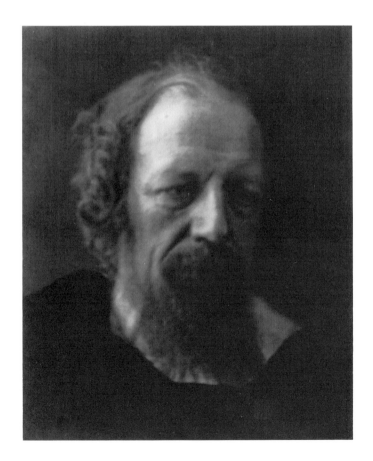

A. Tennyson
1867
Gift of Eastman Kodak Company:
 ex-collection Gabriel Cromer

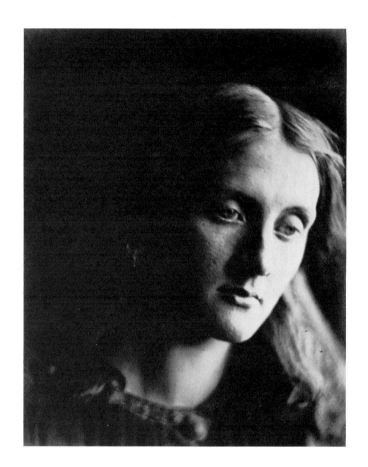

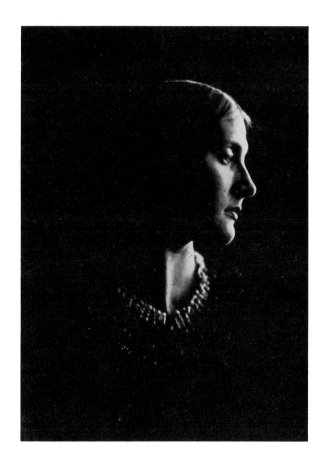

**(La Santa Julia) (Julia Jackson
Duckworth Stephen)**
(1867)
Center for Creative Photography

**Mrs. Herbert Duckworth as Julia
Jackson**
(1867)
Gift of Alden Scott Boyer

50

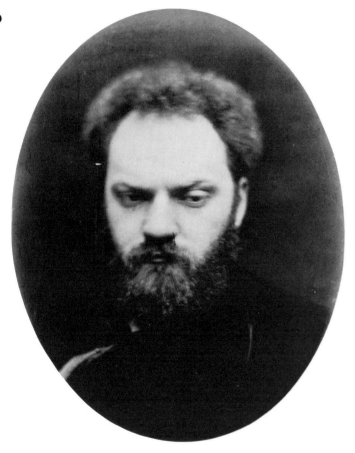

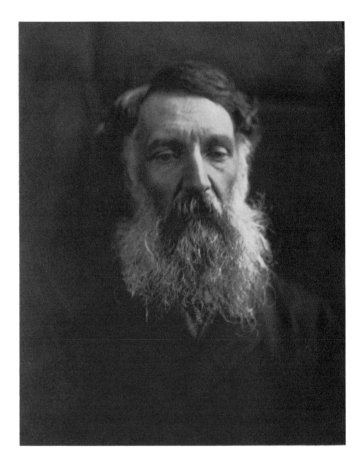

(Valentine Prinsep)
(1867?)
Paul Walter Collection

E. Eyre
(1867)
Gift of Alden Scott Boyer

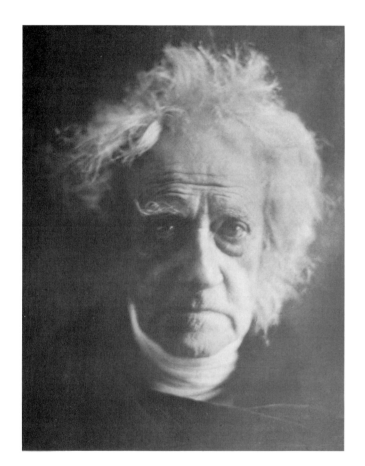

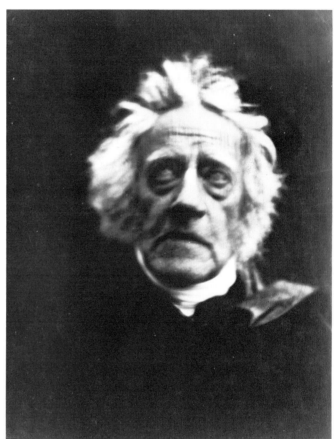

(Sir John Herschel)
(c. 1875 reproduction of 1867
 subject)
National Gallery of Canada, Ottawa

**The Astronomer (Sir John
Herschel)**
(1867)
Collection of the Royal Photographic
 Society of Great Britain.

52

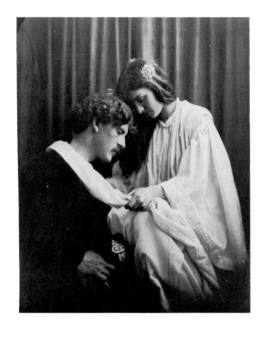

Browning's Sordello
(1867)
Gift of Eastman Kodak Company:
 ex-collection Gabriel Cromer

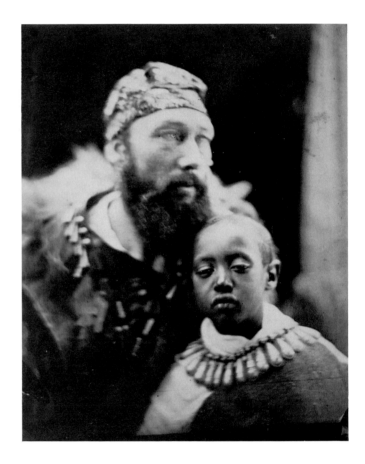

**Dejátch Alámáyou and Báshá
Félika King Theodore's son and
Captain Speedy**
1868
National Gallery of Canada, Ottawa

(Standing woman)
(1867)
Gift of Alden Scott Boyer

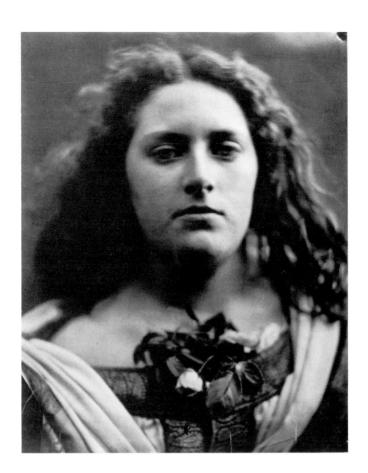

Rosalba
(1867)
Gift of Eastman Kodak Company:
ex-collection Gabriel Cromer

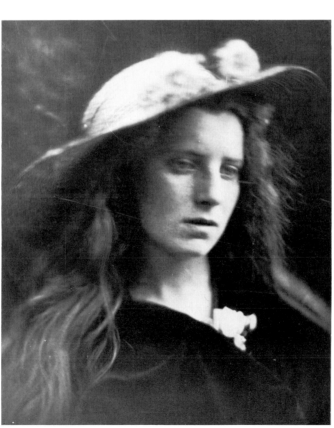

Ophelia Study No. 2
(1867)
Gift of Eastman Kodak Company:
ex-collection Gabriel Cromer

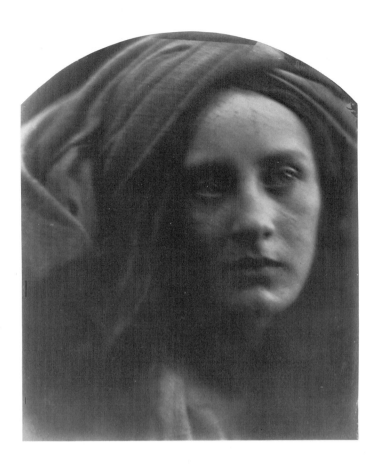

(Light study)
(1866)
Gift of Eastman Kodak Company:
 ex-collection Gabriel Cromer

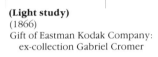

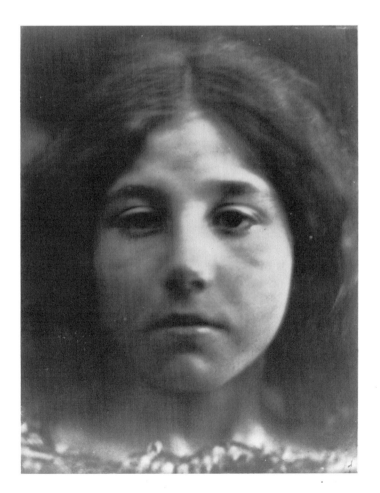

(Light study)
1866
Gift of Eastman Kodak Company:
 ex-collection Gabriel Cromer

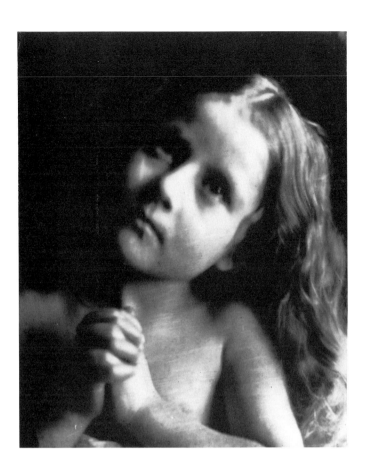

55

Prayer
(1866?)
Gift of Eastman Kodak Company:
 ex-collection Gabriel Cromer

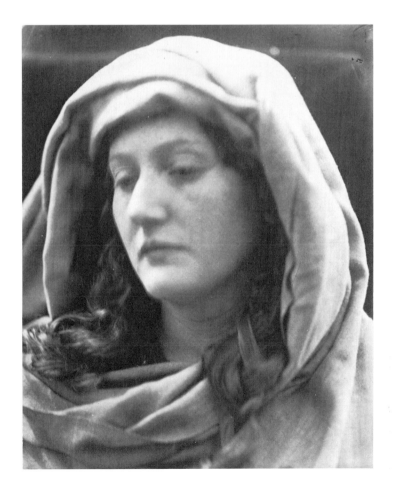

La Madonna
(c.1866-67)
Gift of Eastman Kodak Company:
 ex-collection Gabriel Cromer

(Mabel Lowell Burnett) (profile)
1869
Anonymous loan

(Mabel Lowell Burnett)
1869
Anonymous loan

**(Portrait of a man in a deer-
stalker cap)**
1869
Collection of the Royal Photographic
 Society of Great Britain, Gift of
 Alvin Langdon Coburn, 1930.

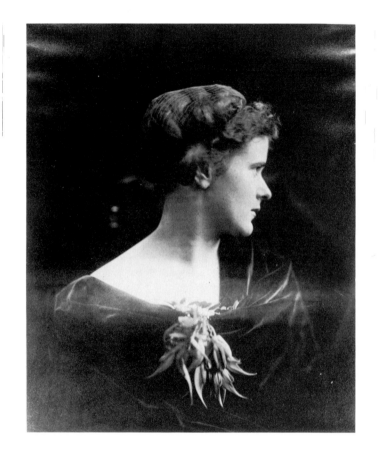

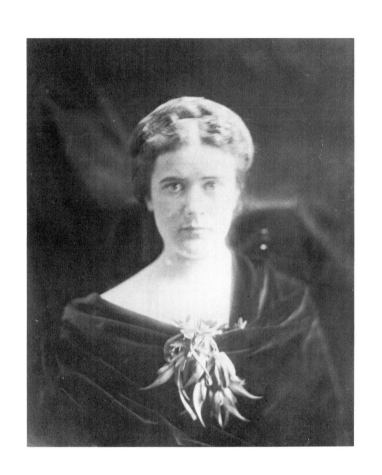

58

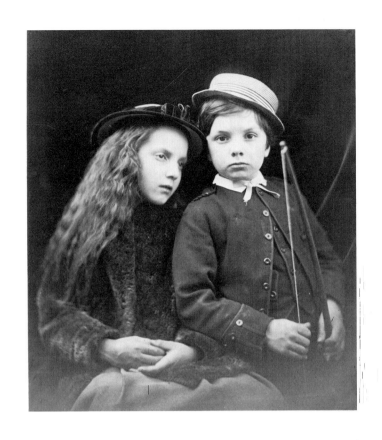

**My grandchildren Charlotte
Norman George Norman Junior!**
1868
Museum purchase

Henry W. Longfellow
(1868)
Gift of Helmut Gernsheim

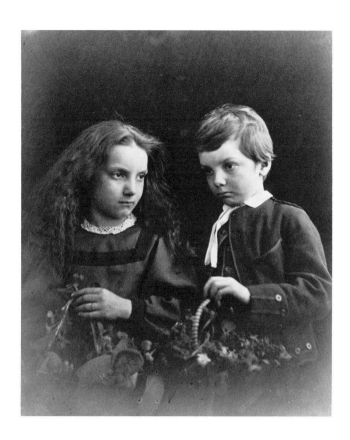

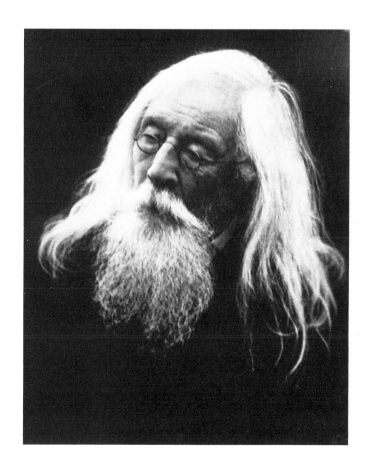

59

(Charlotte and George Norman, Jr. without hats)
(1868)
Museum purchase

C.H. Cameron
(c. 1875 reproduction of 1869 subject)
University of Nebraska Art Galleries, Sheldon Memorial Art Gallery F.M. Hall Collection

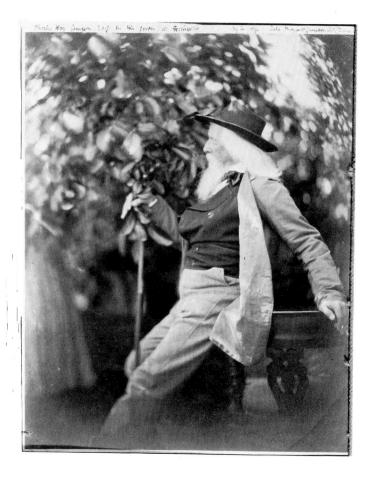

**Charles Hay Cameron in his
garden at Freshwater**
(c.1868)
Lent by The Metropolitan Museum of
 Art, Harris Brisbane
 Dick Fund, 1941.

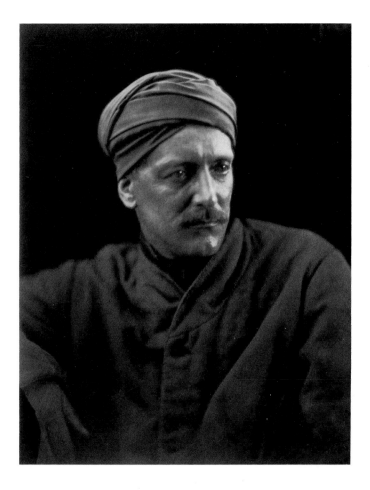

W. G. Palgrave
(1868)
Gift of Alden Scott Boyer

(Henry Herschel Hay Cameron)
(c. 1867)
Collection of the Royal Photographic
 Society of Great Britain

(Hardinge Hay Cameron)
(c. 1867)
Collection of the Royal Photographic
 Society of Great Britain, Gift of
 Mrs. Trench, 1929.

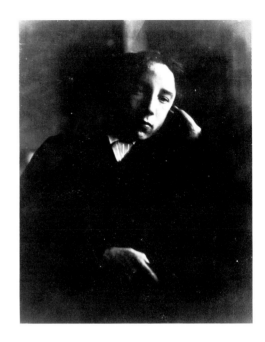

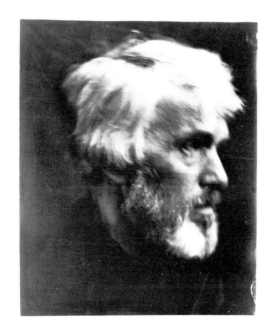

(Thomas Carlyle)
(1867)
Gift of Eastman Kodak Company:
 ex-collection Gabriel Cromer

Perugino," and "The May Queen." The registrations also include such subjects as "Beatrice Cenci," and "Aurora" and numerous unidentified subjects with female models.[7] The number of photographs registered for copyright in 1866 was 58, down from the 90 of the previous year; the total rose again to 87 in 1867, before dropping to 72 in 1868 and 15 in 1869.

In the late 1860s Cameron continued the extensive promotion and exhibition of her work, contributing to the 1867 Universal Exhibition in Paris, the Annual Exhibitions of the Photographic Society of London in 1866, 1867 and 1868, and holding two one-woman shows in London, the first at the French Gallery in November, 1865, and the second at the German Gallery in January-February, 1868.[8] When Cameron's life-sized heads were displayed in the Annual Exhibitions of the Photographic Society of London, and in the Universal Exhibition in Paris,[9] they won great praise in the photographic press: the life-sized heads fulfilled

62

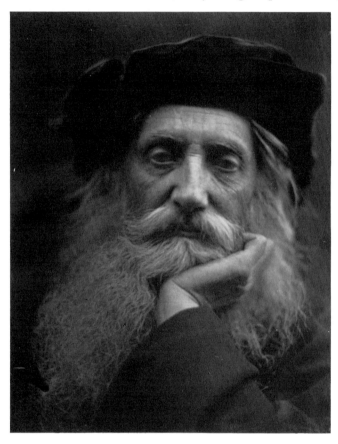

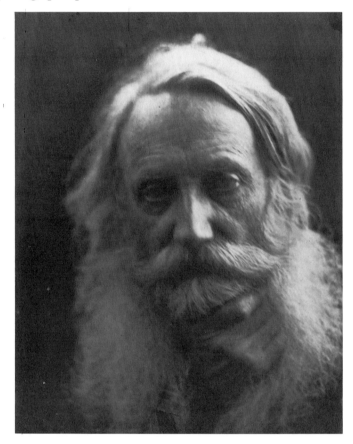

Henry Taylor
1867
Museum purchase

Henry Taylor DCL
1867
Gift of Eastman Kodak Company:
 ex-collection Gabriel Cromer

7. Copyright registrations. Public Record Office, Kew, England.

8. See Appendix I.

9. In addition to the reviews quoted below, see the unsigned reviews, "The Exhibition Meeting of the Photographic Society," *Photographic News* 11 (November 15, 1867): 545-6; "Photography at the French Exhibition," *Photographic News* 11 (June 21, 1867): 290-91.

their expectation that photography's artistry was achieved by utilizing photography's technical capacities (the life-sized heads were also a considerable technical accomplishment). The *Photographic News* review of the exhibition soirée of the Photographic Society of London in 1866 reported:

> *We have always felt pleasure in doing justice to the artistic feeling which distinguished many of the [Cameron's] pictures and in regard to many of those exhibited on Thursday evening, we can not praise this quality too highly. Some of the large heads, in which the definition was quite sufficiently precise for the subjects, were exceedingly charming and possessed artistic qualities rarely seen in photography. Of those which pleased us best we may especially mention the beautiful head of a little boy, simply distinguished as No. 6, which was perfect in drawing and modeling, admirable in expression, grand in massing of light and shade and sunny and transparent in a grand degree. Some profile heads were also very fine and free from the blurred contours and smudgy gradations we have before condemned.* [10]

<div style="float:right">63</div>

(The Beauty of Holiness)
(c. 1866)
Gift of Eastman Kodak Company:
 ex-collection Gabriel Cromer

Aspiration
(c. 1866)
Gift of Eastman Kodak Company:
 ex-collection Gabriel Cromer

Even the *British Journal of Photography* conceded, "We were glad to observe . . . that this lady seems to be acquiring some facility in manipulation, her pictures being more perfect in photographic technicalities then when we last had occasion to notice her works."[11] In his 1869 *Pictorial Effect in Photography,* photographer and photographic art theorist Henry Peach Robinson made a similar concession to Cameron's technical improvement, but concluded, "photography is preeminently the art of definition, and when an art departs from its *function* it is lost."[12]

At the Photographic Section of the Universal Exhibition in Paris Cameron won an Honorable Mention; in a review Dr. Vogel elaborated upon his earlier praise, observing that Cameron's technique had improved and that her photographs belong, "if not to the most

10. Unsigned, "The Exhibition Soirée of the Photographic Society," *Photographic News* 10 (June 15, 1866): 278-79.

11. Unsigned, "Soirée of the Photographic Society," *British Journal of Photography* 13 (June 15, 1866): 285-86.

12. Henry Peach Robinson, *Pictorial Effect in Photography, being Hints on Composition and Chiaroscuro for Photographers,* (London, 1869), Reprint, with introduction by Robert A. Sobieszek, (Pawlet, VT, 1971), p. 144-45.

beautiful, then to the most remarkable of the English section."[13] The "Fine Arts" critic of the *Illustrated London News* was thrilled by Cameron's contribution to the Photographic Society of London's Annual Exhibition of 1867, awarding a "foremost place" to "several heads about the scale of nature which for lifelike softness and grandly suggestive breadth of effect were unapproached by anything exhibited on this occasion."[14]

The acclaim awarded Cameron's large portrait heads by these reviewers coincided with the appearance of another expectation of the practice of photography; according to this expectation Cameron's non-portrait subjects were considered as deviations from the appropriate use of the camera. An early example of this expectation is the review by Coventry Patmore, poet and critic, of Cameron's November, 1865, exhibition at the French Gallery. Patmore (as had the *Illustrated London News)* praised Cameron's portrait heads as evidence of the existence of ideal nature:

> ... *the fact of the existence of such photography ought to modify very greatly some of the prevailing theories concerning art. It will not do, as far at least as the human head is concerned, to speak any longer of ideality as the peculiar character of art. The greatest heads of the early painters were evidently nothing more than nature seen with an eye of perfect sincerity.* [15]

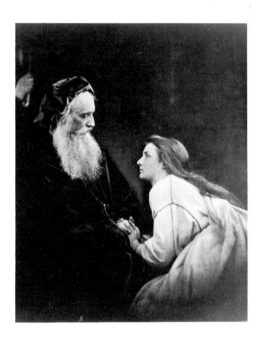

(Prospero and Miranda)
(Undated reproduction of 1865
 subject)
Collection of the Royal Photographic
 Society of Great Britain

Patmore differed from the *Illustrated London News* by characterizing Cameron's *tableaux vivant* photographs as "strange" and "somewhat grotesque":

> *The simple human head is the only thing in which nature can rival art. It is impossible to compose, by juxta-posing, real figures, so as to emulate, in the faintest degree, the composition of great artists.* [16]

Patmore assigned limits to the operation of the camera: there was no photographic composition, only photographic juxtaposition. By this assignment Patmore qualified the relation of photography to ideal nature. For Patmore Cameron's "out of focus" did not represent a superior practice of photography and record of ideal nature because there were limits to the extent that the practice of photography could be made symbolic.

13. Quoted in Gernsheim, *Cameron,* p. 63-4.

14. Unsigned, "Fine Arts: Exhibition of the Photographic Society," *Illustrated London News* 51 (November 23, 1867): 236.

15. (Coventry Patmore), "Mrs. Cameron's Photographs," *Macmillan's Magazine* 13 (January 1866): 230-31; another review of this exhibition is Unsigned, "Fine Arts," *Illustrated London News* 47 (November 16, 1865): 486.

16. (Patmore), "Mrs. Cameron's Photographs," 231.

An *Athenaeum* review of a later exhibition, Cameron's German Gallery exhibition of 1868, also differentiated between Cameron's portrait and non-portrait photographs according to expectations of the operation of the camera:

> *Of these [photographs] we dismiss at once such as bear "fancy" names, and pretend to subjects of the poetic and dramatic sorts. When such productions are due to the camera, or any other scientific or mechanical instrument, aim at that which is properly brain-work, the less that is said about the results the better for all parties. In this case, when the poetic or dramatic titles have any aptitude, they are, to say the least, unpleasant, and often wreck that which, without an intendedly suggestive name, would be grateful to the artistic eye.* [17]

The critic, however, warmly commended Cameron's portraits. A *Pall Mall Gazette* review of the same exhibition also praised Cameron's portraits, but observed, "some of the groups or *tableaux vivants* lose, from the very reason of their artificialness, that noble and natural harmony of expression which is the charm of Mrs. Cameron's productions."[18] The validation offered by Cameron's photography was still desired, and applicable to representations of the human face, but if the camera was a "scientific or mechanical instrument," Patmore and the others couldn't consider Cameron's *tableaux vivants* in the same fashion.

As a "scientific or mechanical instrument," however, the operation of the camera could be applied to artistic ends. In two articles in the *Intellectual Observer* of 1866-67,[19] Cameron's photography was cited to support the argument that "photography need not remain on the lower stages of a mere imitative craft" but could enjoy "the dignified position of a fine art."[20] The *Intellectual Observer* argued for photography as a fine art, in opposition to an art founded upon "realistic imitation," because realistic imitation enabled one "to be satisfied with the operations of photography as soon as they were conducted with a sufficient amount of technical skill."[21] According to the *Intellectual Observer*, Cameron used:

> *...a method of focussing by which the delineations of the camera are made to correspond with the method of drawing employed by the great Italian artists...[and] the introduction of an ideal pictorial element, by selecting good models and calling forth the kind of expression which a judicious artist would desire to enshrine in his work...* [22]

The distinction between "mere imitative craft" and "dignified fine art" was evidence of the mastery of the artist's intellect over his or her material and the choice of appropriate subject matter. The "great Italian artists" were to be emulated, but there was no intrinsic connection between the method of focusing and the ideal nature these artists represented; focusing was used here merely to achieve resemblance to another art form. Presumably, if the standard of artistic achievement changed from "great Italian artists" to something else, the focusing technique and appropriate subject matter would accommodate. This change in artistic standards occured in the 1890s, and a "school of 'Cameronians'" (as it were) did develop.

17. Unsigned, "Fine Arts Gossip," *Athenaeum*, February 15, 1868, p. 258.

18. (William Allingham), "Mrs. Cameron's Photographs," *Pall Mall Gazette*, January 29, 1868, p. 10; William Allingham's diary entry for February 7, 1868 included a citation referring to "blowing the trumpet" for Cameron's exhibit in the *Pall Mall Gazette*, see Gernsheim, *Cameron*, p. 61.

19. Unsigned, "Photography as a Fine Art," *Intellectual Observer* 10 (August?, 1866): 19-22 and (H. J. Stack), "Mrs. Cameron's Photographs," *Intellectual Observer* 11 (February, 1867): 30-33; for a reaction to this article from the photographic press, see "Photography as a Fine Art," *Photographic News* 10 (August 24, 1866): 398-99.

20. Unsigned, "Photography as a Fine Art," *Intellectual Observer* 10 (November, 1866): 19-22.

21. Ibid.

22. Ibid.

In the late 1860s Cameron's photographic technique did not polarize opinion in the photographic press as it had when she began. Her life-sized heads were a technical accomplishment and critics noted her attention to such photographic niceties as clean negatives. The division of Cameron's photographs along the lines of commendable portraits and unfortunate *tableaux vivants* applied a conception of the operation of the camera to overrule Cameron's superior practice of photography. The discussions of the *Intellectual Observer* raised the prospect of the application of the camera to artistic ends, but not the representation of ideal nature. The influence of these changes in the expectations of photographic practice is apparent in the reviews of Cameron's photographs in the 1870s: reviewers were less concerned with the form of Cameron's photographs than with the content. The influence of these changes upon Cameron's work is obvious, and her activities in the 1870s suggest that while Cameron maintained many of her aspirations about photography, she confined her efforts to ennoble photography to an audience which would appreciate them.

Later Work and Conclusion: 1870-1879

RS. CAMERON, the author of the work in question, is a photographer who had tried to photograph something more than a mere inanimate copy of this or that object before her, and yet the commonest stories and events of everyday life are the subjects of her art. "Trust," "Resignation," "Meekness," "'Thy will be done,'" are the names she has given to some of her pictures. Children's solemn eyes and fair waving locks, mothers tending them, Madonnas, here and there an old friend greeting us out of a sea of marginal pasteboard, these are all her materials; but it is difficult to believe that these quiet and noble-looking people are of the same race as those men and women whom we are accustomed to meet with in all our own and our friend's photograph books. [1]

"A Book of Photographs"
Anne Thackeray 1874

The changes in the representation of space in Cameron's photographs, fully realized in the *Illustrations,* began to appear in the early 1870s. In the later work forms were no longer realized in space, but figures and objects were represented in a specific setting. Within this specific setting there was a greater use of backgrounds and props, as in "May" (p. 23), "Sun-lit Memories" (p. 68), and "Study of a St. John the Baptist" (p. 69). The subjects of these photographs indicate that, despite changes in photographic form, Cameron's interest in subjects of women persisted. Cameron also continued to label her photographs as "From Life," and in the account of her photography given in her unfinished 1874 "Annals of My Glass House" she described her work as a continuous effort.

A striking change in Cameron's photographic activity, which began in 1869, was the drastic decline in the number of photographs registered for copyright: 27 in 1870, 2 in 1871, 10 in 1872, 2 in 1873, 35 in 1874 and 9 in 1875. [2] There are, however, prints dating from this period with Cameron's copyright inscription not entered in the copyright registrations; [3] the reasons for this development are unknown. Cameron registered *Idylls of the King* photographs, and photographs of Sir John Herschel and the Bishop of Winchester after their deaths, [4] suggesting that, although she inscribed many subjects as copyrighted, she actually registered material if it had commercial prospects. In the 1870s there were fewer photographs which she apparently believed required protection under commercial regulation, and there was a change in the meaning of "out of focus" representation.

1. Anne Thackeray, "A Book of Photographs," in *Toilers and Spinners and Other Essays,* (London, 1874), p. 224-29.

2. Copyright registrations, Public Record Office, Kew, England.

3. See p. 88.

4. For the Bishop of Winchester, see the copyright registration for July 23, 1873, and for Sir John Herschel, see February 6, 1874.

Cameron maintained an active exhibition schedule in the 1870s, participating in the London International Exhibitions of 1871 and 1872, the Universal Exhibition of 1873 in Vienna, the Philadelphia International Exhibition of 1876 and the Annual Exhibitions of the Photographic Society of London in 1870, 1871, 1873, and 1874. The photographic press reviews of these exhibitions were less concerned with the implications of Cameron's technique than with the content of her subjects. The *British Journal of Photography* was characteristically antagonistic in its review of the Photographic Society of London's exhibition of 1870:

> Place aux dames. *Mrs. Julia Cameron exhibits a considerable number of pictures. Among these* Town Life *(16) represents a boy and a girl, neither of whom convey any idea sufficient to warrant the title given to the picture. The boy has certainly got a piece of net-work, not unlike an "anti-macassar," round his neck, which may be suggestive of town life, but only so in its odd*

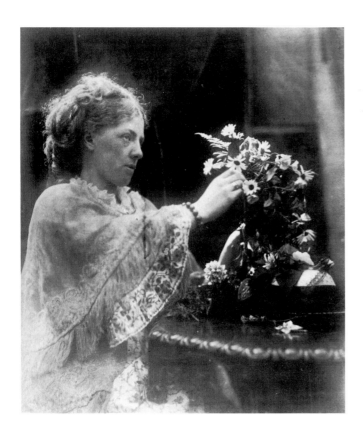

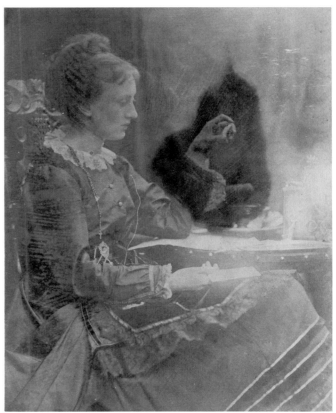

Sun lit memories
1873
Collection of the Royal Photographic
 Society of Great Britain

May
1870
Lent by The Metropolitan Museum of
 Art, The Elisha Whittelsey Collec-
 tion, The Elisha Whittelsey Fund,
 1969.

> *moments. We observe that on the mount of this picture some friendly critic has recorded in bold caligraphy [sic] his opinion that it is "very beautiful," with which the fair artist has been apparently so gratified as not to have deleted it before placing the picture in its frame. Of* Dora *(15) Mrs. Cameron notes the interesting domestic fact (scratched on the frame) that she "is my daughter-in-law."* May *is the title that Mrs. Cameron has selected for several pictures, Nos. 240-1-2-3 being all thus designated. Some of the figures are nicely posed; but the air of unhappiness or listlessness which seems to pervade the majority of this artist's subjects prompts feeling more identical with dull November than with the jocund month of May. Several of these pictures have for some time been exhibited in the shop windows of photographic publishers.* [5]

5. Unsigned, "The Photographic Society's Exhibition, (First Notice)," *British Journal of Photography* 17 (November 11, 1870): 528-29; on October 17, 1870, Cameron registered 7 studies of May Prinsep for copyright.

Benjamin Wyles in the *Photographic News* reviewed Cameron's contributions to the Annual Exhibition of the Photographic Society of London in 1870:

> *Looked at* en masse *there is a sort of misty "glamour" about Mrs. Cameron's productions that is decidedly pleasing, but a closer examination is not nearly so satisfactory. There is a sort of feeling after art—a suggestiveness; but that is all. The beholder is left to work out the idea in his own imagination, if he can; but as nine out of ten cannot, not being blessed with the artistic faculty—it follows that the peculiar line this lady has chosen will never allow of her works being very popular.* [6]

Cameron's work was also discussed as comparable to that of other photographers, in particular, Col. Stuart Wortley and Ronald Leslie Melville. A *British Journal of Photography* critic noted in 1871 that, if Cameron "has dropped her artistic mantle," Ronald

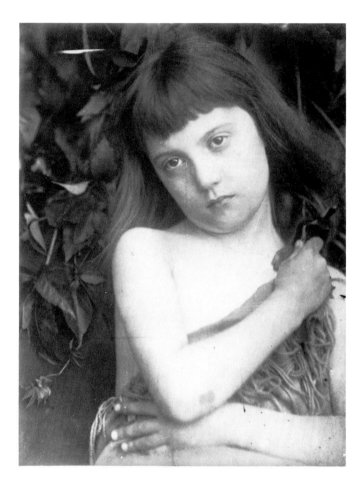

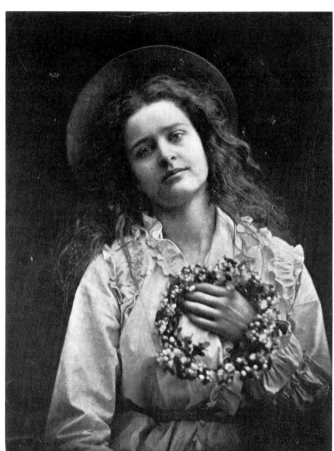

Study of a St. John the Baptist
1872
Gift of Eastman Kodak Company:
 ex-collection Gabriel Cromer

The May Queen
(Undated reproduction of 1875
 subject)
Courtesy, Museum of Fine Arts,
 Boston

6. Benj. Wyles, "Impression of the Photographic Exhibition," *British Journal of Photography* 17 (December 9, 1870): 577-78.

70

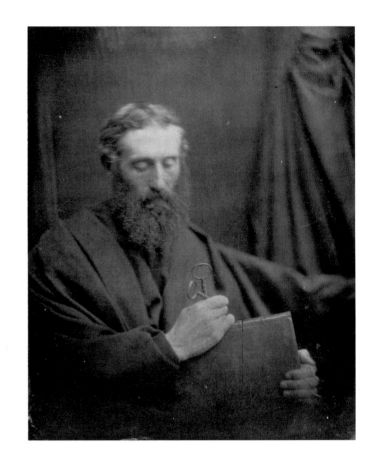

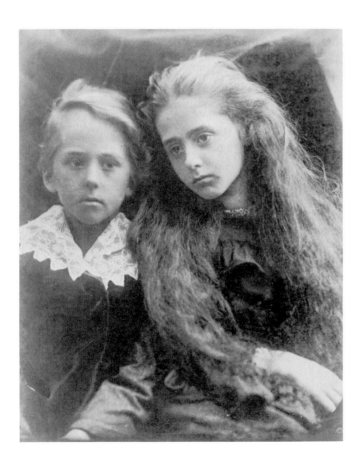

(Charles Norman)
(c. 1872)
Gift of Eastman Kodak Company:
 ex-collection Gabriel Cromer

Days at Freshwater
1870
Cincinnati Art Museum, The Alfred P.
 Strietmann Collection

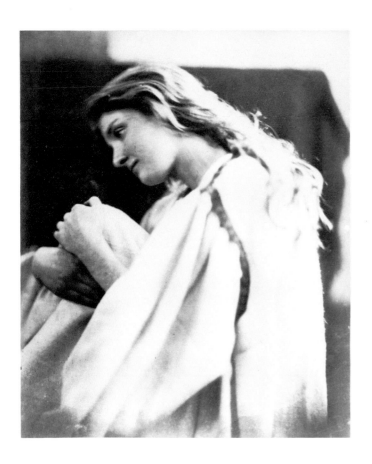

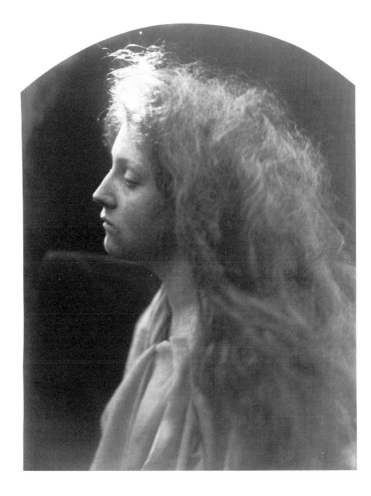

The Irish Immigrant
1870
Collection of the Royal Photographic
 Society of Great Britain

The Angel at the Tomb
1870
Museum purchase

72

Daisy Norman
1870
Seattle Art Museum, Floyd A.
 Naramore Memorial Purchase Fund

S. Winton
1872
Lent by The Metropolitan Museum of
 Art, Gift of Lucy Chauncey, in
 memory of her father, Henry
 Chauncey, 1935.

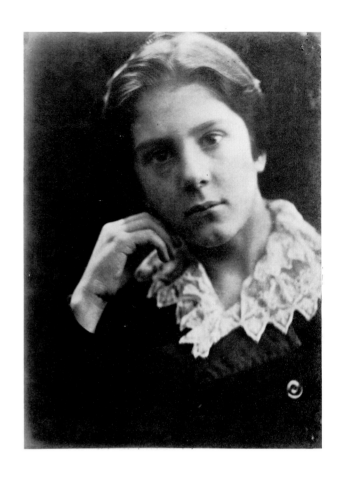

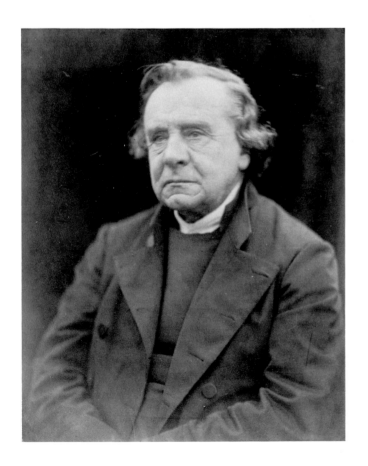

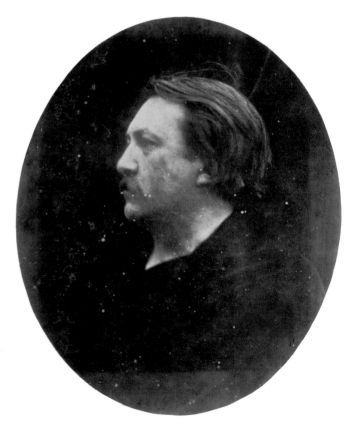

Gustave Doré
1872
Collection of the Royal Photographic
 Society of Great Britain

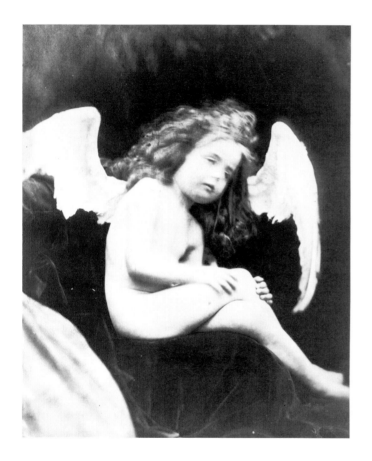

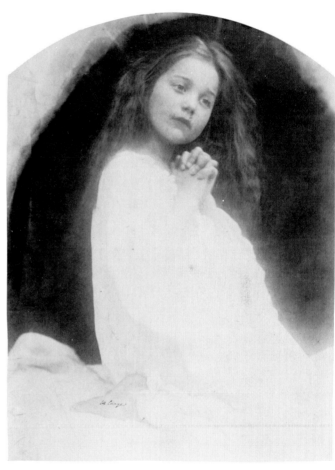

Cupid Considering
1872
Gift of Eastman Kodak Company:
ex-collection Gabriel Cromer

Beatrice Cameron
1872
Gift of Eastman Kodak Company:
ex-collection Gabriel Cromer

Leslie Melville was to be congratulated, "upon having appropriated it and improved upon her manner."[7] Cameron's photography had become a manner, no longer a threat to the first class opticians around which the *British Journal of Photography* once rallied. Her photographs, however, were still capable of generating hostility. In 1871 the *British Journal of Photography* reported approvingly of how a visitor to the Photographic Society Annual Exhibition, doubting that a Cameron photograph was actually a burnt-in photograph (i.e. an enamel photograph), scraped off the emulsion to assure himself that it was only a photograph on opal glass.[8]

By the 1870s resentment was visited upon Cameron's subject matter, not her "out of focus" form. This development could be explained by the change in the form of Cameron's photographs in the 1870s; the reviewer's indifference to Cameron's "out of focus" form could also explain why Cameron ceased to employ it: the form no longer symbolized a

74

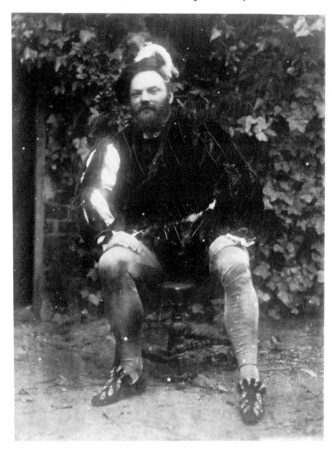

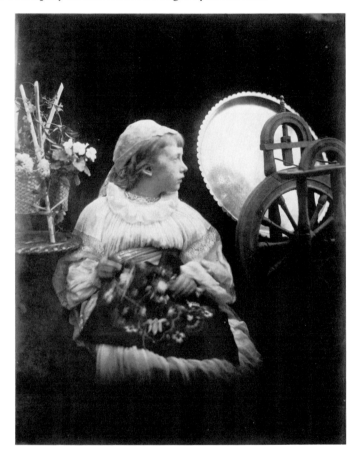

Our Royal Cousin—(Val Prinsep, RA)
1874
Collection of the Royal Photographic
 Society of Great Britain, Gift of
 Mrs. Trench, 1929.

Acting the Lily Maid of Astolat
1874
National Gallery of Canada, Ottawa

7. Unsigned, "The International Exhibition: Second Notice," *British Journal of Photography* 18 (May 12, 1871): 216; Helen Smaills, "A Gentleman's Exercise: Ronald Leslie Melville, 11th Earl of Leven, and the Amateur Photographic Association," *The Photographic Collector* 3 (Winter, 1982): 262-93.

8. Unsigned, "The Photographic Exhibition: Sixth Notice," *British Journal of Photography* 8 (December 22, 1871): 600-1; enamel photographs, "burnt-in" were permanent images made by firing ceramic with a photograhic image, composed of an option of materials, and fusing it into the ceramic, see Luc Verkoren, "Enamel Photography," *The Photographic Collector* 2 (Summer 1981): 76-79. Photographic emulsions were applied to opal glass for the softened effect achieved when the light passed through the translucent glass; Cameron exhibited several photographs on glass at the French Gallery Exhibition, listed in the catalogue of this exhibition in the collection of the National Art Library, Victoria and Albert Museum.

(Ceylonese woman, standing, with hand on hip)
(December 1875—January 1879)
Museum purchase.

(Three Ceylonese women)
(December 1875-January 1879)
Paul Walter Collection

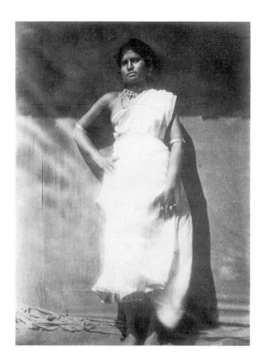

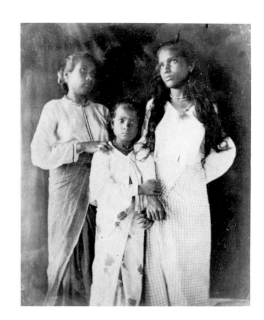

superior practice of photography. The continuities of Cameron's work, such as her use of the description "From Life" suggest that Cameron's photographs continued to support the values of an ideal life. These values, however, were not applicable to the ennoblement of photography in general, but to the gratification of a particular audience. The *British Journal of Photography*'s account of the defacement of Cameron's enamel photograph gives an indication of how Cameron and her audience were resented by this commercially-oriented journal.

Among her peers Cameron's photographs were very popular. The *Morning Advertizer* review of the Photographic Society of Great Britain's Annual Exhibition of 1874 reported that Cameron was "esteemed almost as a prophetess" by a large section of "tasteful society" and likened the style of her photographs to that of the "best painters, past and present."[9] A review in *The Globe,* November, 1873, of a one-woman exhibition of Cameron's photographs, praised the "beautiful faces that look like beauties painted long ago, with a quiet, distant air about them so strikingly in contrast with ordinary photographs."[10] In the comparison of Cameron's photographs to the "best art" (some of it painted "long ago") and the contrast of her photographs to ordinary work (even to Thackeray's contrast of Cameron's photographs to a "mere inanimate copy of this or that object") there are continuities with the 1864-65 praise of Cameron's and Wynfield's photographs. The camera could be used to confirm these values, but it was one operation among many, no longer applicable, as Cameron's "out of focus" form had been, to the practice of photography.

The reference in the *British Journal of Photography* to Cameron "dropping her mantle" coincides with the decrease in number of copyright registrations. Cameron did continue active participation in exhibitions after 1871, and remained a member of the Photographic Society of London/Great Britain through the mid-1870s.[11] Cameron's *Illustrations*

9. Unsigned, "Opinions of the Daily Press on the Photographic Exhibition," *British Journal of Photography* 21 (October 23, 1874): 509-11.

10. "Mrs. Cameron's Photographs," leaflet, privately printed, in the collection of the Royal Photographic Society of Great Britain, Bath, England. Reviews reprinted in the leaflet were from the *London Morning Post, Graphic, The Globe,* and *The Morning Post*; Cameron, "Annals of My Glass House," p. 136-40.

11. See the Membership Lists published in the *Photographic Journal*: March, 1870, 1871, 1872; May, 1873; September, 1875.

were a major project, available in carbon print reproductions, as well as in the limited edition of the gift book. Cameron's continued interest in the promotion of her photographs is evident in the arrangement she made in mid-1875 to have her negatives (and prints for which there were no negatives) reproduced as carbon prints by the Autotype Company of London. Cameron wrote to a friend of this decision, explaining "[I] could not bear that all my ten years labor should be forgotten and 'the grace of the fashion of it' perish"[12] (several carbon print reproductions are inscribed by Cameron, and she registered four carbon reprints for copyright[13]). The Autotype Company announced the forthcoming publication of a portfolio of Cameron carbon prints in the *Art Journal* in 1876, and displayed her "Arthurian subjects" in the Annual Exhibition of the Photographic Society of Great Britain the same year.[14]

In 1874 Cameron began an account of her photography, "Annals of My Glass House," which she did not finish, and which was not published until after her death. The discussions of Cameron's technique in the "Annals" are noteworthy for the lack of importance attached to Cameron's considerable efforts in "out of focus" photography (if there is a persistent theme of the "Annals" it is the triumph of work and determination over discouragement). Cameron recalled her initial "out of focus" work:

> I believe that what my youngest boy, Henry Herschel, who is now himself a very remarkable photographer, told me is quite true—that my first successes in my out of focus pictures were a fluke. That is to say, that when focussing and coming to something which, to my eye, was quite beautiful, I stopped there instead of screwing on the lens to the more definite focus which all other photographers insist upon.[15]

The "fluke" theory of photographic innovation retains the quality of spontaneous discovery of the Watts Album photographs, but does not account for the meaning of Cameron's photographic form, her use of a larger negative format, and her extensive promotion of her work. The characterization of Cameron's focusing as a "fluke" (an interpretation provided Cameron by her son) refers to the conception of the camera as a mechanical or scientific instrument: its practice was no longer subject to transformation and deviations from its operation were random, not an activity undertaken by design.

In October, 1875, Cameron and her husband moved from Freshwater to Ceylon to rejoin their sons.[16] She continued to contribute to exhibitions, including the International Exhibition in Philadelphia in 1876; the exhibition of Cameron's work in 1876, through the offices of the Autotype Company, was her only contribution to the Annual Exhibitions of the Photographic Society of Great Britain after her move to Ceylon.[17] While in Ceylon Cameron did photographs of Ceylonese people (p. 75), extending the values of her family photographs and imposing characterizations upon individuals of a different culture. Cameron returned to England for a visit in the Spring of 1878. She died in Ceylon, after a short illness, on January 26, 1879.[18]

12. Letter to Blanche Cornish, quoted in Gernsheim, *Cameron*, p. 53-54.

13. Autotype copies of portraits of Joseph Joachim, Charles Darwin, Alfred Tennyson, Sir John Herschel and G. F. Watts were registered on October 18, 1875.

14. Unsigned, "Art Publications," *Art Journal* n.s., 15 (July, 1876): 256; Unsigned, "The Photographic Exhibition," *Photographic News* 20 (October 20, 1876): 500.

15. Cameron, "Annals," p. 136.

16. Unsigned, "Mrs. Julia Margaret Cameron," *British Journal of Photography* 22 (October 15, 1875): 504.

17. See Appendix I.

18. Gernsheim, *Cameron*, p. 56-57; Ford, *The Cameron Collection*, p. 22 (excerpts from the London *Times* and *Autotype News* notices).

Afterword:
"One of photography's few 'classics'"

ER PORTRAIT WORK is characterized by a breadth of force seen in that of no one else since the time of Hill, and it is only by one of two modern workers, of whom Steichen may be noted in particular, that the succession is maintained.

R. Child Bayley, "Julia Margaret Cameron," 1913 [1]

Cameron's obituary was published in the London *Times,* the *Athenaeum,* the *British Journal of Photography,* the *Photographic News,* the *Photographic Journal,* and in other publications.[2] Seven years later the "Lady Amateur" speculated as to whether photographers still remembered Cameron.

The role of the Autotype Company in keeping Cameron's work before the public after her death is difficult to determine,[3] but by the end of the 1880s there was interest in Cameron's photography because of the exhibitions, associations, and publications generated by the turn of the century fine art photography movement in Europe and the United States. This popularity, facilitated by Julia Cameron's youngest son, the photographer Henry Herschel Hay Cameron, was based upon the applicability of Cameron's "out of focus" photographs to contemporary debates on the expressive use of focus.[4] These debates elaborated upon the arguments for photography as a fine art made in 1866-67 in the *Intellectual Observer*: the photographer exercised artistic control over the operation of the camera and selected appropriate subjects in order to make photographs which resembled another art form. By the 1890s the taste for Italian old masters had been replaced by the taste for Impressionist and Symbolist subjects, but the photographer's role was the same.

Henry Herschel Hay Cameron had been a member of the Photographic Society of Great Britain before his family's move to Ceylon. In 1885 his name reappears in the Annual Exhibition list of the Society and he became a professional photographer around this

1. Unsigned, "Julia Margaret Cameron, Our Plates," *Camera Work* 4 (January, 1913): 41-42; this text excerpts a long quote from R. Child Bayley, *The Complete Photographer* (London, 1906). The *Camera Work* text is reprinted in Stanford, "*Mrs. Cameron's Photographs from the Life,*" p. 60-61.

2. "Mrs. Julia Cameron," *Athenaeum,* March 8, 1879, p. 320; G. Thomas, "Bogawantalawa, the Final Resting Place of Julia Margaret Cameron," *History of Photography* 5 (April, 1981): 103-4; London *Times,* March 4, 1879; [reprinted in Royal Photographic Historical Section *Newsletter* 34 (January, 1979): 4]; *Photographic Journal* (February 20, 1879): 56-57; "The Late Mrs. Julia Cameron," *British Journal of Photography* 26 (March 7, 1879): 115-6 [reprinted in the *Photographic Times* 9 (April, 1879): 82-83]; "Death of Mrs. Cameron," *Photographic News* 23 (February 28, 1879): 105, 108; *Photographic Mosaics: An Annual Record of Photographic Progress* (Philadelphia, PA) 1880: 21.

3. As cited above, the Autotype Company announced the publication of Cameron photographs in the *Art Journal* in 1876, but the 1885 (6th edition) catalogue (the earliest known to the author), in the collection of the National Art Library, Victoria and Albert Museum, does not include Cameron subjects.

The 8th, 1889, and 9th, 1896, editions of *A Catalogue of the fine art reproductions of the Autotype Company* in the collection of the Department of Prints and Drawings, British Museum, and the British Library, respectively, do not include Cameron subjects. A 1911 catalogue, *An*

time.[5] An 1893 article in *The Studio* described Julia Cameron as the "honored founder" of Henry Cameron's photographic studio. A book Henry Cameron published the same year exemplified his use of his mother's reputation and photographs: *Alfred Lord Tennyson and His Friends,* photogravure reproductions of Julia Cameron's and Henry Cameron's portraits of Tennyson and his circle, with an introduction by Anne Thackeray Ritchie.[6] Henry Cameron's photographic activities included portraiture, art reproductions, and photographic reproductive processes, the range of different photographic activities among the applied art practices of the Arts and Crafts movement. Henry Cameron exhibited his own and his mother's photographs in London in 1889; on this occasion the "Annals of My Glass House" was published. In 1892 Henry Cameron was a founding member of the Linked Ring, an English association for the advancement of photography as a fine art, and one of an international

78

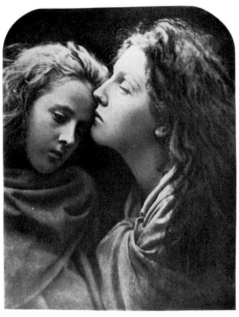

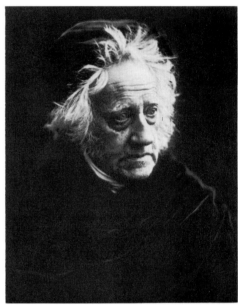

The Kiss of Peace
Sun Artists 1890
International Museum of Photography at George Eastman House Library

J.F.W. Herschel
Die Photographische Rundschau
1901
International Museum of Photography at George Eastman House Library.

network of similar societies. Henry Cameron displayed his mother's photographs in exhibitions in Paris, Belgium and Hamburg throughout the 1890s, entering Julia Cameron's photography into contemporary discussion of fine art photography.[7]

Illustrated Catalogue of Fine Art Reproductions, in the collection of the IMP/GEH, has six Cameron subjects, all portraits. It is difficult to determine if the absence of references to Cameron photographs indicates that they were unavailable.

On September 4, 1912, a representative of the Autotype Fine Art Company, Limited, sent Alfred Stieglitz a list of the 12 Cameron subjects in their possession; eleven are portraits, the twelfth, "Three Fishers," perhaps an alternative title for the Cameron photograph, "Pray God Bring Father Safely Home" (the title is from the Charles Kingsley poem, "Three fishers went sailing out into the deep" see Gernsheim, *Cameron,* p. 79, 194). The letter to Stieglitz is in the Collection of American Literature, Beinecke Rare Books and Manuscript Library, Yale University.

4. Robert Doty, *Photo-Secession, Stieglitz and the Fine Art Movement in Photography,* Revised edition, (New York, 1978), p. 2; Rochester, *The Last Decade: The Emergence of Art Photography in the 1890s,* International Museum of Photography at George Eastman House, p. 3; for a discussion of the place of focus in the artistic theories of the fine art photography movement, see Ulrich Keller, "The Myth of Art Photography: An Iconographic Analysis," *History of Photography* 9 (January—March, 1985): 16-26.

5. See Photographic Society of Great Britain, Exhibition Catalogues, 1881-1888; Marie A. Belloc, "The Art of Photography: Interview with Mr. H. Hay Herschel *(sic)* Cameron," *The Woman at Home* No. 43 (April, 1897): 581-90; the connections between the fine art photography movement and the international arts and crafts movement are discussed in Ulrich Keller, "The Myth of Art Photography: A Sociological Analysis," *History of Photography* 8 (October-December, 1984): 249-252.

6. G. W., "Photographic Portraiture: An Interview with Mr. H. H. Hay Cameron," *The Studio: An Illustrated Magazine of Fine and Applied Art* 2 (December, 1893): 84-89; Anne Thackeray Ritchie, *Alfred Lord Tennyson and His Friends: a Series of 25 Portraits. . . from the Negatives of Mrs. Julia Margaret Cameron and H. H. Hay Cameron,* Reminiscences by Anne Thackeray Ritchie, with an introduction by H. H. Hay Cameron. (London, 1893).

Julia Cameron's photographs were used to support contemporary artistic taste; work which did not agree with this taste was largely ignored or criticized. Peter Henry Emerson, the photographer and photographic art theorist, discussed the 1889 London exhibition of Julia and Henry Cameron's work in his "English Letter," a feature in the *American Amateur Photographer*. Emerson praised Julia Cameron's "naturalistic portraits" (Henry Cameron's contribution to the exhibition was unmentioned), but characterized her "angels with wings, etc.," as "spurious work" in which "Mrs. Cameron showed herself as the amateur and imperfectly trained artist that she was."[8] In contrast, Cameron's portrait photographs and fidelity to photography "from Life" were compatable with Emerson's art photography theories. In *Naturalistic Photography for Students of the Art* (1889) Emerson praised Cameron for her efforts to defeat the inadequate focus of the portrait lens, and her avoidance of such

(Sir Henry Taylor)
(Modern print by A.L. Coburn,
c. 1915, from copy negative
of c. 1865 print)
Bequest of Alvin Langdon Coburn

(Aubrey de Vere)
(Modern print by A.L. Coburn,
c. 1915, from copy negative
of 1868 print)
Bequest of Alvin Langdon Coburn

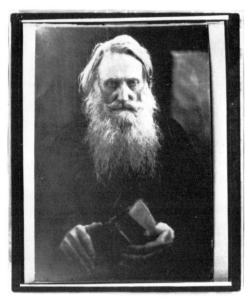
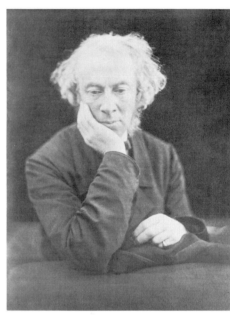

artificialities as vignetting, enlarging, and retouching.[9] In *Sun Artists* in 1890, Emerson wrote that Cameron was "not an impressionist or naturalist, but what is known to some as an 'idealist,' she saw her models through the old master's spectacles, fondly, lovingly, joyfully, as a child."[10] This paean to Cameron's childlike vision possibly achieves the nadir of this period's appraisals of Cameron's photography. Emerson gave a stylistic characterization to photographs whose form had represented a particular practice of photography. Emerson's view of Cameron as an amateur, and defense of her work against photographic philistines misrepresented her photographic context by placing her activities in terms of disdain for commercial activity, not as an improvement of photography by which Cameron had intended to profit.

7. For a discussion of H. H. Hay Cameron's Linked Ring activity, see Margaret Harker, *The Linked Ring: The Secession Movement in Photography in Britain, 1892-1910,* (London, 1979), p. 83-4, 181, 190.
 Julia Margaret Cameron's photographs were exhibited in the 1895 *"Salon Photographique"* of the *Cercle Artistique et Littéraire* in Brussels; the 1895 *"Premier Exposition d'Art Photographique"* of the *Photo-Club de Paris*; the 1898 Royal Photographic Society, International Exhibition, London, and the 1899 *"Internationale Ausstellung von Kunst-Photograph"* of the *Gesellschaft zur Fördering der Amateur Photographie,* Hamburg.

8. P. H. Emerson, "English Letter," *American Amateur Photographer* 1 (September, 1889): 121-23; Emerson referred here to a review in the *Magazine of Art,* "Exhibitions of the Month," 12 (1889): xxxiv-xxv.

9. P. H. Emerson, *Naturalistic Photography for Students of the Art,* (London, 1889), p. 137, 152, 187, 189, 197.

10. P. H. Emerson, "Mrs. Julia Margaret Cameron," *Sun Artists* 5 (October, 1890): 33-41.

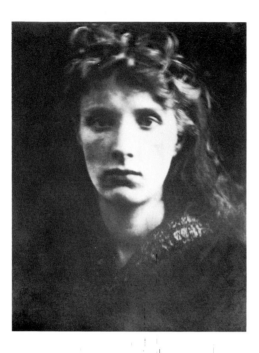

(Mountain Nymph Sweet Liberty)
(Modern print by A.L. Coburn,
c. 1915, from copy negative
of 1867 print)
Bequest of Alvin Langdon Coburn

In a series of letters written in October, 1890, in the English journal, the *Amateur Photographer,* Emerson described Cameron as the "first photographer to put diffusion of focus into practice." Emerson's statement is noteworthy for the response it provoked from Henry Peach Robinson, photographer and photographic theorist. Robinson had been Cameron's contemporary, and apparently her advisor on lenses:

> ... it is well known that her earlier photographs were out of focus more by accident than design. It was not done with the intention of giving her pictures more 'profound expression.' She knew nothing of the qualities of lenses and worked at first with a very bad one, not knowing that it was bad. She afterwards, at my recommendation, procured a better lens, and her work improved, especially in definition, and she was delighted with the improvement... In his [Emerson's] present statement he says I called Mrs. Cameron's work "smudges" in the discussion arising in 1865... It will be seen that I referred only to the early works, and highly praised their art qualities, while I condemned the ignorance of those who attributed their excellence to their undoubted faults rather than to the artistic manner in which they were conceived. At the time... I actually strongly recommended diffusion of focus. [11]

Robinson's characterization of Cameron's lens technique as accidental maintained the fluke theory of photographic innovation, at the additional expense of Cameron's own judgment. Robinson's distinction between Cameron's "early work" and the improvement of her technique is consistent with the change in attitude of the photographic press in 1866, after Cameron switched to a larger format negative and lens. The "discussion arising in 1865" was maintained through 1869 and after in Robinson's *Pictorial Effect in Photography* (reprinted into the twentieth century); Robinson's account of his presentation of Cameron's photography is consistent with the 1869 text. [12]

11. H. P. Robinson, "The Present State of the Focus Question," *Amateur Photographer* 12 (October 10, 1890): 258-9; Dr. P. H. Emerson, "The Present State of the Focus Question," *Amateur Photographer* 12 (October 24, 1890): 288-9; H. P. Robinson, "Letters to the Editor: the Focus Question," *Amateur Photographer* 12 (October 31, 1890): 306. The extensive quote is from Robinson's October 31, 1890, letter.

12. H. P. Robinson, *Pictorial Effect in Photography, being Hints on Composition and Chiaroscuro for Photographers,* (London, 1869); Robinson's mention of the "discussion arising in 1865" perhaps referred to a passage from Cameron's "Annals of My Glass House," in which she described the judges of the 1865 Annual Exhibition of the Photographic Society of Scotland passing over her photographs to give a medal to a photograph, "Brenda." Cameron did not name the photographer, but it was H. P. Robinson. Robinson's mention of "smudges" referred to a passage in his *Pictorial Effect* where, in the discussion of "some photographs by a lady," he proclaimed that it "was not the mission of photography to produce smudges" p. 144-5.

The circumstances of photographic activity which made it possible for Cameron in 1874 to characterize her "out of focus" as a fluke were still applicable to photography twenty and thirty years later: "out of focus" indicated a variation on the operation of the camera. As apparent in the writings of Emerson and Robinson, the assignment to Cameron of a precursor role was made at cost to Cameron's credibility as an artist, who had valid reasons for putting wings on angels. The absence of period detail in Cameron's portraits lent them to *fin de siècle* tastes to an extent impossible with "Sun-lit Memories" (p. 68) and "The Passing of Arthur" (p. 37). The 1913 *Camera Work* photogravure reproductions of Cameron portraits of Carlyle, Herschel, Joachim, and Terry transformed Cameron's luminosity and spatial distortions into softened shapes and tonal gradations. The majority of the subjects in Alvin Langdon Coburn's 1914-15 exhibition, "The Old Masters of Photography," were of identified portraits or of single figures (see the discussion in *Guide to the Catalogue*), and the platinum copy prints Coburn produced for the exhibition emphasized tonality and surface, not Cameron's manipulation of form in space or her scale. Cameron's portraits also indicated that some of the major figures of Victorian society had been interested in Cameron's photography, a fact attractive to a movement interested in gaining artistic status for its activities.[13] In form and content the fine art photography movement interpreted Cameron according to their own expectations of photographic artistry and the proper operation of the camera to these ends. In doing so they also imposed a conception of photographic activity upon a period to which it did not apply, to the exclusion of other possibilities of meaning and analysis.

13. Unsigned, "Julia Margaret Cameron: Our Plates," *Camera Work* 41 (January, 1913): 41-42; five photogravures were published in this issue: "Carlyle," "Carlyle," "Herschel," "Joachim," and "Ellen Terry at the age of sixteen."

Alvin Langdon Coburn, "The Old Masters of Photography," *Century Magazine* 90 (October, 1915): 909-920. Coburn curated "Exhibition of the Old Masters of Photography," which ran at the Ehrich Galleries, New York City, and at the Buffalo Fine Arts Academy, Albright Art Gallery, Buffalo, in 1914-5. The exhibition featured copy prints of photographs of Cameron and of Lewis Carroll, and prints from the original negatives by D. O. Hill and by Dr. Thomas Keith.

Coburn's disinclination to reproduce the Cameron photographs to scale was not a consequence of the physical limitations of the platinum paper, because his prints from the Keith negatives are larger than his Cameron copy prints.

For a discussion of the significance of "tone" to the fine art photography movement, see Keller, "The Myth of Art Photography: An Iconographic Analysis," p. 21.

Catalogue

The Albumen Print and Cameron's Work

Grant B. Romer, Conservator

A significant number of the prints of Cameron's imagery have deteriorated to a degree which makes them markedly different from how they appeared in her lifetime. This is due not only to factors such as poor processing and storage, but also to the inherent susceptibility of Cameron's choice of printing material, albumen paper. A great deal of the dramatic pictorial beauty and impact of her work is dependent upon the print quality. It is very important to understand which factors of albumen print deterioration alter the aesthetics of the print before we can form a full appreciation of her work.

Cameron worked during the period when the universally predominant method of photographic production was the wet glass plate collodion negative/albumen paper positive system. This system had evolved out of a desire to improve the resolution and brilliancy of the paper photographic system of the first era of photography. Once the wet glass plate collodion negative/albumen paper positive system was perfected in the late 1850s, it rapidly was adopted by both professionals and amateurs, and significantly changed both the aesthetics and commerce of photography. The system remained dominant until the 1880s, when the next evolutionary phase of photography dawned with dry plates and developed-out paper systems.

Thus, Cameron would logically have turned to albumen paper as her printing medium of choice. Although albumen paper had been developed to give greater rendition of detail, it could still serve admirably to render the broad and massive conception of Cameron's imagery with lustre, richness and vivacity. Only those photographic printing alternatives as the carbon print, platinotype or photogravure could offer the appropriate dramatic, atmospheric beauty requisite for her imagery.

Undoubtedly print quality was important to Cameron, despite her notorious lack of attention to the demanding smaller details of the photographic craft. The task of making prints by this process, although somewhat simplified over earlier practice, was none the less, extremely laborious by contemporary standards. Albumen paper could be entirely prepared by the photographer, however, it lent itself to being manufactured in a semi-prepared state of high quality. Companies in France and Germany made a speciality of the production of albumen paper, and it was tempting for photographers to save labor and buy the paper already coated with a thin layer of salted albumen (derived from the whites of hen's eggs) from photographic supply houses. In order to print, it was necessary to float this paper on a solution of silver nitrate, which combined with the salt to form silver chloride. After drying, the paper was pressed in contact with the glass negative in a frame and exposed out of doors to sunlight. The light reached the exposed areas of the sensitive paper through the negative, producing a

darkening of the silver chloride resulting in a positive image. The darkening was a gradual process, and the amount of time required depended upon such factors as the time of day, season of the year, and weather. Therefore, it was necessary to monitor the printing-out of the image constantly to prevent under- or over-exposure of the print. When the print was judged to be of proper density (i.e., darkness), it was removed from the frame and processed in much the same fashion as modern photographic materials today.

One feature of the printed-out silver is that it has a reddish color, in contrast to the neutral black color of developed-out silver. This reddish color was objectionable to 19th century photographers, and they chose to tone the print, most commonly with gold chloride. This toning converted the reddish color to a rich, deep, cold purple-brown. The toning also protected the image, making it less subject to fading. The toned prints were exceedingly brilliant, with a wide and subtle range of tonal rendition, highlights, shadow detail, and a beautiful pictorial hue.

Despite the beauty of the albumen print, the labor and time involved must have been taxing to one impatient to gain the pictorial fruit. Surely Cameron enlisted the aid of her household staff, at least in part, to help with this labor. It was common for the photographer who could afford it to hire others to do their printing, and when Cameron wished to produce prints in great numbers, she turned to the publishing firm of Colnaghi and Company. One cannot assume, therefore, that Cameron made every print herself, though she certainly passed final approval. We can safely assume that the prints in the Watts Album are her own productions; since these retain a great deal of their original aspect, they afford us a good model from which to judge her print aesthetic.

It is important to bear in mind, when viewing many of the prints in the exhibition, that they have markedly changed through deterioration, usually in the form of the yellowing of the "whites" of the image, loss of detail in the lighter areas of the image, a color shift of tones from cool purple-brown to warm reddish brown. Although this deterioration can sometimes add an atmosphere not entirely in conflict with the subject of the prints, we should not mistake this for the intention of the photographer.

In summation, it must be said that we have been robbed of much of the beauty and power of Cameron's work through the deterioration of her prints. The blame does not lie with her carelessness in processing alone, but rather more with the vulnerability of the albumen print and the variabilities of caretakership. Nevertheless, her imagery is strong enough to withstand so unkind a fate, and if we look upon her photographs with an educated eye, much can be reclaimed.

Catalogue

Guide to the Catalogue

Introduction: Cameron Photographs at the International Museum of Photography at George Eastman House.

The work of Julia Margaret Cameron represented in the collection of the International Museum of Photography at George Eastman House consists of 84 individual photographs, an album of 39 Cameron photographs, presented by her to George F. Watts on February 22, 1864, and twenty-five photographs in two volumes of Cameron's *Illustrations to Tennyson's "Idylls of the King" and Other Poems* (London, 1875).[1] There are also 22 platinum copy prints of Cameron photographs made by Alvin Langdon Coburn, associated with an exhibition he curated in 1914, "The Old Masters of Photography."

The Gabriel Cromer Collection is one of the major components of the Museum's collection and the largest single source of Cameron photographs. Cromer, a French lawyer turned photographer and collector, amassed one of the most important private collections of photographica ever assembled before his death in 1937. In 1939 the Eastman Kodak Company purchased the major part of the Cromer Collection and included it in its donation of the Eastman Historical Photographic Collection to the newly-formed George Eastman House in 1947. The Cromer Camerons are a distinguished group, ranging in date from 1864 ("The Five Wise Virgins," p. 28) to 1872 ("Study of a St. John the Baptist" p. 69), and include two "light studies" (p. 54) not duplicated in the other public collections of Cameron photographs in England.[2] Eleven of the Cromer Camerons have inscriptions to George F. Watts (i.e., "To the 'Signor' "—Watts's nickname), but the possibility that Watts was the source of Cameron photographs in the Cromer Collection must remain a tantalizing speculation unless additional documentation comes to light.[3] In the Eastman Historical Photographic Collection there are also five Cameron photographs purchased from Gerald Massay through the American collector A. E. Marshall. In 1971 the Watts Album, which Cameron gave to Watts within two months of her first dated photograph, "Annie, My first Success," was donated to the Museum in honor of Dr. Walter Clark. Clark assisted Dr. C. Kenneth Mees in the purchase of the major part of the Cromer Collection for the Eastman Kodak Company and arrangement for the transfer of the Collection to the United States before the German invasion of France in 1939.

My thanks to Pat Byrne of the Catalogue Staff, for her patient and thorough work in the transformation of exhibition research into machine-readable form, and to Carolee Aber, former Intern, who carefully surveyed the entire run of *IMAGE* for the citations.

1. The Cameron photographs are on the first twenty-two leaves of a commercially-produced album. Tipped into the latter pages of an album, with a different adhesive than used for the Cameron photographs, are three salt prints and a drawing, artist unknown; two of the salt prints are of plaster casts, the third is a full-length image of a young girl; the drawing is on laid paper, in pencil, and appears to be a preliminary figure study in illustration of a text inscribed in ink on the paper (the text describes the action of a king who arranged for the suffering inhabitants of a distant province to be established in the capital; see the International Museum of Photography at George Eastman House catalogue record for complete text). There are also thirteen drawings on the album leaves, artist unknown; the thirteen drawings are figure studies and not by a practiced artist.

 The second volume of the *Illustrations to Tennyson's "Idylls of the King" and Other Poems* is missing the photograph, "And Enid Sang."

The American collector Alden Scott Boyer's gift of his major photographic collection to Eastman House in 1950 included seven Cameron portraits and cartes-de-visite; the portraits all have "Gernsheim Collection" stamps, their provenance the collection of Helmut and Alison Gernsheim. The famous profile of Julia Jackson Duckworth Stephen, "Mrs. Duckworth as Julia Jackson," (p. 49) is part of Boyer's gift. Helmut Gernsheim gave a portrait of Henry W. Longfellow (p. 58) to Eastman House in 1959. Cameron photographs were purchased from the private collections of Americans Lorraine Dexter and Emily Driscoll; the purchase of the photographic collection of the Wadsworth Library, Geneseo, New York in 1976 brought two carbon print copies of Cameron portraits, the only Cameron photographs of this process in the collection. The volumes of the *Illustrations to Tennyson's "Idylls of the King" and Other Poems* were purchased at auction, and other prints were purchased from booksellers, galleries and auction houses in the United States and England.

Catalogue Format

Titles and dates without parentheses are from the inscriptions on the International Museum of Photography at George Eastman House print; dates and titles within parentheses were assigned by the curator from information cited in the Bibliographic Reference (BIB REF) section. Dates with "(?)," were assigned on the basis of copyright registrations, and without visual verification. The following publications were consulted in the preparations of the BIB REF section of each catalogue entry; when a print is reproduced, the page or plate number of the publication is noted. With these citations it is possible to evaluate individual photographs in reference either to Cameron's own compilations of her work, or to significant twentieth century presentations of her photographs.

> Colin Ford. *The Cameron Collection: An Album of Photographs by Julia Margaret Cameron Presented to Sir John Herschel.* (New York, 1975).
>
> Paris. *Hommage de Julia Margaret Cameron à Victor Hugo.* Maison de Victor Hugo, 1980.
>
> London. *Sotheby's Belgravia Auction Catalogue* 26 June 1975. Lot 45: Album presented by Julia Margaret Cameron to Lord Overstone in August, 1865.
>
> Julia Margaret Cameron. *Victorian Photographs of Famous Men and Fair Women.* Introductions by Virginia Woolf and Roger Fry. (London, 1926).
>
> Helmut Gernshcim. *Julia Margaret Cameron: Her Life and Photographic Work.* rev. ed. (Millerton, New York, 1975).

The first three citations are completely illustrated publications of photographs Cameron gave to prominent individuals: an album of 94 photographs to Sir John Herschel in November, 1864 (with additions in September, 1867); an album of 111 photographs to Lord Overstone in August, 1865; gifts of a total of 29 photographs to Victor Hugo in 1869-70 and 1875.[4] The remaining two books are important twentieth century interpretations of Cameron's work:

2. The major public collections of Cameron photographs in the United States and England are: Gernsheim Collection, Harry Ransom Humanities Research Center, University of Texas at Austin, Austin, Texas; the Getty Museum, Los Angeles, California; the Victoria and Albert Museum, London; the Royal Photographic Society of Great Britain, Bath, England.

3. There are thirteen Cameron photographs in the International Museum of Photography at George Eastman House collection inscribed to Watts; eleven of these have a clear Cromer provenance, while the other two have no provenance outside of the Eastman Historical Photographic Collection. These two photographs may be from the Cromer Collection, but there is no concrete evidence.

4. The Sotheby Belgravia Auction Catalogue gives small reference reproductions, inscriptions and dimensions for the Overstone Album. *The Cameron Collection* and *Hommage de Julia Cameron à Victor Hugo* provide good discussions of individual photographs and of the subjects in general. *The Cameron Collection* is an especially valuable resource.

Virginia Woolf's selection and publication of her great aunt's photographs, with introductions by Roger Fry and by Woolf, brought Woolf's vision of Cameron's work to a distinctly non-photographic audience and Gernsheim's monograph, despite serious critical imbalances, is the standard reference book on Cameron.[5] The BIB REF section also includes citations of the discussion and/or reproduction of Cameron photographs in IMAGE, the International Museum of Photography at George Eastman House magazine, and occasional references to articles on specific photographs.

Copyright Citations

Cameron frequently inscribed the phrase "registered photograph copy right" on her photographs and the phrase "registered photograph" was incorporated into the blind-stamp of Colnaghi and Company commonly found on the mounts of her photographs. These phrases refer to the right of English photographers to register their images for protection under copyright, a provision passed into law on July 29, 1862.[6] In order to qualify for copyright protection, photographers paid a one shilling fee and filled out a memorandum with a description of the photograph; there was an option to deposit a copy of the photograph with the memorandum. The individual description on the memorandum was edited and entered into a ledger, not necessarily on the same day as the memorandum was prepared.

Five hundred and five Cameron photographs were registered for copyright from 1864 to 1875. Between May 30, 1864 and November 17, 1865, Cameron registered one hundred and ninety-eight photographs. Between February 20, 1866 and October 25, 1870, different agents for Cameron registered two hundred and fifty-nine photographs and Cameron returned to the registration procedure between August 18, 1871 and October 18, 1875 for forty-eight entries. Cameron's own copyright descriptions are fuller than the spare lines written by her agents and they constitute just under half of the total registrations of her work recorded.

Unfortunately, Cameron did not deposit a copy of the photograph with its registration memorandum. In the absence of visual verification, any assignment of a copyright description to a specific photograph is necessarily provisional and apt to confirm existing knowledge. With this caveat, the copyright citations in this catalogue were assigned to photographs on the basis of title and description, weighed against evidence of date and size. When a copyright description provided useful information, but was of questionable connection with the image, the sign (?) was added to the citation. The copyright date and description cited are from the memorandum, not from the ledger records.

5. See Anita Ventura Mozley's review, "The Priestess of the Sun and the Historian of Photography," *Afterimage* 3 (November, 1975): 6-7, 13. Gernsheim evaluated Cameron's photographs according to the values of twentieth century photographic modernism, praising her portraits and criticizing her illustrations and fancy subject photographs (p. 67-9, 79-84) for their violation of the "realism" which is the main contribution of photography to art. Discussion of the third major twentieth century interpretation of Cameron is appropriate here: Beaumont Newhall's *The History of Photography from 1839 to the Present Day* (New York, 1949) reproduced "Summer Days" from the Eastman Historic Photographic Collection. The enlarged and revised edition of the book, published by the Museum of Modern Art in collaboration with George Eastman House in 1964, reproduced the bust portrait of Sir John Herschel, credited jointly to MOMA and GEH. Virginia Woolf's book was published in an expanded and revised edition by the Hogarth Press in 1973 edited by Tristram Powell.

6. There is no significance to the use of the phrase, "registered photograph" as opposed to "registered photograph copy right" to indicate that the photograph was copyrighted; this information is from correspondence with T.R. Padfield of the Public Record Office, Kew, England. For details of the registration procedure see the unsigned article, "New Copyright Act," *The Photographic Journal* 6 (August 1862): 100-102, reprinted in *"Mrs. Cameron's Photographs from the Life,"* p. 51-2.

7. In the International Museum of Photography at George Eastman House collection there are Coburn platinum prints from negatives by Dr. Keith and by Hill and Adamson and platinum copy prints of photographs by Lewis Carroll. A similar coincidence of subject and "Old Masters of Photography" exhibition titles exists, but there is also no evidence to indicate that these were exhibited. In the Albright Art Gallery catalogue the photographs on exhibit were offered for sale.

Cameron Reprints
by Alvin Langdon Coburn

The 1967 gift of Alvin Langdon Coburn photographs, negatives, books and equipment from his estate included twenty-two platinum prints made by Coburn from copy negatives of original Cameron photographs. The gift also included two photogravure reproductions of Cameron portraits, possibly related to the photogravure reproductions in *Alfred Lord Tennyson and His Friends* (London, 1893). Among the Coburn platinum copy prints are multiple copies of the same image printed on different paper stocks and with different surface finishes.

There are references in the Bibliographic Reference section entries of the Coburn copy prints to the exhibition, "The Old Masters of Photography," which opened at the Ehrich Gallery in New York City in November, 1914 and ran at the Albright Art Gallery (now the Albright-Knox Museum) in Buffalo, New York from January 30 to February 28, 1915. The exhibition was of platinum copy prints of the work of Cameron and Lewis Carroll and of platinum prints from the original negatives of Hill and Adamson and Dr. Thomas Keith. The catalogue of the Albright Gallery exhibition has a list of titles and a preface by Coburn; the following Cameron titles are given:[7]

Self Portrait	*Mrs. Duckworth*
Thomas Carlyle	*Adolphus Liddell*
G. F. Watts	*Madonna and Child*
Sir Henry Taylor	*Three Heads*
Sir John F. W. Herschel	*Toe, Maid of Athens*
Aubrey de Vere	*Mountain Nymph—Sweet Liberty*
William Michael Rossetti	*King Lear*
Holman Hunt	*Florence* (Inscribed by G. F. Watts:
The Kiss of Peace (Watts and children)	"I wish I could paint such a picture
Miss Magdalen Brookfield	as this")
The Gipsy	*Miss May Prinsep*

At International Museum of Photography at George Eastman House there are Coburn copy prints of Cameron photographs whose subjects coincide with eighteen of the twenty titles (not included are *Thomas Carlyle* and *William Michael Rossetti*); while this coincidence is significant enough to merit notice of the "Old Masters" exhibition in the individual entries, there is no evidence that these prints were exhibited in "The Old Masters of Photography."

Carbon Reprints

Before her departure to Ceylon in October, 1875, Cameron arranged to have her negatives, and prints for which there were no negatives, reprinted in carbon by the Autotype Company of London (see the discussion in *Later Work and Conclusion*). Cameron inscribed some carbon reprints (p. 59) "Autotype taken from the Registered Photograph from the Life by Julia Margaret Cameron;" some carbon prints also bear an Autotype Company blindstamp (p. 25). According to an 1879 *Autotype Notes* article, Cameron's negatives were retouched and altered before reprinting, alterations which are particularly notable in facial details (p. 69 and p. 37). The carbon print process allowed variations in pigment color, ranging in the examples displayed here from brown to bright red, and to a sepia color which resembled the color of albumen prints.[8]

8. The *Autotype Notes* article is quoted in Ford, *The Cameron Collection,* p. 22; as noted previously, it is difficult to determine the extent of the marketing done by the Autotype Company. P. H. Emerson in his 1890 *Sun Artists* feature referred to Cameron photographs "formerly available at Colnaghi's," but did not mention the Autotype Company.

 At the Boston Museum of Fine Arts there is a large collection of carbon print reproduction of Cameron's photographs, given Mrs. J. D. Cameron Bradley, accessioned in 1942. These prints are all of a sepia color (see p. 23) and undated; an inscription on one of the prints (42.335) reads "The late Miss (sic) Leslie Stephen," dating the inscription to after 1895. I have been unable to determine if Mrs. Bradley was a descendant of Cameron's. Anne Hewat kindly provided me with an extensive genealogy of the descendants of Eugene Cameron; J. D. Cameron Bradley is not among these.

88 **(Julia and Charlotte Norman)**
(1864)
albumen print
22.9 x 21.0 cm. (arched and trimmed)
71:0109:0015
Museum collection
GEH NEG: 15869

BIB REF: Barrow, Tom. "Talent"
 Image 15 (December, 1971): 29-31;
 reprinted *Image* 25(1982): 19-20.
INSCRIP: mat recto-(inscription in
 pencil) "15"
NOTES: From album given to G.F.
 Watts by Julia Margaret Cameron
 on Feb. 22, 64, plate 15;
 Provenance, G.F. Watts, Ronald
 Chapman.
Illustrated on p. 11.

**My grandchild Archie aged 2
years & 3 months**
(1865)
albumen print
20.9 x 23.8 cm.
81:1121:0024
Gift of Eastman Kodak Company:
 ex-collection Gabriel Cromer
GEH NEG: 3602
OTHER #: EHPC 387-24

BIB REF: Gernsheim, Helmut. *Julia
 Margaret Cameron: Her Life and
 Photographic Work*. Millerton,
 1975, p.138 (variant).
EXH HIST: Print possibly exhibited
 in "291 Gallery-Prints and Photo-
 graphs", San Francisco Museum of
 Art, Aug. 4-Sept. 30, 1959.
INSCRIP: mat recto-(signature and
 inscriptions in ink by artist) title
 "Julia Margaret Cameron" "For
 Signor" (Colnaghi blindstamp) mat
 verso-(blue stamp) "366"
Illustrated on p. 14.

**For Signor my chef d' oeuvre My
grand child age 2 years & 3
months**
Born at Barbados May 1863
(1865)
albumen print
23.0 x 28.1 cm.
81:1118:0001
Gift of Eastman Kodak Company:
 ex-collection Gabriel Cromer
GEH NEG: 3651 14170
OTHER #: EHC 365

EXH HIST: "British Masters of the
 Albumen Print 1860-1880" IMP/
 GEH, March 16-August 20, 1973.
INSCRIP: mat recto-(signature and
 inscriptions in ink by artist) title
 "Julia Margaret Cameron"
 (Colnaghi blindstamp) mat verso-
 (blue stamp) "365"
Illustrated on p. 14.

My grandchild my chef d' oeuvre
(1865)
albumen print
15.4 x 23.6 cm.
81:1123:0001
Gift of Eastman Kodak Company:
 ex-collection Gabriel Cromer
GEH NEG: 15021
OTHER #: EHC 369

INSCRIP: mat recto-(signature and
 inscriptions in ink by artist) title
 "Julia Margaret Cameron" "For
 Signor" (under My grandchild) "age
 2 years & 3 months" (Colnaghi
 blindstamp) mat verso-(blue stamp)
 "369"
Illustrated on p. 15.

Beatrice Cameron
1872
albumen print
35.4 x 26.4 cm. (arched)
81:1121:0008
Gift of Eastman Kodak Company:
 ex-collection Gabriel Cromer
GEH NEG: 3620 7768
OTHER #: EHPC 387-8

INSCRIP: recto-(inscription in ink on
 print) "7 too large" mat recto-
 (signature and inscriptions in ink
 by artist) title "From Life Registered
 Photograph Copyright Julia
 Margaret Cameron Freshwater
 1872" (Colnaghi blindstamp) mat
 verso-(blue stamp) "385" No
 photograph of this description
 registered for copyright in 1872.
Illustrated on p. 73.

(Charles Norman)
(c. 1872)
albumen print
36.2 x 29.1 cm.
81:1121:0010
Gift of Eastman Kodak Company:
 ex-collection Gabriel Cromer
GEH NEG: 3592 15057
OTHER #: EHPC 387-10

INSCRIP: mat recto-(signature and
 inscriptions in ink by artist) "From
 Life Julia Margaret Cameron"
 (Colnaghi blindstamp) mat verso-
 (blue stamp) "362"
Illustrated on p. 70.

**(Charlotte and George Norman,
Jr. without hats)**
(1868)
albumen print
28.7 x 23.2 cm.
81:1124:0002
Museum purchase
GEH NEG: 7746
OTHER #: 6645-2

INSCRIP: mat recto-(pencil inscrip-
 tion) "21" (pencil inscription over
 erased notations) "2" (and symbol
 for shillings) pencil inscription-
 erased) "SJW" (Colnaghi blind-
 stamp)
NOTES: Provenance, Brussels Associ-
 ates, New York City, 1961
Illustrated on p. 59.

**My grandchildren Charlotte
Norman George Norman Junior!**
1868
albumen print
29.9 x 25.9 cm.
81:1124:0004
Museum purchase
GEH NEG: 7748 14193
OTHER #: 6645-4

INSCRIP: mat recto-(signature and
 inscriptions in ink by artist) title
 "from Life Freshwater April 1868
 Registered Photograph Copyright"
NOTES: Provenance, Brussels Associ-
 ates, New York City, 1961 No
 photograph of this description
 registered for copyright in 1868
Illustrated on p. 58.

Daisy Norman
1870
albumen print
36.0 x 26.2 cm
Seattle Art Museum, Floyd A.
 Naramore Memorial Purchase
 Fund.

INSCRIP: mat recto-(signature and
 inscriptions in ink by artist) title
 "From Life Registered Photograph
 Copyright Julia Margaret Cameron
 Fresh Water Aug 1870" (Colnaghi
 blindstamp)
NOTES: No photograph of this
 description registered for copy-
 right in 1870.
Illustrated on p. 72.

C.H. Cameron
(c. 1875 reproduction of 1869
subject)
carbon print
31.4 x 24.4 cm
University of Nebraska Art Galleries,
 Sheldon Memorial Art Gallery,
 F.M. Hall Collection.

INSCRIP: mat recto-(signature and
 inscriptions in ink by artist) "Auto-
 type taken from the Registered
 Photograph from the life of Julia
 Margaret Cameron" (embossed
 stamp) "Autotype" (letterpress)
 "(Taken by Julia Margaret
 Cameron)" (lithographed signature)
 "C.H. Cameron"
BIB REF: Gernsheim, Helmut. *Julia
 Margaret Cameron: Her Life and
 Photographic Work*. Millerton,
 1975, p. 154.
NOTES: No photograph of this
 description registered for copy-
 right in 1869.
Illustrated on p. 59.

**Charles Hay Cameron in his
garden at Freshwater**
(c.1868)
albumen print
33.4 x 26.7 cm.
Lent by The Metropolitan Museum of
 Art, Harris Brisbane Dick Fund,
 1941.

INSCRIP: mat recto-(inscriptions in
 ink) title "By his wife Julia Margaret
 Cameron" (signature in ink) "C.H.
 Cameron" mat verso-postmarked
 17 July 1868.
Illustrated on p. 60.

(Hardinge Hay Cameron)
(c. 1867)
albumen print
28.2 x 22.6 cm.
Collection of the Royal Photographic
 Society of Great Britain
 Gift of Mrs. Trench, 1929.

INSCRIP: (Colnaghi blindstamp)
Illustrated on p. 61.

Madonnas and Cherubs

(Henry Herschel Hay Cameron)
(c. 1867)
albumen print
28.3 x 24.0 cm.,
Collection of the Royal Photographic Society of Great Britain

INSCRIP: mat recto-(signature and inscriptions in ink by artist) "From Life registered photograph copyright Julia Margaret Cameron, Freshwater" (Colnaghi blindstamp)
NOTES: No photograph identified as Henry Herschel Hay Cameron registered for copyright.
Illustrated on p. 61.

(Valentine Prinsep)
(1867?)
albumen print
34.3 x 26.7 cm
Paul Walter Collection

INSCRIP: (Colnaghi blindstamp)
NOTES: Copyright registration for June 14, 1867, "Photograph, Portrait of Valentine Prinsep." (?)
Illustrated on p. 50.

Our Royal Cousin—(Val Prinsep, RA)
1874
albumen print
34.0 x 25.5 cm.
Collection of the Royal Photographic Society of Great Britain,
Gift of Mrs. Trench, 1929.

INSCRIP: mat recto-(pencil inscription by Dudley Johnston) title "Mrs. Julia Margaret Cameron 1874"
Illustrated on p. 74.

Love
1864
albumen print
16.2 x 13.8 cm
Boni Collection, Department of Special Collections, University Research Library, University of California, Los Angeles

NOTES: Plate 51 from an album given to Aubry Ashwooth Taylor on September 29, 1869. "Love" (out of a series of nine studies of the fruits of the spirit). Freshwater 1864.
Illustrated on p. 20.

La Madonna Riposata
1864
albumen print
24.0 x 19.1 cm.
Boni Collection, Department of Special Collections, University Research Library, University of California, Los Angeles.

BIB REF: Overstone plate 91. From album given to Lord Overstone by Julia Margaret Cameron on August 5, 1865. Ford, Colin. *The Cameron Collection: An Album of Photographs by Julia Margaret Cameron Presented to Sir John Herschel.* Wokingham and New York, l975, plate 46.
NOTES: Plate 47 from an album given to Aubry Ashwooth Taylor on September 29, 1869.
Illustrated on p. 28.

(Woman with two children)
(c. 1864-65)
albumen print
25.3 x 21.4 cm.
Gift of Eastman Kodak Company: ex-collection Gabriel Cromer
GEH NEG: 14173 3582 24483
OTHER #: EHPC 387-36

INSCRIP: mat recto-(signature and inscriptions in ink by artist) "Julia Margaret Cameron" "JMC" (pencil inscription) "1"(and symbol for shillings) (Colnaghi blindstamp) mat verso-(blue stamp) "386"
Illustrated on p. 42.

(Mother and child)
(c.1864-65)
albumen print
24.1 x 19.0 cm
Paul Walter Collection
Illustrated on p. 20.

"Wist ye not that Your Father and I sought thee sorrowing?"
(1865)
albumen print
25.2 x 28.8 cm.
81:1121:0027
Gift of Eastman Kodak Company: ex-collection Gabriel Cromer
GEH NEG: 3595 14069
OTHER #: EHPC 387-27

BIB REF: Ford, Colin. *The Cameron Collection: An Album of Photographs by Julia Margaret Cameron Presented to Sir John Herschel.* Wokingham and New York, 1975, plate 55.
EXH HIST: "British Masters of the Albumen Print 1860-1880" IMP/GEH March 16-August 20, 1973. Survey of the History of 19th Century Photography IMP/GEH Exhibition 1974-1975, 1987-1980.
INSCRIP: mat recto-(signature and inscriptions in ink by artist) title "Registered Photograph Julia Margaret Cameron" mat verso-(blue stamp) "374"
NOTES: Copyright registration July 17, 1865, "A photograph called the return from The Temple group of four figures three women & Boy Boy full face women keep their head bent down wards lilies and roses in foreground."
Illustrated on p. 26.

Sister Spirits
(1865?)
albumen print
31.6 x 26.6 cm.
81:1121:0028
Gift of Eastman Kodak Company: ex-collection Gabriel Cromer.
GEH NEG: 14169 3609 3577
OTHER #: EHPC 387-28

EXH HIST: "British Masters of the Albumen Print 1860-1880" IMP/GEH March 16-August 20, 1973. "Women of Photography" San Francisco Museum of Art, Feb. 1975-Aug. 1977.
INSCRIP: mat recto-(inscription in pencil by artist) title (signature in ink by artist) "Julia Margaret Cameron" (Colnaghi blindstamp) mat verso-(blue stamp) "395"
NOTES: Copyright registration July 18, 1865, "A photograph called The Sister Spirits three heads of female figure to waist two profiles center face full face 2 children full face below one child asleep lilies along center of picture."
Illustrated on p. 44.

The Adoration
(c. 1865)
albumen print
24.8 x 28.7 cm.
72:0026:0001
Museum purchase
GEH NEG: 16971

BIB REF: Sobieszek, Robert A. "New Acquisitions: A Note on Early Photomontage Images." *Image.* 15(December, 1972): 19-22, ill.
EXH HIST: "Composite Imagery, 1850-1935: An Early History of Photomontage" IMP/GEH Oct. 27, 1978-Feb. 18, 1979.
INSCRIP: mat recto-(inscription in ink) title mat verso-(inscription in pencil) "34"
NOTES: Auction: Sotheby's, London, Belgravia Dec. 21, 1971, #274
Illustrated on p. 27.

Mary Mother
(1867)
albumen print
32.2 x 26.6 cm.
81:1124:0006
Museum purchase
GEH NEG: 7766
OTHER #: 6645-6

BIB REF: Cameron, Julia Margaret. *Victorian Photographs of Famous Men and Fair Women.* New York, 1926, plate 18. Paris. *Hommage de Julia Cameron à Victor Hugo.* Maison de Victor Hugo, l980, plate 7.
EXH HIST: "Mrs. Cameron's Photographs from the Life" Stanford University Museum of Art, Stanford, Jan. 22-March 10. 1974. Sybron Corporation, Rochester, March-April, 1977. Survey of the History of 19th Century Photography IMP/GEH Feb. 1985-
INSCRIP: mat recto-(signature and inscriptions in ink by artist) title "From Life Registered Photograph Copy right Julia Margaret Cameron" (inscription in pencil) "16" (Colnaghi blindstamp) mat verso-(inscription in pencil) "39"
NOTES: Provenance, Brussels Associates, New York City, 1961
Illustrated on p. 21.

La Madonna

(c. 1866-67)
albumen print
33.1 x 26.4 cm.
81:1121:0023
Gift of Eastman Kodak Company:
 ex-collection Gabriel Cromer
GEH NEG: 3624 14203 3602
OTHER #: EHPC 387-23

INSCRIP: mat recto-(signature and
inscriptions in ink by artist) title
"From Life Registered Photograph
Copy right Julia Margaret Cameron
Freshwater" (Colnaghi blindstamp)
mat verso-(blue stamp) "396"
(rubber stamp) "Eastman Historical
Photographic Collection"
Illustrated on p. 55.

The Vision

1867
albumen print
31.6 x 24.7 cm.
University Art Museum, The Univer-
sity of New Mexico, Albuquerque.

INSCRIP: mat recto-(signature and
inscriptions in ink by artist) title
"From Life Freshwater July 1867
Julia Margaret Cameron"
BIB REF:Ford,Colin. *The Cameron
Collection: An Album of Photo-
graphs by Julia Margaret Cameron
Presented to Sir John Herschel.*
Wokingham and New York, 1975,
plate 51. "A Study after the manner
of Francia."
Illustrated on p. 26.

Cherub and Seraph

(1865)
albumen print
22.8 x 28.6 cm. (oval)
81:1121:0016
Gift of Eastman Kodak Company:
 ex-collection Gabriel Cromer
GEH NEG: 15058 2837 3615
OTHER #: EHPC 387-16

BIB REF: Ford, Colin. *The Cameron
Collection: An Album of Photo-
graphs by Julia Margaret Cameron
Presented to Sir John Herschel.*
Wokingham and New York, 1975,
plate 41.
EXH HIST: "British Masters of the
Albumen Print 1860-1880" IMP/
GEH March 16-Aug. 20, 1973.
INSCRIP: mat recto-(signature and
inscriptions in ink by artist) title
"From Life Julia Margaret
Cameron" (inscription in pencil)
"1" (and symbol for shillings)
(Colnaghi blindstamp) mat verso-
(blue stamp) "378" (rubber stamp)
"Eastman Historical Photographic
Collection" "4369" (inscription in
ink) list of names
Illustrated on p. 21.

Love in Idleness

(c.1866)
albumen print
16.2 x 12.6 cm. (oval)
81:1121:0001
Gift of Eastman Kodak Company:
 ex-collection Garbriel Cromer
GEH NEG: 3611
OTHER #: EHPC 387-1

BIB REF: Gernsheim, Helmut. *Julia
Margaret Cameron: Her Life and
Photographic Work.* Millerton,
1975, p. 66.

INSCRIP: mat recto-(signature and
inscriptions in ink) title "From Life
Julia Margaret Cameron" (inscrip-
tion in pencil) "5" (and symbol for
shillings) (Colnaghi blindstamp)
mat verso-(blue stamp) "394"
Illustrated on. p. 19.

Love in Idleness

(c.1866)
albumen print
28.8 cm. (diameter)
81:1121:0017
Gift of Eastman Kodak Company:
 ex-collection Gabriel Cromer
GEH NEG: 3615 3588
OTHER #: EHPC 387-17

BIB REF: Gernsheim, Helmut. *Julia
Margaret Cameron: Her Life and
Photographic Work.* Millerton,
1975, p. 66.
INSCRIP: mat recto-(inscription in
pencil by artist) title "Study No. 1
of Love in Idleness" "For the
Signor/from JMC" (inscription in
pencil) "14/" (signature and inscrip-
tions in ink by artist) "From Life
Julia Margaret Cameron" (Colnaghi
blindstamp) mat verso-(blue stamp)
"398"
NOTES: Copyright registration May
8, 1866, "Portrait of Cupid sitting
with bow & arrow (large face) full
face."
Illustrated on p. 16.

Aspiration

(c.1866)
albumen print
29.0 cm. (diameter)
81:1121:0013
Gift of Eastman Kodak Company:
 ex-collection Gabriel Cromer
GEH NEG: 3612
OTHER #: EHPC 387-13

EXH HIST: Print possibly exhibited
in "291 Gallery-Prints and Photo-
graphs", San Francisco Museum of
Art, Aug. 4-Sept. 30, 1959.
INSCRIP: mat recto-(inscription in
pencil) title "1" (and symbol for
shillings) (signature and inscrip-
tions in ink) "From Life not
enlarged Julia Margaret Cameron"
"For the Signor/from JMC"
(Colnaghi blindstamp) mat verso-
(blue stamp) "399"
Illustrated on p. 63.

(The Beauty of Holiness)

(c.1866)
albumen print
19.3 cm. (diameter)
81:1121:0004
Gift of Eastman Kodak Company:
 ex-collection Gabriel Cromer
GEH NEG: 3599
OTHER #: EHPC 387-4

BIB REF: Paris. *Hommage de Julia
Margaret Cameron à Victor Hugo.*
Maison de Victor Hugo, 1980, plate
25.
EXH HIST: Print possibly exhibited
in "291 Gallery-Prints and Photo-
graphs", San Francisco Museum of
Art, Aug. 4-Sept. 30, 1959.
INSCRIP: mat recto-(signature and
inscriptions in ink by artist) "From
Life Julia Margaret Cameron"
(inscription in pencil) "5" (and
symbol for shillings) (Colnaghi
blindstamp) mat verso-(blue stamp)
"381"
Illustrated on p. 63.

Prayer

(1866 ?)
albumen print
34.7 x 27.8 cm.
81:1121:0009
Gift of Eastman Kodak Company:
 ex-collection Gabriel Cromer
GEH NEG: 3623 3592
OTHER #: EHPC 387-9

BIB REF; Ford, Colin. *The Cameron
Collection: An Album of Photo-
graphs by Julia Margaret Cameron
Presented to Sir John Herschel.*
Wokingham, and New York,1975,
plate 81.
EXH HIST: "British Masters of the
Albumen Print 1860-1880" IMP/
GEH March 16-Aug. 20. 1973; Print
possibly exhibited in "291 Gallery-
Prints and Photographs", San Fran-
cisco Museum of Art, Aug. 4-Sept.
30, 1959.
INSCRIP: mat recto-(inscription in
pencil by artist) title (inscription in
pencil) "1" (and symbol for shil-
lings) "No. 8 of this series" (signa-
ture and inscriptions in ink by
artist) "From Life not enlarged Julia
Margaret Cameron Freshwater Bay
Isle of Wight", (Colnaghi blind
stamp) mat verso-(blue stamp)
"384"
Illustrated on p. 55.

Cupid Considering

1872
albumen print
34.2 x 27.5 cm.
81:1121:0014
Gift of Eastman Kodak Company:
 ex-collection Gabriel Cromer
GEH NEG: 3614 14201 3618
OTHER #: EHPC 387-14

INSCRIP: mat recto-(inscription in
pencil by artist) title (signature and
inscriptions in ink by artist) "From
Life Registered Photograph Copy
right Julia Margaret Cameron Fresh-
water 1872" (Colnaghi blindstamp)
mat verso-(blind stamp) "397"
NOTES:Copyright registration
November 8, 1872, "A Photograph
study of Rachel Gurney with wings
both arms folded over each other
leaning on ledge." (?)
Illustrated on p. 73.

Thy will be done

1872
albumen print
32.5 x 29.0 cm.
81:1121:0015
Gift of Eastman Kodak Company:
 ex-collection Gabriel Cromer
GEH NEG: 3618 15058
OTHER #: EHPC 387-15

INSCRIP: mat recto-(inscription in
pencil by artist) title, (inscription in
pencil) "year 1872" "1" (and
symbol for shillings) "M. S. Warth"
"Laura Gurney" "from Mrs
FW . . .(illegible) (signature and
inscriptions in ink by artist) "From
Life Registered Photograph Copy
right Julia Margaret Cameron Fresh-
water Oct 1872" (Colnaghi blind-
stamp) mat verso-(blue stamp)
"377"
NOTES: Copyright citation of
November 8, 1872, "A Photograph
study of Watt Laura Gurney with
wings flying and hands clasped." (?)
Illustrated on p. 23.

The May Queen

(1864)
albumen print
25.3 x 20.3 cm.
81:1125:0002
Museum collection
GEH NEG: 3578 14177 14192
OTHER #: EHPC 352-2

BIB REF: Ford, Colin. *The Cameron
Collection: An Album of Photo-
graphs by Julia Margaret Cameron
Presented to Sir John Herschel.*
Wokingham and New York, 1975,
plate 28.
EXH HIST: "Early Photography",
Smith College, Northampton, Feb.
24-March 30, 1950.
INSCRIP: mat recto-(signature and
inscriptions in ink by artist) title
"From Life Julia Margaret
Cameron" (inscription in pencil)
"7/6" (inscription in blue pencil)
"16 x 20" (Colnaghi blindstamp)
mat verso-(blue stamp) "393"
NOTES: Provenance, Gerald Massay,
A.E. Marshall (1940) Copyright
registration Nov. 4, 1864, "Photo-
graph of May Queen Mary Ryan
and Caroline Hawkins one figure in
bed ¾ face the other profile."
Illustrated on p. 42.

The Three Marys

(1864)
albumen print
25.4 x 19.7 cm.
81:1121:0035
Gift of Eastman Kodak Company:
 ex-collection Gabriel Cromer
GEH NEG: 14168 3577 14173
OTHER #: EHPC 387-35

BIB REF: Overstone plate 104. From
album given to Lord Overstone by
Julia Margaret Cameron on August
5, 1865.
EXH HIST: "291 Gallery-Prints and
Photographs", San Francisco
Museum of Art, 1959; Sybron
Corporation, Rochester, 1978.
INSCRIP: mat recto-(inscription in
brown ink by artist) title (signature
in black ink) "Julia Margaret
Cameron" (inscription in ink) "For
the Signor" (Colnaghi blindstamp)
mat verso-(blue stamp) "387"
NOTES: Copyright registration Dec.
12, 1864, "A Photograph of the
Three Marys at the Sepulchre (illeg-
ible) one Mary in strict profile black
& white drapery one Mary on same
level 3rd face the 3rd one Mary
above the other two also ¾ face."
Cover illustration.

90

The five Wise Virgins
(1864)
albumen print
25.5 x 20.0 cm.
81:1121:0029
Gift of Eastman Kodak Company:
ex-collection Gabriel Cromer
GEH NEG: 3579 14175
OTHER #: EHPC 387-29

BIB REF: Overstone plate 39. From album given to Lord Overstone by Julia Margaret Cameron on August 5, 1865.
INSCRIP: mat recto-(signature and inscriptions in ink by artist) title "From Life Registered Photograph Julia Margaret Cameron" (inscription in pencil) "5" (and symbol for shillings) mat verso-(blue stamp) "391"
NOTES: Copyright registration Dec. 12, 1864, "A Photograph of the five Wise Virgins five maidens draped with lamps in their hands two in profile at each end of group one ¾ two full face."
Illustrated on p. 28.

Decidedly Pre-Raphaellete (sic)
(c. 1864-1865)
albumen print
28.9 x 24.0 cm.
81:1121:0033
Gift of Eastman Kodak Company:
ex-collection Gabriel Cromer
GEH NEG: 14172 3616 3581
OTHER #: EHPC 387-33

INSCRIP: mat recto-(inscription in ink by artist) title mat verso-(blue stamp) "390" (inscription in pencil) "not in Gernsheim"
Illustrated on p. 45.

Queen Philippa Interceding for the Burghers of Calais
(c. 1865)
albumen print
28.0 x 22.9
Yale University Art Gallery; Director's Discretionary Fund

INSCRIP: mat recto-(inscription in ink) title mat verso-(inscription in ink) "The Burghers of Calais; 'The King' Ewen Cameron; 'The Queen' Miss Louisa French; by Mrs. Julia Margaret Cameron of Freshwater Isle of Wight; Photograph a gift from Miss Corisande Bridges, Daughter of 'The Queen'; Ewen Cameron son of Mrs. Cameron; The Author of this work; 1860"
Illustrated on p. 45.

(Prospero and Miranda)
(Undated reproduction of 1865 subject)
carbon print
28.2 x 22.6 cm.
Collection of the Royal Photographic Society of Great Britain

INSCRIP: mat recto-(inscription in pencil) Julia Margaret Cameron
BIB REF: Gernsheim, Helmut. *Julia Margaret Cameron: Her Life and Photographic Work*. Millerton, 1975, p.31.
NOTES: Copyright registration of November 11, 1865, "a Photograph Mary Ryan and Henry Taylor called Prospero and Miranda."
Illustrated on p. 64.

Sappho
(c. 1866)
albumen print
34.8 x 27.2 cm.
81:1121:0026
Gift of Eastman Kodak Company:
ex-collection Gabriel Cromer
GEH NEG: 15056 7765 3595
OTHER #: EHPC 387-26

BIB REF: Cameron, Julia Margaret. *Victorian Photographs of Famous Men and Fair Women*. New York, 1926, plate 20. Overstone plate 4. From album given to Lord Overstone by Julia Margaret Cameron on August 5, 1865. (related work)
EXH HIST: "British Masters of the Albumen Print 1860-1880" IMP/GEH March 16-Aug. 20, 1973.
INSCRIP: mat recto-(signature and inscription in ink by artist) title, "From Life not enlarged Julia Margaret Cameron" "A gem for the Signor, from JMC" (inscription in pencil) "14" (and symbol for shillings) (Colnaghi blindstamp) mat verso-(blue stamp) "372" (inscription in pencil) "#"
NOTES: Copyright registration May 3, 1865, "Photograph of Mary Hillier as "Sappho" ¾ face & figure also ¾ in embroidered jacket ornament of drops around throat hand over lyre." (related work)
Illustrated on p. 28.

The Mountain Nymph Sweet Liberty
(1866)
albumen print
35.9 x 25.7 cm.
81:1127:0001
Museum collection
GEH NEG: 35786

BIB REF: Ford, Colin. *The Cameron Collection: An Album of Photographs by Julia Margaret Cameron Presented to Sir John Herschel*. Wokingham and New York, 1975, plate 82. Gernsheim, Helmut. *Julia Margaret Cameron: Her Life and Photographic Work*. Millerton, 1975, p. 157.
EXH HIST: "Camera Consciousness" IMP/GEH Sept. 1954-March 1957, Circulated by American Federation of Arts. "The Art of Photography" IMP/GEH May 22, 1961-(?).
INSCRIP: mat recto-(signature and inscriptions in ink by artist) title "From Life Julia Margaret Cameron" (inscription in pencil) "1" (and symbol for shillings) "31" "No. 1 of this subject" (Colnaghi blindstamp) mat verso-(blue stamp) "379" (inscription in pencil) "5007" "C"
Illustrated on p. 39.

Beatrice
(1866)
albumen print
35.7 x 27.5 cm.
81:1124:0008
Museum purchase
GEH NEG: 5881
OTHER #: 6645-8

BIB REF: Ford, Colin. *The Cameron Collection: An Album of Photographs by Julia Margaret Cameron Presented to Sir John Herschel*. Wokingham and New York, 1975, plate 83. Paris. *Hommage de Julia Cameron à Victor Hugo*. Maison de Victor Hugo, l980, plate 5. Gernsheim, Helmut. *Julia Margaret Cameron: Her Life and Photographic Work*. Millerton, 1975, p. 129.
EXH HIST: "The Art of Photography" IMP/GEH May 22, 1961-(?). "Mrs Cameron's Photographs from the Life", Stanford University Museum of Art, Stanford, Jan. 22-March 10, 1974.
INSCRIP: mat recto-(inscription in pencil by artist) title (inscription in pencil) "#5", (signature and inscriptions in ink by artist) "from Life not enlarged Registered Photograph Copyright Julia Margaret Cameron" (Colnaghi blind stamp)
NOTES: Provenance, Brussels Associates, New York City, 1961
Illustrated on p. 21.

(Light study)
1866
albumen print
36.6 x 27.8 cm.
81:1121:0019
Gift of Eastman Kodak Company:
ex-collection Gabriel Cromer
GEH NEG: 3619
OTHER #: EHPC 387-19
 EHC 382

INSCRIP: mat recto-(signature and inscriptions in ink by artist) "From Life not enlarged Julia Margaret Cameron" "Taken after sunset May 17, 1866" (Colnaghi blindstamp) mat verso-(blue stamp) "382" (handwritten in pencil) "20 x 24 French gray liner Cover Line Bronze Bevel"
Illustrated on p. 54.

(Light study)
(1866)
albumen print
34.0 x 28.1 cm. (arched)
81:1121:0039
Gift of Eastman Kodak Company:
ex-collection Gabriel Cromer
GEH NEG: 2804 3589
OTHER #: EHPC 387-39

EXH HIST: "The Roots of Photography", Museum of Modern Art, April 27-July 24, 1949. "Light in Art", Fogg Art Museum, Cambridge, May 10-May 29, 1954. Print possibly exhibited in "291 Gallery-Prints and Photographs", San Francisco Museum of Art, Aug. 4-Sept. 30, 1959. British Masters of the Albumen Print 1860-1880" IMP/GEH March 16-Aug. 20, 1973. Survey of the History of 19th Century Photography IMP/GEH Exhibition, 1974, 1975, 1978-1980.
INSCRIP: mat recto-(signature and inscriptions in ink by artist) "From Life Julia Margaret Cameron" "For the Signor from JMC taken after sunset 7 pm May 17" (Colnaghi blindstamp) mat verso-(blue stamp) "373" (rubber stamp) "Eastman Historical Photographic Collection"
Illustrated on p. 54.

Browning's Sordello
(1867)
albumen print
29.1 x 23.4 cm.
81:1121:0011
Gift of Eastman Kodak Company:
ex-collection Gabriel Cromer
GEII NEG: 3597 15057 3593
OTHER #: EHPC 387-11

BIB REF: Ford, Colin. *The Cameron Collection: An Album of Photographs by Julia Margaret Cameron Presented to Sir John Herschel*. Wokingham and New York, 1975, plate 80.
INSCRIP: mat recto-(signature and inscriptions in ink by artist) title "From Life Julia Margaret Cameron" "For Signor" (inscription in brown ink by artist, notations partially effaced) "Sate at her knees the very maid (effaced) Of the North chamber-her red lips as rich The same pure fleecy hair; one weft of which golden and great quite touched his cheek as o'er She leant speaking some six words and no more He answered something, any thing and she Unbound a scarf and laid it he (effaced) Upon him, Her necks warmth and all" (Colnaghi blindstamp) mat verso-(blue stamp) "225" (rubber stamp) "Eastman Historical Photographic Collection"
Illustrated on p. 52.

Rosalba
(1867)
albumen print
35.4 x 27.9 cm.
81:1121:0025
Gift of Eastman Kodak Company:
ex-collection Gabriel Cromer
GEH NEG: 3608 15056
OTHER #: EHPC 387-25

BIB REF: Gernsheim, Helmut. *Julia Margaret Cameron: Her Life and Photographic Work*. Millerton, 1975, p. 109.
EXH HIST: "Mrs. Cameron's Photographs from the Life" Stanford University Museum of Art, Stanford, Jan. 22-March 10. 1974.
INSCRIP: mat recto-(signature and inscriptions in ink by artist) title "From Life Julia Margaret Cameron" (inscription in pencil) "7" (and symbol for shillings) (Colnaghi blindstamp) mat verso-(blue stamp) "371"
Illustrated on p. 53.

Ophelia Study No. 2
(1867)
albumen print
33.0 x 27.1 cm.
81:1121:0012
Gift of Eastman Kodak Company:
ex-collection Gabriel Cromer
GEH NEG: 7768 14192 3612
OTHER #: EHPC 387-12

BIB REF: Gernsheim, Helmut. *Julia Margaret Cameron: Her Life and Photographic Work*. Millerton, 1975, p. 105 (variant).
INSCRIP: mat recto-(signature and inscriptions in ink by artist) title "From Life Julia Margaret Cameron" (inscription in pencil) "1" (and symbol for shillings) (Colnagh blindstamp) mat verso-(blue stamp) "389" (inscription in pencil) "38"

NOTES: Copyright registration July 4, 1867, "Photograph of Mary (sic) Peacock as "Ophelia (underlined)" (?).
Illustrated on p. 53.

(Gypsy Children)
(c. 1867)
albumen print
24.1 x 20.3 cm
University of Nebraska Art Galleries, Sheldon Memorial Art Gallery, Gift of Robert Schoelkopf

INSCRIP: (Colnaghi blindstamp)
Illustrated on p. 16.

(The Minstrel Group) Study No. 2
(1867)
albumen print
35.1 x 28.1 cm. (trimmed at left)
71:0159:0001
Museum purchase
GEH NEG: 35788

BIB REF: Ford, Colin. *The Cameron Collection: An Album of Photographs by Julia Margaret Cameron Presented to Sir John Herschel.* Wokingham and New York, 1975, plate 86.
EXH HIST: "British Masters of the Albumen Print 1860-1880" IMP/GEH March 16-Aug. 20, 1973.
INSCRIP: mat recto-(signature and inscriptions in ink by artist) "From Life Study No. 2 Julia Margaret Cameron" (portion of other inscription trimmed away) mat verso-(inscription in pencil) "33"
NOTES: Provenance, Motley Books, London, 1971. Copyright registration May 25, 1867, "Photograph. Three female minstrels Numbers 1-4."
Illustrated on p. 24.

Dejátch Alámáyou and Báshá Félika King Theodore's son and Captain Speedy
1868
albumen print
35.0 x 27.6 cm.
National Gallery of Canada, Ottawa

INSCRIP: mat recto-(signature and inscriptions in ink by artist) title "From life registered photograph taken at Freshwater 20 July 1868 Julia Margaret Cameron" "For the window immediately orders will be taken study no.2"
NOTES: Copyright registration of July 23, 1868," Photograph Portrait of Dejátch Alámáyou full face and Báshá Félika ¾ face King Theodore's Son and Captain Speedy."
Illustrated on p. 52.

(Woman, full face)
(c.1866-67)
albumen print
carte-de-visite
81:1128:0001
Gift of Alden Scott Boyer
GEH NEG: 7740 35794
OTHER #: 13458-2

INSCRIP: mat verso-(inscription in pencil by Alden Scott Boyer) "original photograph by Julia Margaret Cameron Florence Nightengale From Dr. Weil London 1947, Excessively Rare & Valuable, These small cards-unknown Boyer"
NOTES: Provenance, Dr. Weil, London, 1947
Illustrated on p. 39.

(Standing woman)
(1867)
albumen print
carte-de-visite
81:1128:0002
Gift of Alden Scott Boyer
GEH NEG: 7741 35794 35793
OTHER #: 13458-3

INSCRIP: mat verso-(inscription in pencil by Alden Scott Boyer) "by Julia Margaret Cameron, original photograph of Florence Nightengale, Rare & Valuable-from Dr. Weil London 11/1947, these small cards unknown (underlined)"
NOTES: Provenance, Dr. Weil, London, 1947
Illustrated on p. 52.

(Floss and Iolande)
(1865)
albumen print
carte-de-visite
81:1128:0003
Gift of Alden Scott Boyer
GEH NEG: 7742 35793 35054
OTHER #: 13458-4

BIB REF: Overstone plate 36. From album given to Lord Overstone by Julia Margaret Cameron on August 5, 1865.
EXH HIST: Survey of the History of 19th Century Photography IMP/GEH March 1985.
INSCRIP: mat recto-(signature and inscriptions in red ink by artist) "From Life Copyright Julia Margaret Cameron" mat verso-(inscription in pencil by Alden Scott Boyer) "assigned title" "Florence Nig Rare & Valuable from Dr. E. Weil, London (underlined) Boyer 11/1947 Weil sold Herschel's Photo in this size, @ $40-I ordered & did not get"
NOTES: Provenance, Dr. Weil, London, 1947.
Illustrated on p. 23.

A Flower of Paradise
(1867)
albumen print
25.6 x 17.8 cm.
81:1125:0003
Museum collection
GEH NEG: 3601
OTHER #: EHPC 352-3

EXH HIST: "Early Photography", Smith College, Northampton, Feb. 24-March 30, 1950.
INSCRIP: mat recto-(erased inscription by artist) title, (signature and incription in ink by artist) "From Life Julia Margaret Cameron" (inscription in pencil) "8" (and symbol for shillings) (Colnaghi blindstamp) "388"
NOTES: Provenance, Gerald Massay, A.E. Marshall (1940)
Illustrated on p. 22.

Madame Reiné (see Village on the Cliffs)
1869
albumen print
33.0 x 26.9 cm
Collection of the Royal Photographic Society of Great Britain, Presented by Frederick Hollyer, 1931.

INSCRIP: mat recto-(signature and inscriptions in ink by artist) title "From life registered photograph copyright Julia Margaret Cameron, Freshwater, July, 1869" (signature and inscriptions in pencil) "I like that very much—G.F. Watts"
NOTES: No photograph of this description registered for copyright in 1869.
Illustrated on p. 20.

Days at Freshwater
1870
albumen print
34.5 x 27.6 cm
Cincinnati Art Museum, The Alfred P. Strietmann Collection

INSCRIP: mat recto-(signature and inscriptions in ink by artist) title "From Life Registered Photograph copyright Julia Margaret Cameron Freshwater August 1870" "given to Mrs. Mayor by Mrs. Cameron" (Colnaghi blindstamp)
NOTES: No photograph of this description registered for copyright in 1870.
Illustrated on p. 70.

The Irish Immigrant
1870
albumen print
32.2 x 26.2 cm
Collection of the Royal Photographic Society of Great Britain

INSCRIP: mat recto-(signature and inscriptions in ink by artist) title "From Life registered photograph copyright Julia Margaret Cameron 1870"
NOTES: No photograph of this description registered for copyright in 1870.
Illustrated on p. 71.

The Angel at the Tomb
1870
albumen print
34.8 x 26.3 cm. (arched)
81:1124:0009
Museum purchase
GEH NEG: 5883
OTHER #: 6645-9

BIB REF: Paris. *Hommage de Julia Margaret Cameron à Victor Hugo.* Maison de Victor Hugo, 1980, plate 11.
EXH HIST: "The Art of Photography" IMP/GEH May 22, 1961-(?).
INSCRIP: mat recto-(signature and inscriptions in ink by artist) title "From Life Registered Photograph Copy right Julia Margaret Cameron Fresh Water 1870" "God's glory smote her on the face" "For Mr Warde sent by his friend's mother with her love" "(a corruscation of spiritual unearthly light is playing over the head in mystic lightning flash of glory)" (inscription in pencil) "8" mat verso-(inscription in pencil) "Cameron"

NOTES: Provenance, Brussels Associates, New York City, 1961 Copyright registration April 6, 1870, "Photograph. "The Angel at the Tomb." (underlined)
Illustrated on p. 71.

May
1870
albumen print
34.0 x 27.5 cm.
Lent by The Metropolitan Museum of Art, The Elisha Whittelsey Collection, The Elisha Whittelsey Fund, 1969.

INSCRIP: mat recto-(signature and inscriptions in ink by artist) title "From Life Registered Photograph Copyright Julia Margaret Cameron Freshwater Oct 1870" (Colnaghi blindstamp)
NOTES: Copyright registration of October 11, 1870, "Photograph No. 1 Portrait of Miss May Prinsep, sitting in act of sealing letter." (? one of series of eight studies of Prinsep entered on this date)
Illustrated on p. 68.

Gretchen at the Altar
(Undated reproduction of c. 1872 subject)
carbon print
33.9 xx 25.1 cm
Courtesy, Museum of Fine Arts,Boston, Gift of Mrs. J.D.Cameron Bradley

INSCRIP: mat recto-(inscriptions in pencil) title "Julia Margaret Cameron"
Illustrated on p. 23.

Study of a St. John the Baptist
1872
albumen print
35.3 x 26.3 cm.
81:1121:0005
Gift of Eastman Kodak Company: ex-collection Gabriel Cromer
GEH NEG: 3590 3593 3622
OTHER #: EHPC 387-5

BIB REF: Cameron, Julia Margaret. *Victorian Photographs of Famous Men and Fair Women.* New York, 1926, plate 23. Gernsheim, Helmut. *Julia Margaret Cameron: Her Life and Photographic Work.* Millerton, 1975, p. 162.
EXH HIST: "Pageant of Photography from 1839 to the Present" New York State Exposition, Syracuse, Fall 1962.
INSCRIP: mat recto-(signature and inscriptions in ink by artist) title "From Life Registered Photograph Copy right Julia Margaret Cameron Saxonbury Sept 1872" (inscription in pencil) "From Mrs F.W. Rawsshey (sic) Florence Fisher" (Colnaghi blindstamp) mat verso-(blue stamp) "376", (inscription in pencil) "20 x 24 French gray Cover Line Bronze Bevel"
NOTES: No photograph of this description registered for copyright in l872
Illustrated on p. 69.

Sun lit memories
1873
albumen print
33.5 x 28.0 cm.
Collection of the Royal Photographic
Society of Great Britain.

INSCRIP: mat recto-(signature and
inscriptions in ink by artist) title
"From Life. Registered photograph
copyright Julia Margaret Cameron,
Freshwater, July 1873" (Colnaghi
blindstamp)
NOTES: No photograph of this
description registered in 1873.
Illustrated on p. 68.

**Queen Henrietta Maria
announcing to her Children the
coming fate of their Father King
Charles the First**
1874
albumen print
36.2 x 23.5 cm
Paul Walter Collection

BIB REF:Paris. *Hommage de Julia
Margaret Cameron à Victor Hugo.*
Maison de Victor Hugo, 1980, p.24.
INSCRIP: mat recto-(signature and
inscriptions in ink by artist) title
"From life registered photograph
Julia Margaret Cameron Fresh
Water June 1874" (Colnaghi blind-
stamp)
NOTES: Copyright registration of
June 6, 1874, "A Photograph of
Isabel Bateman as Henrietta Maria
in Charles I standing with a child
on each side of her The child being
Rachel Gurney & Daisy Taylor.
This illustrates Miss Isabel Bateman
in her character of Henrietta Maria
in Charles I."
Illustrated on p. 22.

Acting the Lily Maid of Astolat
1874
albumen print
32.9 x 25.7 cm
National Gallery of Canada, Ottawa

INSCRIP: mat recto-(signature and
inscriptions in ink by artist) title
"From Life Registered photograph
copyright Julia Margaret Cameron
Oct, 1874" "For the beloved
Mother"
NOTES: No photograph of this
description registered for copy-
right in 1874.
Illustrated on p. 74.

The May Queen
(Undated reproduction of 1875
subject)
carbon print
33.3 x 25.0 cm.
Courtesy,Museum of Fine
Arts,Boston, Gift of Mrs.
J.D.Cameron Bradley

BIB REF: Gernsheim, Helmut. *Julia
Margaret Cameron: Her Life and
Photographic Work.* Millerton,
l975, p. 95.
INSCRIP: mat recto-(inscriptions in
pencil) title "Julia Margaret
Cameron"
NOTES: Copyright registration of
May 1, 1875, "A Photograph of the
Queen of the May Study from Miss
Emily Peacock in broad brimmed
hat with flowing hair full face head
slightly thrown back & smile over
face white dress one hand holding
her wreath of May flowers."
Illustrated on p. 69.

**(Ceylonese woman, standing,
with hand on hip)**
(December 1875-January 1879)
albumen print
27.2 x 19.9 cm.
71:0163:0001
Museum purchase
GEH NEG: 16972

BIB REF: Czach, Marie. "Some
Thoughts on Cameron's Ceylon
Photographs." *Afterimage.* 1
(September, 1973): 2-3.
INSCRIP: (inscribed in negative)
incomplete calligraphic notations
NOTES: Provenance, D'Offray Coupe
Gallery
Illustrated on p. 75.

(Three Ceylonese women)
(December 1875-January 1879)
albumen print
26.0 x 21.3 cm
Paul Walter Collection

BIB REF: Czach, Marie. "Some
Thoughts on Cameron's Ceylon
Photographs." *Afterimage.* 1
(September, 1973):2-3.
Illustrated on p. 75.

Portraits

A. Tennyson
(1865)
albumen print
25.3 x 20.1 cm.
71:0011:0001
Museum purchase
GEH NEG: 14960

BIB REF: Cameron, Julia Margaret.
*Victorian Photographs of Famous
Men and Fair Women* New York,
1926, plate 4. Ford, Colin. *The
Cameron Collection: An Album of
Photographs by Julia Margaret
Cameron Presented to Sir John
Herschel.* Wokingham and New
York, 1975, plate 73. Overstone
plate 1. From album given to Lord
Overstone by Julia Margaret
Cameron on August 5, 1865.
Gernsheim, Helmut. *Julia
Margaret Cameron: Her Life and
Photographic Work.* Millerton,
1975, p. 30.
EXH HIST: Survey of the History of
19th Century Photography, IMP/
GEH March 1985-
INSCRIP: mat recto-(lithographed
signature by Alfred Tennyson) "A.
Tennyson" (signature and inscrip-
tions in ink by artist) "From Life
Julia Margaret Cameron" (Colnaghi
blindstamp)
NOTES: Provenance, Emily Driscoll
Copyright registration May 3, 1865,
"Photograph of Alfred Tennyson
nearly profile portion of second
eyelid and eyebrow showing throat
bare holding a folio book with
hand over one side draped in
cloak."
Illustrated on p. 48.

A. Tennyson
(c.1865-66)
albumen print
27.9 x 22.3 cm.
81:1125:0001
Museum collection
GEH NEG: 3585
OTHER #: EHPC 352-1 43698-A

EXH HIST: Exhibited, "Early Photog-
raphy", Smith College, North-
ampton, Feb. 4-March 30, 1950.
Exhibited, "The Art of Photog-
raphy", IMP/GEH, May 22,
1961-(?).

INSCRIP: mat recto-(lithographed
signature) "A. Tennyson", (signa-
ture and inscriptions in ink by
artist) "Registered Photograph Julia
Margaret Cameron" "For the
Signor" mat verso-(blue stamp)
"361", (rubber stamp) "Eastman
Historical Photographic
Collection", "43698A"
NOTES: Provenance, Gerald Massay,
A.E. Marshall (1940) Eight portraits
of Tennyson registered for copy-
right on July 9, 1866 4 described as
with cape; also see the copyright
registration of August 4, 1865, "A
Photograph of Alfred Tennyson ¾
face cap on head throat base
draped in drapery over chest &
shoulders eyes looking straight."
Illustrated on p. 38.

A. Tennyson
(1867)
albumen print
29.4 x 24.9 cm.
81:1129:0005
Gift of Alden Scott Boyer
GEH NEG: 18383
OTHER #: 13807-5 359

BIB REF: Ford, Colin. *The Cameron
Collection: An Album of Photo-
graphs by Julia Margaret Cameron
Presented to Sir John Herschel.*
Wokingham and New York, plate
76. Paris. *Hommage de Julia
Margaret Cameron à Victor Hugo.*
Maison de Victor Hugo, 1980, plate
2. Gernsheim, Helmut. *Julia
Margaret Cameron: Her Life and
Photographic Work.* Millerton,
1975, p. 93.
EXH HIST: "The Roots of Photog-
raphy", Museum of Modern Art,
New York City, April 27-July 24,
1949. "Mrs. Cameron's Photo-
graphs from the Life" Stanford
University Museum of Art, Stan-
ford, Jan. 22-March 10, 1974.
INSCRIP: mat recto-(signature in ink)
"A. Tennyson" (signature and
inscription in ink by artist) "From
Life Registered Photograph Copy-
right Julia Margaret Cameron"
(Colnaghi blindstamp) mat verso-
(rubber stamp) "Gernsheim
Collection" (inscription in pencil)
"Copy"
NOTES: Provenance, Helmut
Gernsheim
Illustrated on p. 48.

**Mrs. Herbert Duckworth as Julia
Jackson**
(1867)
albumen print
34.0 x 24.4 cm.
81:1129:0003
Gift of Alden Scott Boyer
GEH NEG: 3563
OTHER #: 13807-3 65914

BIB REF: Cameron, Julia Margaret.
*Victorian Photographs of Famous
Men and Fair Women.* New York,
plate 16. Ford, Colin. *The Cameron
Collection: An Album of Photo-
graphs by Julia Margaret Cameron
Presented to Sir John Herschel.*
Wokingham and New York, 1975,
plate 79. Paris. *Hommage de Julia
Margaret Cameron à Victor Hugo.*
La Maison de Victor Hugo, 1980,
plate 3. Gernsheim, Helmut. *Julia
Margaret Cameron: Her Life and
Photographic Work.* Millerton,
1975, p. 149.

EXH HIST: "The Art of Photography" IMP/GEH May 22, 1961-(?). "Glamour Portraits" Museum of Modern Art New York City, Aug. 2-Sept. 19, 1965. "Mrs. Cameron's Photographs from the Life", Stanford University Museum of Art, Stanford, Jan. 22-March 10, 1974.

INSCRIP: mat recto-(signature and inscriptions in ink by artist) title "From Life Registered Photograph Copy right Julia Margaret Cameron Freshwater" (Colnaghi blindstamp) mat verso-(rubber stamp) "Gernsheim Collection" (inscription in pencil) "40"

NOTES: Copyright registration April 13, 1867, "Photograph. Portrait of Miss Julia Jackson profile with light on the nose."

Illustrated on p. 49.

(La Santa Julia) (Julia Jackson Duckworth Stephen)
(1867)
albumen print
28.3 x 22.7 cm.
Center for Creative Photography

BIB REF: Ford, Colin. *The Cameron Collection: An Album of Photographs by Julia Margaret Cameron Presented to Sir John Herschel.* Wokingham and New York, 1975, plate 67.

Illustrated on p. 49.

Henry Taylor
(1864)
albumen print
25.3 x 20.1 cm.
81:1122:0004
Museum purchase
GEH NEG: 7750
OTHER #: 8380

INSCRIP: mat recto-(signature in ink by Henry Taylor) "Henry Taylor" (signature and inscriptions in ink by artist) "From Life Julia Margaret Cameron" (inscription in pencil) "9 ⅛ x 12" "110/73" (Colnaghi blind stamp) mat verso-(inscription in pencil) "1 of 649", "56"

NOTES: Provenance, Mrs. Byron Dexter

Illustrated on p. 42.

Henry Taylor
(1865)
albumen print
25.3 x 20.1 cm.
81:1119:0001
Gift of Eastman Kodak Company: ex-collection Gabriel Cromer
GEH NEG: 7761
OTHER #: 1996

BIB REF:Paris. *Hommage de Julia Margaret Cameron à Victor Hugo.* Maison de Victor Hugo, 1980, plate 1. Overstone plate 4. From album given to Lord Overstone by Julia Margaret Cameron on August 5, 1865. Gernsheim, Helmut. *Julia Margaret Cameron: Her Life and Photographic Work.* Millerton, 1975, p. 131 (variant).

EXH HIST: "The Roots of Photography" Museum of Modern Art, New York City, April 27-July 24, 1949. "Julia Margaret Cameron", San Francisco Museum of Art, Aug. 18-Oct. 9, 1949. "British Masters of the Albumen Print 1860-1880" IMP/GEH March 16-Aug. 20, 1973.

INSCRIP: mat recto-(signature in ink) "Henry Taylor" (signature and inscriptions in ink by artist) "From Life Julia Margaret Cameron" (inscription in pencil) "229"

Illustrated on p. 24.

Henry Taylor DCL
1867
albumen print
35.7 x 28.0 cm.
81:1121:0022
Gift of Eastman Kodak Company: ex-collection Gabriel Cromer
GEH NEG: 3591 3624
OTHER #: EHPC 387-22

INSCRIP: mat recto-(inscription in pencil) title (signature and inscriptions in ink by artist) "From Life Freshwater October 1867 Julia Margaret Cameron" (inscription in pencil) "one pound" (Colnaghi blindstamp) mat verso-(blue stamp) "400"

NOTES: Copyright registration October 16, 1867, "Portrait of Henry Taylor life size (underlined) Nos. 1-6 large head."

Illustrated on p. 62.

Henry Taylor
1867
albumen print
35.0 x 27.2 cm.
81:1124:0010
Museum purchase
GEH NEG: 5882
OTHER #: 6645-10

BIB REF: Gernsheim, Helmut. *Julia Margaret Cameron: Her Life and Photographic Work.* Millerton, 1975, p. 103.

EXH HIST: "The Art of Photography" IMP/GEH May 22, 1961-(?). Sybron Corporation, Rochester, March-April, 1977.

INSCRIP: mat recto-(lithographed signature) "Henry Taylor", (signature and inscriptions in ink by artist) "From Life Registered photograph Copy right Julia Margaret Cameron Fresh Water 1867" (inscription in pencil) "11" (Colnaghi blindstamp) mat verso-(inscription in pencil) "Cameron"

NOTES: Provenance, Brussels Associates, New York City, 1961 Copyright registration October 16, 1867, "Portrait of Henry Taylor life size No. 1-6. large head."

Illustrated on p. 62.

G.F. Watts R.A.
(1864)
albumen print
22.0 cm. (diameter)
81:1124:0005
Museum purchase
GEH NEG: 7764
OTHER #: 6645-5

BIB REF: Cameron, Julia Margaret. *Victorian Photographs of Famous Men and Fair Women.* New York, 1926, plate 6. Ford, Colin. *The Cameron Collection: An Album of Photographs by Julia Margaret Cameron Presented to Sir John Herschel.* Wokingham and New York, 1975, plate 9. Overstone plate 56. From album given to Lord Overstone by Julia Margaret Cameron on August 5, 1865. Gernsheim, Helmut. *Julia Margaret Cameron: Her Life and Photographic Work.* Millerton, 1975, p. 101.

INSCRIP: mat recto-(signature in ink) "G.F. Watts" (signature and inscriptions in ink by artist) "From Life Julia Margaret Cameron" (inscription in pencil) "13"

NOTES: Provenance, Brussels Associates, New York City, 1961

Illustrated on p. 19.

W.M. Rossetti
(1865)
albumen print
25.2 x 20.0 cm.
81:1121:0031
Gift of Eastman Kodak Company: ex-collection Gabriel Cromer
GEH NEG: 3610 35787
OTHER #: EHPC 387-31

BIB REF: "Pictures from the Collection." *Image.* 5 (June 1956): 139. Overstone plate 93. From album given to Lord Overstone by Julia Margaret Cameron on August 5, 1865.

EXH HIST: Print possibly exhibited in "Early Photography", Smith College, Northampton, Feb. 24-March 30, 1950. "Landmarks of 19th Photography from the George Eastman House" (?)-Sept. 1954. Circulated by American Federation of Arts.

INSCRIP: mat recto-(inscription in ink) title (signature and inscriptions in ink by artist) "From Life Julia Margaret Cameron" (inscription in pencil) "228" (Colnaghi blindstamp)

NOTES: Copyright registration July 18, 1865, "Photograph of Wm. Rossetti No. 2 cap on head light shining on outline of face & one eye face ¾ hand partly seen figure draped." (?) Copyright registration July 18, 1865, "Photograph of Wm. Rossetti with cap ¾ face eyes looking out light behind drapery thrown over one shoulder." (?)

Illustrated on p. 43.

(Lord Overstone)
(Undated reproduction of 1865? subject)
carbon print
22.0 x 22.6 cm.
Collection of the Royal Photographic Society of Great Britain, Gift of Alvin Langdon Coburn, 1930.

INSCRIP: (embossed stamp) "Autotype"

BIB REF: Gernsheim, Helmut. *Julia Margaret Cameron: Her Life and Photographic Work.* Millerton, 1975, p.91.

NOTES: Copyright registration July 18, 1865, "a Photograph of Lord Overstone nearly full face one hand resting on stick one finger of hand extended."

Illustrated on p. 25.

The Astronomer (Sir John Herschel)
(1867)
albumen print
30.2 x 23.2 cm.
Collection of the Royal Photographic Society of Great Britain.

INSCRIP: mat recto-(signature and inscriptions in ink by artist) title "From Life Julia Margaret Cameron"

NOTES: See copyright registrations for **Sir J. F. W. Herschel (Bart)** (Turn of the Century Transformations)

Illustrated on p. 51.

(Sir John Herschel)
(c. 1875 reproduction of 1867 subject) collotype print (?)
30.0 x 23.2 cm
National Gallery of Canada, Ottawa

INSCRIP: mat recto-(signature and inscriptions in ink by artist) "From Life Registered photograph copyright Julia Margaret Cameron Imperishable Carbon printing" (embossed stamp) "H. Obernetter"

BIB REF: Gernsheim, Helmut. *Julia Margaret Cameron: Her Life and Photographic Work.* Millerton, 1975, p.121.

NOTES: See copyright registrations for **Sir J. F. W. Herschel (Bart)** (Turn of the Century Transformations)

Illustrated on p. 51.

E. Eyre
(1867)
albumen print
32.6 x 25.7 cm.
81:1129:0002
Gift of Alden Scott Boyer
GEH NEG: 3584
OTHER #: 13807-2

BIB REF: Gernsheim, Helmut. *Julia Margaret Cameron: Her Life and Photographic Work.* Millerton, 1975, p. 97.

INSCRIP: mat recto-(signature in ink) "E Eyre" (signature and inscriptions in ink by artist) "From Life Julia Margaret Cameron" (Colnaghi blindstamp) mat verso-(rubber stamp) "Gernsheim Collection" (inscription in pencil by artist) "Copy"

NOTES: Copyright registration June 8, 1867, "Photograph. Portrait of Governor Eyre No. 1-3."

Illustrated on p. 50.

W. G. Palgrave
(1868)
albumen print
34.0 x 25.9 cm.
81:1129:0006
Gift of Alden Scott Boyer
GEH NEG: 3583
OTHER #: 13807-6

BIB REF: Gernsheim, Helmut. *Julia Margaret Cameron: Her Life and Photographic Work.* Millerton, 1975, p. 119 (variant).

EXH HIST: "Mrs. Cameron's Photographs from the Life", Stanford University Museum of Art, Stanford, Jan. 22-March 10, 1974.
INSCRIP: mat recto-(inscription in pencil) title (signature and inscriptions in ink by artist) "From Life Freshwater Photograph Copyright Julia Margaret Cameron" (Colnaghi blindstamp) mat verso-(rubber stamp) "Gernsheim Coll" (inscription in pencil) "phot. in 1868"
NOTES: Provenance, Helmut Gernsheim. Copyright registration June 17, 1868, "Photograph Portrait of W. Gifford Palgrave Bust ¾ face with turban No. 1."
Illustrated on p. 60.

Herr Joachim
1868
albumen print
31.6 x 24.3 cm.
81:1122:0002
Museum purchase
GEH NEG: 15025
OTHER #: 8380

BIB REF: Gernsheim, Helmut. *Julia Margaret Cameron: Her Life and Photographic Work*. Millerton, 1975, p. 122.
INSCRIP: mat recto-(inscribed in pencil by artist) title (inscribed in pencil) "11 ½ x 14 1/1", (signature and inscriptions in ink by artist) "From Life Registered Photograph Copy right 1868 Julia Margaret Cameron"
NOTES: Provenance, Mrs. Byron Dexter. Copyright registration April 13, 1868, "Photograph Portrait of Mr. Joachim with violin nearly profile ½ length."
Illustrated on p. 25.

(Portrait of a man in a deer-stalker cap)
1869
albumen print
34.2 x 26.7 cm.
Collection of the Royal Photographic Society of Great Britain, Gift of Alvin Langdon Coburn, 1930.
INSCRIP: mat recto-(signature and inscriptions in ink by artist) "From Life registered photograph copy-right April 1869 Julia Margaret Cameron Freshwater" (Colnaghi blindstamp)
NOTES: No photograph of this description registered for copy-right in 1869.
Illustrated on p. 57.

(Mabel Lowell Burnett) (profile)
1869
albumen print
30.2 x 24.3 cm.
Anonymous loan

INSCRIP: mat recto-(signature and inscriptions in ink by artist) "From Life Registered photograph copy-right Julia Margaret Cameron May 27th 1869"
NOTES: No photograph of this description registered for copy-right in 1869; Mabel Lowell Burnett was the daughter of the American writer James Russell Lowell.
Illustrated on p. 56.

(Mabel Lowell Burnett)
1869
albumen print
30.2 x 21.8 cm.
Anonymous loan

INSCRIP: mat recto-(signature and inscriptions in ink by artist) "From Life Freshwater May 27th 1869 copyright Julia Margaret Cameron"
NOTES: No photograph of this description registered for copy-right in 1869.
Illustrated on p. 57.

Gustave Doré
1872
albumen print
31.5 x 25.8 cm. (oval)
Collection of Royal Photographic Society of Great Britain

INSCRIP: mat recto-(signature and inscriptions in ink by artist) "From life registered photograph copy-right Julia Margaret Cameron Fresh-water, Aug. 1872" (inscription in pencil) "Gustave Doré"
NOTES: Copyright registration of August 5, 1872, "Photographic Portrait of Gustave Doré profile throat uncovered draped in cloak."
Illustrated on p. 72.

S. Winton
1872
albumen print
35.9 x 29.3 cm.
Lent by The Metropolitan Museum of Art, Gift of Lucy Chauncey, in memory of her father, Henry Chauncey, 1935.

INSCRIP: mat recto-(signature and inscriptions in ink by artist) "From life registered photograph Julia Margaret Cameron 1872" (inscription in sepia ink) "From Life copy-right Julia Margaret Cameron" (Mechanical facsimilie of hand-writing) "Lavington House Petworth Oct 30 1872. I have this day found the beautiful present you have sent me I am carrying the picture off to Lavington—its proper home. I hope you are as well satisfied with it as I am because I know there is a reward for labor in satisfied act, and I know all the labor—intellectual, yea & physical, which you took on that afternoon. I am Ever Most humbly yours S. Winton." (Colnaghi blindstamp)
NOTES: London. "Mrs. Cameron's Photographs." (1874?) p. 15, for text of Winton's inscription.
Illustrated on p. 72.

The Idylls of the King

Elaine, the Lily Maid of Astolat
(1874)
From: *Julia Margaret Cameron's Illustrations to Tennyson's "Idylls of the King" and Other Poems* London, l875.
albumen print
34.2 x 27.8 cm.
74:087:06
Museum purchase
GEH NEG: 19748

BIB REF: Millard, Charles W. "Julia Margaret Cameron and Tennyson's *Idylls of the King*." *Harvard Library Bulletin*. 21(April l973): 187-201.
INSCRIP: mat recto-(signature and inscriptions in ink) title "From Life Registered Photograph Copyright Julia Margaret Cameron"
NOTES: Auction: Sotheby's Belgravia, December 4, 1973, lot #68 Copyright registration December 8, 1874, "A Photograph second illustrating Idyll Elaine study from May Prinsep now Hitchens seated looking up side face with shield before her & embroidery on lap."
Illustrated on p. 34.

Elaine
1874
albumen print
33.5 x 27.2 cm.
Collection of the Royal Photographic Society of Great Britain.

INSCRIP: mat recto-(signature and inscriptions in ink by artist) "From Life Registered photograph Julia Margaret Cameron I.o.W. 1874" (Inscriptions in pencil by artist) Title
NOTES: Copyright registration of December 8, 1874, "A Photograph second illustration of Elaine study from May Prinsep Hitchens seated side face looking down with embroidery on lap."
Illustrated on p. 35.

Elaine
(1874-1875)
From: *Julia Margaret Cameron's Illustrations to Tennyson's "Idylls of the King" and Other Poems*. London, 1875.
albumen print
36.3 x 28.3 cm.
Museum purchase
GEH NEG: 28938

INSCRIP: mat recto-(signature and inscriptions in ink by artist) title "Then rose the dumb old servitor, and the dead (underlined), oar'd by the dumb went upward with the flood" "From Life Registered Photograph Copy right Julia Margaret Cameron Fresh Water Isle of Wight"
NOTES: Presentation copy from Julia Margaret Cameron to Sir William Gregory Ceylon, 1876, Easter Monday.
Illustrated on p. 36.

Enid
(1874)
albumen print
33.3 x 23.8 cm.
Detroit Institute of Arts, Founders Society Purchase, Joseph M. de Grimme Memorial Fund.

INSCRIP: mat recto-(signature and inscriptions in ink by artist) title "From Life Registered Photograph copyright Julia Margaret Cameron"
NOTES: Copyright registration December 8, 1874, "A Photograph illustrating Idyll called Enid study from Emily Peacock draped in white standing at wardrobe."
Illustrated on p. 31.

Vivien and Merlin
(1874)
albumen print
31.5 x 28 cm.
Library of Congress

INSCRIP: mat recto-(signature and inscriptions in ink by artist) title, "From Life registered photograph copyright" (inscriptions in ink) "from Mrs. Cameron's volume of illustrations of Tennyson's Idylls of the King"
NOTES: Copyright registration of December 8, 1874, "A Photograph illustrating Merlin and Vivien Vivien seated a study from Miss Agnes Merlin a study from C.H. Cameron."
Illustrated on p. 18.

Merlin and Vivien
(Undated reproduction of 1874 subject)
carbon print
35.2 x 26.2 cm.
Collection of the Royal Photographic Society of Great Britain.

BIB REF: Gernsheim, Helmut. *Julia Margaret Cameron: Her Life and Photographic Work*. Millerton, 1975, p. 43.
INSCRIP: mat recto-(embossed stamp) "Autotype" (inscription in pencil) title "Julia Margaret Cameron"
NOTES: Copyright registration of December 8, 1874, "A Photograph second illustration of Merlin & Vivien the study of Vivien from Miss Agnes and Merlin standing in hollow of tree C.H. Cameron Esq."
Illustrated on p. 18

(Sir Galahad and the Pale Nun)
(1874)
albumen print
34.6 x 27.7 cm.
Lent by The Minneapolis Institute of Arts, The Paul J. Schmitt Fund.

INSCRIP: mat recto-(signature and inscriptions in ink by artist) "Julia Margaret Cameron, From Life Registered Photograph copyright"
NOTES: Copyright registration of December 8, 1874, "A Photograph illustrating the Holy Grail (of) Mary Hillier as Nun and Mr. Coxhead as Sir Galahad figure with helmut & cross on breast in the Holy Grail."
Illustrated on p. 30.

Lancelot and Guinevere
(1874-negative)
Harper's Weekly: A Journal of Civilization
September 1, 1877
Wood engraved reproduction
35.6 x 20.3 cm.
University of Rochester, Rush Rhees Library

BIB REF: Gernsheim, Helmut. *Julia Margaret Cameron: Her Life and Photographic Work*. Millerton, 1975, p. 159.
Illustrated on p. 32.

King Arthur
(Undated reproduction of 1874 subject)
carbon print
34.6 x 26.5 cm.
Courtesy, Museum of Fine Arts, Boston, Gift of Mrs. J.D. Cameron Bradley

BIB REF: Gernsheim, Helmut. *Julia Margaret Cameron: Her Life and Photographic Work*. Millerton, 1975, p. 165.
INSCRIP: mat recto-(inscription in pencil) title "Julia Margaret Cameron"
NOTES: Copyright registration of December 8, 1874, "Photograph illustrating King Arthur study of King Arthur from Mr. Warder head of man in helmet with dragon crest & armour to waist."
Illustrated on p. 17.

(The Passing of King Arthur)
(Undated reproduction of 1874 subject)
carbon print
33.8 x 25.4 cm.
Collection of the Royal Photographic Society of Great Britain.

BIB REF: Gernsheim, Helmut. *Julia Margaret Cameron: Her Life and Photographic Work*. Millerton, 1975, p. 81.
INSCRIP: mat recto-(embossed stamp) "Autoty"
Illustrated on p. 37.

H.W. Longfellow
(1893 reproduction of 1868 subject)
photogravure print
24.4 x 18.5 cm.
IMP/GEH Library
From: *Alfred Lord Tennyson and His Friends* London, 1893, plate 17
Provenance: Mrs. Byron Dexter
Not illustrated.

Longfellow
(Undated reproduction of 1868 subject)
carbon print
35.4 x 25.3 cm.
76:0020:0006
Museum purchase
GEH NEG: 7342

INSCRIP: mat verso-(inscription in ink) title, (inscription in pencil) "583" "Julia Ward Cameron photographer" "$100.00?" "This is not (underlined) an original Cameron. Modern print from her neg."
NOTES: Provenance, Wadsworth Library, Geneseo, New York
Not illustrated.

Henry W. Longfellow
(1868)
albumen print
35.2 x 27.3 cm.
83:2398:0001
Museum purchase
GEH NEG: 1328
OTHER #: Acc 6517

BIB REF: Cameron, Julia Margaret. *Victorian Photographs of Famous Men and Fair Women*. New York, 1929, plate 3. Mann, Charles W. "The Poet's Pose." *History of Photography*. 3 (April, 1979): 125-27. Gernsheim, Helmut. *Julia Margaret Cameron: Her Life and Photographic Work*. Millerton, 1975, p. 120.
EXH HIST: "291 Gallery-Prints and Photographs" San Francisco Museum of Art, Aug. 4-Sept. 30, 1959. Survey of the History of 19th Century Photography, IMP/GEH Aug. 1979-Nov. 1983.

INSCRIP: mat recto-(lithographed signature) "Henry W Longfellow" (signature and inscriptions in ink by artist) "From Life Registered Photograph Copy right Julia Margaret Cameron 1868" (inscriptions in pencil) "By Mrs Cameron Signed Proof" "13" mat verso-(inscription in ink) "M Heywood Palace Gardens", (inscription in pencil) "1 in...& ½ in..." "Duplicate" (rubber stamp) "Gernsheim Collection"
NOTES: Copyright registration July 23, 1868, "Photograph Portrait of Longfellow the Poet profile (underlined) bust."
Illustrated on p. 58.

Alfred Tennyson
(1905 reproduction of 1867 subject)
carbon print
34.4 x 25.6 cm.
Lent by The Metropolitan Museum of Art, Alfred Stieglitz Collection, 1949.

NOTES: Published by the Autotype Fine Arts Company, London.
Not illustrated.

A. Tennyson
1867
albumen print
33.3 x 27.0 cm.
81:1121:0038
Gift of Eastman Kodak Company: ex-collection Gabriel Cromer
GEH NEG: 3596 3589
OTHER #: EHPC 387-38

BIB REF: Ford, Colin. *The Cameron Collection: An Album of Photographs by Julia Margaret Cameron Presented to Sir John Herschel*. Wokingham and New York, 1975, plate 3.
EXH HIST: "The Roots of Photography" Museum of Modern Art, New York City, April 27-July 24, 1949. "British Masters of the Albumen Print 1860-1880" IMP/GEH March 16-Aug. 20, 1973. Survey of the History of 19th Century Photography, IMP/GEH 1974-1978, 1978-1980.
INSCRIP: mat recto-(lithographed signature) "A Tennyson" (signature and inscriptions in ink by artist) "From Life Freshwater 1867 Julia Margaret Cameron" (Colnaghi blindstamp) mat verso-(blue stamp) "226" (rubber stamp) "Eastman Historical Photographic Collection"
NOTES: No photograph of this description registered for copyright in 1867
Illustrated on p. 48.

The Kiss of Peace
1869
albumen print
36.0 x 27.8 cm. (arched top)
71:0159:0002
Museum purchase
GEH NEG: 20405

BIB REF: Paris. *Hommage de Julia Margaret Cameron à Victor Hugo*. Maison de Victor Hugo, 1980, plate 8. Gernsheim, Helmut. *Julia Margaret Cameron: Her Life and Photographic Work*. Millerton, 1975, p. 167.

EXH HIST: "Women of Photography" San Francisco Museum of Art Feb. 1975-Aug. 1977 (tour). Survey of the History of 19th Century Photography, IMP/GEH June 1981-Dec. 1983.
INSCRIP: mat recto-(signature and inscriptions in ink by artist) title "From Life Registered Photograph Copyright Julia Margaret Cameron 1869" "My best photograph sent with a kiss to the beautiful artist a dear friend Masie" (inscribed in pencil) "Given to Mary Fraser Tytler in 1868" (Colnaghi blindstamp) mat verso-(inscribed in ink) "Miss Mary Fraser" (inscribed in pencil) "1"
NOTES: Provenance, Motley Books, London, 1971. Copyright registration September 23, 1869, "Photograph. A Woman Kissing a Child's brow (call'd) The Kiss of Peace."
Not illustrated.

The Kiss of Peace
(1890 reprint of 1869 photograph)
Sun Artists October, 1890
21.7 x 17.0 cm (rounded corners)
IMP/GEH Library, ex-collection Hector Colard, Gift of Alden Scott Boyer

BIB REF: P.H. Emerson, "Mrs. Julia Margaret Cameron," *Sun Artists* (October, 1890): 33-42. Plate 1.
NOTES: Photogravure by W.L. Colls.
Illustrated on p. 78.

(Thomas Carlyle)
(1867)
albumen print
28.6 c 23.3 cm.
83:2399:0001
Gift of Eastman Kodak Company: ex-collection Gabriel Cromer
GEH NEG: 3564

BIB REF: Cameron, Julia Margaret. *Victorian Photographs of Famous Men and Fair Women*. New York, 1926, plate 10. Ford, Colin. *The Cameron Collection: An Album of Photographs by Julia Margaret Cameron Presented to Sir John Herschel*. Wokingham and New York, 1975, plate 4. Gernsheim, Helmut. *Julia Margaret Cameron: Her Life and Photographic Work*. Millerton, 1975, p. 155.
EXH HIST: "The Art of Photography" IMP/GEH May 22, 1961-(?). Survey of the History of 19th Century Photography, IMP/GEH Dec. 1973. Survey of the History of 19th Century Photography, IMP/GEH Aug. 1978-Nov. 1983.
INSCRIP: mat recto-(signature and inscriptions in ink by artist) "From Life Julia Margaret Cameron" (inscription in pencil) "Carlyle 1867" (Colnaghi blindstamp) mat verso-(green stamp with black ink tracing) "358" (inscription in pencil) "Thomas Carlyle"
NOTES: Copyright citation of June 8, 1867, "Portrait of Carlyle Nos 1-3."
Illustrated on p. 61.

(Thomas Carlyle)
(1913 reprint of 1867 photograph)
Camera Work January, l913
21.5 x 15.8 cm.
IMP/GEH Library, Gift of
Alden Scott Boyer

NOTES: Photogravure by the Auto-
type Fine Arts Company, London,
printed by Rogers and Company,
New York.
Not illustrated

Coburn, Alvin Langdon
(The Day Spring)
(1865)
Modern print by A.L. Coburn, ca.
1910, from copy negative of orig-
inal print
platinum print, tinted stock, mechan-
ically varnished
26.3 x 20.6 cm.
67:0088:0005
Bequest of Alvin Langdon Coburn
GEH NEG: 17745

BIB REF: Coburn, Alvin Langdon.
"The Old Masters of Photography."
Century Magazine. 90 (October,
1915): 909-920.
EXH HIST: Print possibly exhibited
"Madonna and Child" in "Old
Masters of Photography", Albright
(Knox) Art Gallery, Buffalo, N.Y.,
Jan. 20-Feb. 28, 1915. Catalogue
number 49.
Not illustrated.

The Day Spring
(1865)
albumen print
29.0 x 23.5 cm.
81:1121:0034
Gift of Eastman Kodak Company:
ex-collection Gabriel Cromer
GEH NEG: 3581 14168
OTHER #: EHPC 387-34

INSCRIP: mat recto-(signature and
inscriptions in ink by artist) title
"Julia Margaret Cameron Registered
Photograph" mat verso-(blue
stamp) "370" (rubber stamp)
"Eastman Historical Photographic
Collection"
NOTES:Copyright registration July
17, 1865, "A Photograph of a
Mother bending over her sleeping
naked Child called The Day Spring
light falling strongly on edge of
child's arm and ear."
Illustrated on p. 24.

J. F. W. Herschel
(1901 reprint of 1867 photograph)
Die Photographische Rundschau July,
1901
17.6 x 14.3 cm.
IMP/GEH Library

NOTES: Photogravure printed by
Meisenbach, Riffarth and
Company, Berlin.
Illustrated on p. 78.

Sir J. F. W. Herschel (Bart)
1867
albumen print
30.3 x 24.3 cm.
81:1129:0004
Gift of Alden Scott Boyer
GEH NEG: 1987
OTHER #: 13807-4

BIB REF: Cameron, Julia Margaret.
*Victorian Photographs of Famous
Men and Fair Women* New York,
1926 plate 2 (variant). Ford, Colin.
*The Cameron Collection: An Album
of Photographs by Julia Margaret
Cameron Presented to Sir John
Herschel.* Wokingham and New
York, l975, plate 1. *Image* 1 (l952):
4, cover. Gernsheim, Helmut. *Julia
Margaret Cameron: Her Life and
Photographic Work.* Millerton,
1975, p. 153.
EXH HIST: "Camera Consciousness"
IMP/GEH Sept. 1954-March 1957.
Circulated by American Federation
of Arts. "The Art of Photography"
IMP/GEH May 22, 1961-(?). Survey
of the History of 19th Century
Photography IMP/GEH Sept. 1973.
Survey of the History of 19th
Century Photography IMP/GEH
Aug. 1979-Nov. 1983.
INSCRIP: mat recto-(signature and
inscriptions in ink by artist) title
"From Life taken at his own resi-
dence of Collingwood April 1867
Julia Margaret Cameron" (Colnaghi
blindstamp) mat verso-(inscription
in pencil) "Copy" (rubber stamp)
"Gernsheim Collection"
NOTES: Copyright registration April
9, 1867, "Photograph. Sir John
Herschel small head with cape; Sir
John Herschel life size (underlined)
portrait, full face. Nos. 1-3; Group
of Sir John Herschel and the
Honorable Mrs. Gordon."
Not illustrated.

(Whisper of the Muse)
(1865)
Modern print by A.L. Coburn, ca.
1910, from copy negative of orig-
inal print
platinum print, tinted stock, mechan-
ically varnished
23.6 x 20.3 cm.
67:0088:0010
Bequest of Alvin Langdon Coburn
GEH NEG: 7376

BIB REF: Coburn, Alvin Langdon.
"The Old Masters of Photography."
Century Magazine. 90 (October,
1915): 909-920.
EXH HIST: Print possibly exhibited
"The Kiss of Peace (Watts and chil-
dren)" in "Old Masters of Photog-
raphy", Albright (Knox) Art
Gallery, Buffalo, N.Y., Jan. 20-Feb.
28, 1915. Catalogue number 44.
INSCRIP: mat verso-(inscription in
pencil) "44"
Illustrated on p. 22.

(Mountain Nymph Sweet Liberty)
(1867)
Modern print by A.L. Coburn, ca.
1910, from copy negative of orig-
inal print
platinum print, tinted stock, mechan-
ically varnished
26.4 x 20.5 cm.
67:0088:0007
Bequest of Alvin Langdon Coburn
GEH NEG: 1583

BIB REF: Coburn, Alvin Langdon.
"The Old Masters of Photography."
Century Magazine. 90 (October,
1915): 909-920.

EXH HIST: Print possibly exhibited
"Mountain Nymph-Sweet Liberty"
in "Old Masters of Photography",
Albright (Knox) Art Gallery,
Buffalo, N.Y., Jan. 20-Feb. 28,
1915. Catalogue number 52.
Illustrated on p. 80.

(Julia Jackson)
(1867)
Modern print by A.L. Coburn, ca.
1910, from copy negative of orig-
inal print
platinum print, tinted stock, mechan-
ically varnished
26.4 x 21.1 cm.
67:0088:0008
Bequest of Alvin Langdon Coburn
GEH NEG: 35791

BIB REF: Ford, Colin. *The Cameron
Collection: An Album of Photo-
graphs by Julia Margaret Cameron
Presented to Sir John Herschel.*
Wokingham and New York, 1975,
plate 5. Coburn, Alvin Langdon.
"The Old Masters of Photography."
Century Magazine. 90 (October,
1915): 909-920.
EXH HIST: Print possibly exhibited
"Mrs. Duckworth" in "Old Masters
of Photography", Albright (Knox)
Art Gallery, Buffalo, N.Y., Jan.
20-Feb. 28, 1915. Catalogue
number 47.
Illustrated on p. 42.

(William Holman Hunt)
(1864)
Modern print by A.L. Coburn, ca.
1910, from copy negative of orig-
inal print
platinum print, tinted stock, mechan-
ically varnished
25.9 x 19.8 cm. (arched)
67:0088:0023
Bequest of Alvin Langdon Coburn
GEH NEG: 35790

BIB REF: Ford, Colin. *The Cameron
Collection: An Album of Photo-
graphs by Julia Margaret Cameron
Presented to Sir John Herschel.*
Wokingham and New York, 1975,
plate 11. Colburn, Alvin Langdon.
"The Old Masters of Photography."
Century Magazine. 90 (October,
1915): 909-920.
EXH HIST: Print possibly exhibited
"Holman Hunt" in "Old Masters of
Photography", Albright (Knox) Art
Gallery, Buffalo, N.Y., Jan. 20-Feb.
28, 1915. Catalogue number 43.
INSCRIP: mat verso-(inscription in
pencil) "43"
Illustrated on p. 43.

(Sir Henry Taylor)
(c.1865)
Modern print by A.L. Coburn, ca.
1910, from copy negative of orig-
inal print
platinum print, hand applied varnish
27.2 x 18.9 cm.
67:0088:0013
Bequest of Alvin Langdon Coburn
GEH NEG: 35789

BIB REF: Coburn, Alvin Langdon.
"The Old Masters of Photography."
Century Magazine. 90 (October,
1915): 909-920.
INSCRIP: mat verso-(inscription in
pencil) "Copy 1"
Illustrated on p. 79.

(Aubrey de Vere)
(1868)
Modern print by A.L. Coburn, ca.
1910, from copy negative of orig-
inal print
platinum print
26.9 x 21.0 cm.
67:0088:0015
Bequest of Alvin Langdon Coburn
GEH NEG: 35870

BIB REF: Coburn, Alvin Langdon.
"The Old Masters of Photography."
Century Magazine. 90 (October,
1915): 909-920.
EXH HIST: Print possibly exhibited
"Aubrey de Vere" in "Old Masters
of Photography", Albright (Knox)
Art Gallery, Buffalo, N.Y., Jan.
20-Feb. 28, 1915. Catalogue
number 41.
INSCRIP: mat verso-(inscription in
pencil) "Copy 1"
Illustrated on p. 79.

(Aubrey de Vere)
(1868)
Modern print by A.L. Coburn, ca.
1910, from copy negative of orig-
inal print
platinum print, mechanically
varnished
27.0 x 21.1 cm.
67:0088:0016
Bequest of Alvin Langdon Coburn
GEH NEG: 35871

BIB REF: Coburn, Alvin Langdon.
"The Old Masters of Photography."
Century Magazine. 90 (October,
1915): 909-920.
EXH HIST: Print possibly exhibited
"Aubrey de Vere" in "Old Masters
of Photography", A!bright (Knox)
Art Gallery, Buffalo, N.Y., Jan.
20-Feb. 28, 1915. Catalogue
number 41.
INSCRIP: mat verso-(inscription in
pencil) "Copy 2"
Not illustrated.

(Aubrey de Vere)
(1868)
Modern print by A.L. Coburn, ca.
1910, from copy negative of orig-
inal print
platinum print, toned
26.8 x 20.9 cm.
67:0088:0017
Bequest of Alvin Langdon Coburn
GEH NEG: 35865

BIB REF: Coburn, Alvin Langdon.
"The Old Masters of Photography."
Century Magazine. 90 (October,
1915): 909-920.
EXH HIST: Print possibly exhibited
"Aubrey de Vere" in "Old Masters
of Photography", Albright (Knox)
Art Gallery, Buffalo, N.Y., Jan.
20-Feb. 28, 1915. Catalogue
number 41.
INSCRIP: mat verso-(inscription in
pencil) "41"
Not illustrated

98 **(Julia Margaret Cameron)**
(1870)
Modern print by A.L. Coburn, ca.
 1910, from copy negative of orig-
 inal print
platinum print tinted stock, mechani-
 cally varnished
25.6 x 21.9 cm.
67:0088:0012
Bequest of Alvin Langdon Coburn
GEH NEG: 21472

BIB REF: Gernsheim, Helmut. *Julia
 Margaret Cameron: Her Life and
 Photographic Work.* Millerton,
 1975, p. 172. Coburn, Alvin
 Langdon. "The Old Masters of
 Photography." *Century
 Magazine.* 90 (October, 1915):
 909–920.
EXH HIST: Print possibly exhibited
 "Self Portrait" in "Old Masters of
 Photography", Albright (Knox) Art
 Gallery, Buffalo, N.Y., Jan. 20-Feb.
 28, 1915. Catalogue number 36.
Illustrated on title page.

1864

1. Exhibition: Annual Exhibition of the Photographic Society of London,
May—July. "G. F. Watts," "H. Taylor."[1]

2. Cameron joined Photographic Society of London at Ordinary General
Meeting, June 7, 1864.[2]

3. Cameron presented album of photographs to Sir John Herschel (additional
photographs added in September, 1867), November.[3]

4. Cameron elected member of Photographic Society of Scotland.[4]

5. Exhibition: Annual Exhibition of the Photographic Society of Scotland,
(December)—March 1865. Honorable Mention. "(portraits and symbolical
embodiments of the cardinal virtues)."[5]

1865

1. Nine photographs illustrating the "Fruits of the Spirit" presented and
accepted into the collection of the British Museum, January.[6]

2. Exhibition: Annual Exhibition of the Photographic Society of London,
May—June. "Faith," "Hope," "Charity," "Agnes," "James Spedding," "Alfred
Tennyson."[7]

3. Exhibition: Berlin International Photographic Exhibition (organized by the
Photographische Verein von Berlin), May—June. Medal for "Studies." "Henry
Taylor," "Alfred Tennyson," "(Madonnas)".[8]

4. Exhibition: Dublin International Exhibition of Arts and Manufactures, Class
F, Fine Arts (Photography), May—October. Honorable Mention "For artistic
composition." "Alfred Tennyson," "The Foolish Virgins," "The Wise Virgins,"
"The Fruits of the Spirit."[9]

5. Photographs purchased by the Art Library and for the Circulating Collection,
South Kensington (now Victoria and Albert) Museum, June 17, 1865.[10]

6. Photographs on view at Colnaghi and Company, London, July. "Henry
Taylor, "G. F. Watts" (profile), "Sir Coutts Lindsay," "Lady Elcho as a
'Dantesque Vision'," "Lady Elcho as the 'Cumean Sybil'," "Alfred Tennyson,"
"Robert Browning," "Holman Hunt," "J. Spedding," "Lady Adelaide Talbot,"
"Light and Love," "La Madonna Aspettante, " "La Madonna Adolorata,"
"Contemplation," "Charity," "The Shunamite Woman," "Ruth," "Double Star,"
"The Recording Angel," "The Infant Samuel," "Paul and Virginia," "Grace
through Love," "La Madonna Reposata," "Blessing and Blessed," "La Madonna
Ricordanza," "Yes or No," "Maud by Moonlight," "Sadness."[11]

7. Cameron presented album of photographs to Lord Overstone, August.[12]

8. Cameron presented photographs to Art Library, South Kensington (Victoria
and Albert) Museum, (before November).[13]

9. Cameron photographs displayed at South Kensington (Victoria and Albert)
Museum, (before November).[14]

10. Exhibition: French Gallery, Pall Mall, London, in the room above the
Winter Exhibition (described as Cameron's first exhibition), November. "G. F.
Watts," "Tom Hughes," "Alfred Tennyson" (profile), "Astarte," "Il Penseroso,"
"A Vestal," "Henry Taylor as King David" (character portrait), "(full-length nude
sleeping infant)," "(mother over sleeping babe)," "Prospero and Miranda,"
"Queen Esther (as a fainting supplicant) before Ahasuerus," "Friar Lawrence
and Juliet," "Faith, Hope and Charity," "St. Agnes," "The Infant Samuel,"
"The Salutation after Giotto."[15]

1866

1. Exhibition: Exhibition Soirée of the Photographic Society of London, June
7, 1866. "No. 6 (Study of head of little boy)," "Beatrice."[16]

2. Exhibition: The Hampshire and Isle of Wight Loan Exhibition. Class XIII,
Photographs, Lithographs, Manuscripts, Engravings, etc., etc., (Summer?).
Silver Medal and Certificate of Honor.[17]

1867

1. Exhibition: Universal Exhibition, Paris. Group II. Agriculture and Industry. Class 9. Photographic Prints and Equipment, May—October. Honorable Mention, for "artistic photographs." "Sir John Herschel."[18]

2. Cameron presented seven photographs to Dante Gabriel Rossetti, (after July).[19]

3. Exhibition: Exhibition Soirée of the London Photographic Society, November. "Sir John Herschel," "Henry Taylor," "Sir David Brewster."[20]

1868

1. Exhibition: Annual Exhibition of the Photographic Society of London, November.[21]

2. Exhibition: German Gallery, London, January—February. "Poet Laureate [Tennyson]," "H. Taylor," "Herschel," "Ex-Governer Eyre," "Carlyle," "G. F. Watts," "Beatrice," "Study of H. Taylor as King David," "Juliet and Friar Lawrence," "Rachel," "Sappho," "After Perugino," "Study for the head of St. John," "V. Prinsep," "A. Liddell," "Anthony Trollope," "Holman Hunt," "Dean of St. Paul's," "Dean of Christ Church," "(Tennyson with two sons)," "Robert Browning," "T. Prinsep," "Rosalba," "The Gardener's Daughter," "Goodness," "Charity," "Romeo and Juliet," "Christabel," "The Red and White Roses," "The Turtle Doves," "Love in Idleness," "Prospero and Miranda," "Teaching from the Elgin Marbles," "King Cophetua."[22]

1869

1. Exhibition: Photography Exhibition in Groningen, Netherlands, July. Bronze Medal.[23]

2. Cameron did not exhibit in the Annual Exhibition of the Photographic Society of London, (November—December).[24]

1870

1. Exhibition: Annual Exhibition of the French Society of Photography. May-August (?) (about 24 exhibited).[25]

2. Exhibition: Midland Counties Exhibition of Art and Industrial Products, Derby, May.[26]

3. Cameron sends photographs to Victor Hugo, (before August).[27]

4. Exhibition: Annual Exhibition of the Photographic Society of London, November "Dora," "Town Life," "May" (4 subjects), "Beatrice Cenci," "The Kiss of Peace," "(Series of domestic sketches)," "Maria Spartali."[28]

1871

1. Gift of photographs to George Eliot, January.[29]

2. Exhibition: London International Exhibition, Photographs Division I, Class III, (Summer). "Guardian Angel," "Alfred Tennyson," "H. H. H. Cameron," "C. Darwin," "The Echo," "Sir John Herschel," "Lady Florence Anson," "The Rosebud Garden of Girls," "Kiss of Peace."[30]

3. Exhibition: Annual Exhibition of the Photographic Society of London, November—December. "(Enamel photograph)."[31]

1872

1. Exhibition: London International Exhibition, April—(September). "Beatrice Cenci," "(photographs on opal glass)."[32]

2. Cameron didn't participate in the Annual Exhibition of the Photographic Society of London. November—December.[33]

1873

1. Exhibition: Universal Exhibition, Vienna. Group XII. Graphic Arts and Industrial Drawing, Section 3. Photography, May—October. Medal for "Good Taste" for "Artistic Studies." "Herschel," "Ceres," "Darwin," "Darwin," "Venus Chiding Cupid."[34]

2. Exhibition: International Exhibition, South Kensington, July. "(fifteen large heads, some already exhibited)."[35]

3. Exhibition: Annual Exhibition of the Photographic Society of London, October—November. Cameron entered Crawshay Prize competition, didn't win. "Sir Henry Taylor," "The Stray Cupid," "Sir John Herschel (1869)," "Judith," "Gretchen."[36]

4. Exhibition: "Mrs. Cameron's Gallery of Photographs," 9, Conduit Street, Hanover Square, London, November—January 1874. "Katey," "Little Maggie," "Miss Liddell," "Lord Hatherley," "H. T. Prinsep," "Mr. Lecky," "Mr. Tennyson," "Dr. Darwin," "Sir Henry Taylor," "Sir J. F. Herschel," "Mignon" (study of Lady Florence Anson), "Madame Reiné," "Dora" (wife of Ewen Hay Cameron), "The Nesting Angel," "The Recording Angel," "Acting Grandmamma," "Cupid Reposing," "Content," "A Holy Family," "The Departure for School," "Florence," "The Kiss of Peace," "St. John the Baptist" (infant study of Florence Fisher), "Pomona," "Alathea," "Robert Browning," "Aubrey de Vere," "Frederick Lockyer," "Herr Joachim," "Anthony Trollope," "W. M. Rossetti," "Sir Edward Ryan," "Dean Milman," "Professor Jowett," "Sir John Simeon," "Sir James Hooker," "Holman Hunt," "A. H. Layard," "Gustave Doré," "Bishop of Winchester," "Mrs. Ewen Cameron," "G. F. Watts," "Carlyle," "Miss Mary (sic) Spartali," "Miss May," "Miss Emily," "the Lady Mary," "Miss Florence," "Miss Alice," "Miss Doyly," "Studies of Mary, Katie and S. T.," "Lady S. as La Donna Elvira," "Adriana," "Zoe," "Mary," "Florence," "The Brothers," "Ganymede," "The Wings of Morning," "King Lear and His Daughters," "The Two Angels at the Sepulchre," "The Annunciation," "Paul and Virginia," "Enoch Arden and Annie Lee," "Prospero and Miranda," "Friar Lawrence and Juliet."[37]

1874

1. Cameron began work on photographic illustrations to Tennyson's *Idylls of the King,* October.[38]

2. Exhibition: Annual Exhibition of the Photographic Society of Great Britain, October—November. "Kiss Me Mama," "A Portrait of Lady Hood and Her Daughter Mabel," "Miss Isabel Bateman as 'Urania,'" "Queen Henrietta Marie with her Children."[39]

3. Publication of first volumes of Alfred Tennyson's *Works* (London: Henry S. King and Company, 1874-77) with wood-engraved frontispieces after Cameron photographs, November 29, 1874.[40]

4. Publication of Cameron's *Illustrations to Tennyson's "Idylls of the King" and Other Poems* (London: Henry S. King and Company, 1875), December—January 1875.[41]

1875

1. Cameron published second volume of *Illustrations to Tennyson's "Idylls of the King" and Other Poems* (London: Henry S. King and Company, 1875), May.[42]

2. Cameron didn't participate in the Annual Exhibition of the Photographic Society of Great Britain, September—November.[43]

3. Cameron moved with husband to family estate in Ceylon, October.[44]

1876

1. Exhibition: International Exhibition, Philadelphia, May—(September), Medal.[45]

2. Exhibition: Annual Exhibition of the Photographic Society of Great Britain, September—November. Autotype Company of London displayed carbon prints of Cameron's Arthurian subjects.[46]

3. Exhibition: Exhibition of the Edinburgh Photographic Society, December—(January). "The Foolish Virgins," "Prospero and Miranda," "Lancelot and Guinevere."[47]

1877

1. "Parting of Sir Lancelot and Queen Guinevere" reproduced in wood-engraving on the cover of *Harper's Weekly,* September 1, 1877.[48]

1878

1. Cameron returns to England for visit, April 1878.[49]

1879

1. Cameron dies at the age of sixty-four, after a brief illness, January 26, 1879.[50]

References to Appendix I

Unless noted, reviews and articles are unsigned.

1. "The Photographic Exhibition," *Photographic News* 8 (June 3, 1864): 265-266; "The Photographic Society," *The Athenaeum* No. 1910 (June 4, 1864): 779-80.

2. "Photographic Society of London: Ordinary General Meeting," *Photographic Journal* 9 (June 15, 1864): 51.

3. Colin Ford, *The Cameron Collection: An Album of Photographs by Julia Margaret Cameron Presented to Sir John Herschel,* (Wokingham and New York, 1975).

4. Ford, *Cameron Collection,* 140.

5. "Exhibition of the Photographic Society of Scotland," *Photographic News* 9 (January 6, 1865): 4; "Exhibition of the Photographic Society of Scotland: Report of the Prize Committee," *Photographic Journal* (April 15, 1865): 34-36.

6. British Museum, Register, Entries 1294-1302.

7. "The Photographic Society's Exhibition," *British Journal of Photography* 12 (May 19, 1865): 267-68; "The London Photographic Exhibition," *Photographic News* 9 (June 30, 1865): 309-11; "The Photographic Society's Exhibition," *British Journal of Photography* 12 (May 19, 1865): 267-68.

8. Jakob Wothly, *"Aus dem Tagebuche eines Wiener Photographen. Photographische Reisebilder. Berliner photographische Ausstellung. Ein Besuch bei Jakob Wothly,"* *Photographische Correspondenz* 2 (June, July 1865): 162-68, 192-96; "Report of the Exhibition Committee," *Photographic Journal* 10 (May 15, 1865) 62; "Berlin Photographic Exhibition 1865," *British Journal of Photography* (August 4, 1865): 408.

9. Dublin International Exhibition of Arts and Manufactures 1865, *Official Catalogue,* 4th ed. (Dublin, 1865); Antoine Claudet and P. le Neve Foster, "Photography at the Dublin Exhibition: Report and Awards of the Jurors," *Photographic News* 9 (October 6, 1865): 474-7; "The Dublin Exhibition—Photographic Department (Second Notice)," *Photographic Journal* 10 (August 15, 1865): 123-24; "Photography at the Dublin Exhibition, Third Notice," *British Journal of Photography* 12 (June 2, 1865): 291-2.

10. Victoria and Albert Museum, *Early Rare Photographic Collection.* Part B, Reel 1. (London: World Microfilms Publications, Ltd., 1983). Microfilm; Charles and Frances Brookfield, *Mrs. Brookfield and Her Circle,* (London, 1905), p. 515.

11. "Fine Arts: Art in Photography," *Illustrated London News* 47 (July 15, 1865): 50.

12. Sotheby's Belgravia, London, *Auction Catalogue,* June 26, 1975, Lot 45.

13. Victoria and Albert Museum, *Early Rare Photographic Collection,* Part B, Reel 1. (London: World Microfilms Publications, Ltd., 1983). Microfilm.

14. A. H. Wall, "Practical Art Hints: A Critical Review of Artistic Progress in the Domain of Photographic Portraiture," *British Journal of Photography* 12 (November 3, 1865): 557-59.

15. "Fine Arts," *Illustrated London News* 47 (November 18, 1865): 486; (Coventry Patmore), "Mrs. Cameron's Photographs," *Macmillan's Magazine* 13 (January 1866): 230-31.

16. "Soirée of the Photographic Society," *British Journal of Photography* 13 (June 15, 1866); 285-86; "The Exhibition Soirée of the Photographic Society," *Photographic News* 10 (June 15, 1866): 278-79.

17. Ford, *The Cameron Collection,* 18-19.

18. *Catalogue Officiel des Exposants Récompensées par le Jury International Exposition Universelle de 1867 à Paris,* (Paris, 1867); "Photography at the French Exhibition," *Photographic News* 11 (June 21, 1867): 290-91.

19. Harry Ransom Humanities Research Center, University of Texas at Austin, Inventory of Gernsheim Collection.

20. "The Exhibition Meeting of the Photographic Society," *Photographic News* 11 (November 15, 1867): 545-46; "Fine Arts: Exhibition of the Photographic Society," *Illustrated London News* 51 (November 23, 1867): 574.

21. "The Photographic Society's Exhibition," *Photographic News* 12 (November 20, 1868): 553-54.

22. "Photographic Exhibitions in London," *Photographic News* 12 (March 20, 1868): 134; "Minor Topics of the Month," *Art Journal* n.s., 7 (March 1, 1868): 58, "Fine Art Gossip," *Athenaeum* (February 15, 1868): 258; "Mrs. Cameron's Photographs," *The Queen, The Lady's Newspaper,* 43 (February 1, 1868): 83.

23. "The Groningen Awards and Montagna Prizes," *Photographic Journal* 14 (August 16, 1869): 89-90; (List of winners). *Provinciale Groninger Courant,* July 12, 1869.

24. "Exhibition of the Photographic Society from the *Illustrated [London] News,"* *Photographic News* 13 (December 10, 1869): 592-93.

25. "Correspondence: Photography Exhibition in the *Palais de l'Industrie,"* *British Journal of Photography* 17 (June 17, 1870): 284-85; "Correspondence: Portraiture at the Exhibition in the *Palais de l'Industrie,"* *British Journal of Photography* 17 (July 15, 1870): 332.

26. Midlands Countries Exhibition, Derby (England), *Catalogue of Works of Art and Industrial Products, May 1870,* (London and Derby, 1871); "Photographs at the Derby Fine Art Exhibition," *Photographic News* 14 (October 28, 1870): 511-12.

27. Paris. *Hommage de Julia Margaret Cameron à Victor Hugo.* Maison de Victor Hugo, 1980. There was possibly a group of photographs sent in 1869.

28. "The Society's Annual Exhibition," *Photographic Journal* 15 (November 8, 1870): 33-34; "The Photographic Society's Exhibition [First Notice]," *British Journal of Photography* 17 (November 11, 1870): 528-29; "The Exhibition of the Photographic Society," *Art Journal* n.s., 9 (December 1, 1870): 376.

29. Gordon S. Haight, ed., *The George Eliot Letters,* 5, (New Haven, 1954-6), p. 133.

30. London International Exhibition of 1871, *Official Catalogue: Fine Arts Department,* 3rd rev. London, 1871; Lt.-Col. H. Stuart Wortley, "Official Report on Photography in the International Exhibition of 1871," *British Journal of Photography* 18 (August 25, 1871): 400-01.

31. "The Society's Annual Exhibition," *Photographic Journal* 15 (November 14, 1871): 93-94; "The Photographic Exhibition," *Photographic News* 15 (November 17, 1871): 541-42; "The Photographic Exhibition: Sixth Notice," *British Journal of Photography* 18 (December 22, 1871): 600-01.

32. "The Photographs at the International Exhibition," *British Journal of Photography* 19 (May 3, 1872): 204-5; "The International Exhibition," *British Journal of Photography* 19 (October 25, 1872): 505-6.

33. "The Press and the Exhibition," *Photographic News* 16 (November 22, 1872): 557-60.

34. The British Section at the Vienna Universal Exhibition 1873, *Official Catalogue,* (London, 1873); "Photography at Vienna No. II—England," *British Journal of Photography* 20 (July 25, 1873): 351-2.

35. "Photographs at the International Exhibition," *Photographic News* 18 (July 11, 1873): 330-31. "The Photographs at the International Exhibition," *British Journal of Photography* 20 (May 9, 1873): 216.

36. "Report of the Committee of Judges," *Photographic Journal* 16 (November 13, 1873): 6-7; "The Crawshay Prizes," *British Journal of Photography* 20 (October 31, 1873): 503-4; "Exhibition of the Photographic Society [Second Notice]," *British Journal of Photography* 20 (October 31, 1873): 517-18; "Exhibition of the Photographic Society [Fourth Notice]," *British Journal of Photography* 20 (November 14, 1873): 540-41.

37. *Mrs. Cameron's Photographs,* leaflet, privately printed. 1874.

38. Helmut Gernsheim, *Julia Margaret Cameron: Her Life and Photographic Work,* rev. ed. (Millerton, NY, 1975), 42-50.

39. "Opinions of the Daily Press on the Photographic Exhibition," *British Journal of Photography* 21 (October 23, 1874): 509-11; "Opinions of the Daily Press on the Photographic Exhibition," *British Journal of Photography* 21 (November 6, 1874): 535-36.

40. Gernsheim, *Julia Margaret Cameron,* 45.

41. Gernsheim, *Julia Margaret Cameron,* 50.

42. Gernsheim, *Julia Margaret Cameron,* 49-50.

43. "Opinions of the Daily Press on the Photographic Exhibition," *British Journal of Photography* 22 (October 1, 1875): 477-78.

44. Gernsheim, *Julia Margaret Cameron,* 50.

45. United States Centennial Commission, *International Exhibition 1876: Official Catalogue,* 13 and rev. ed. (Philadelphia, 1876); "English Photographs at the Philadelphia Exhibition," *British Journal of Photography* 23 (September 22, 1876): 453-54.

46. "Opinions of the London Daily and Weekly Press on the Photographic Exhibition," *British Journal of Photography* 23 (September 22, 1876): 452-3.

47. "Edinburgh Photographic Exhibition," *British Journal of Photography* 23 (Decmeber 29, 1876): 621-22; "Art Notices from the Provinces. Edinburgh," *Art Journal* n.s., 16 (January 1877): 87.

48. *Harper's Weekly,* September 1, 1877.

49. Gernsheim, *Julia Margaret Cameron,* 54-55.

50. Gernsheim, *Julia Margaret Cameron,* 56.

102 Julia Margaret Cameron's Illustrations to Tennyson's "Idylls of the King" and Other Poems

Volume 1 (January, 1875)

"Gareth and Lynette" *[Gareth and Lynette]*
"Enid" *[Geraint and Enid]*
(And Enid Sang) *[Geraint and Enid]*
"Vivien and Merlin" *[Vivien]*
"Vivien and Merlin" *[Vivien]*
"Elaine, the Lily Maid of Astolat" *[Elaine]*
"Elaine" *[Elaine]*
"Sir Galahad and the Nun" *[The Holy Grail]*
"The Parting of Sir Lancelot and Queen Quinevere" *[Guinevere]*
(The Little Novice and the Queen) *[Guinevere]*
(King Arthur) *[Guinevere]*
(The Passing of Arthur) *[The Passing of Arthur]*

Volume 2 (May, 1875)

"The May Queen" *[The May Queen]*
"The May Queen and Robin" *[The May Queen]*
"The May Queen" *[The May Queen]*
"The Princess" *[The Princess]*
"O hark, O hear..." *[The Princess]*
"Tears from the depths..." *[The Princess]*
"Mariana in the Moated Grange" *[Mariana]*
"King Cophetua and the Beggar Maid" *[The Beggar Maid]*
"Elaine" *[Elaine]*
"The Corpse of Elaine in the Palace of King Arthur" *[Elaine]*
"King Arthur wounded lying in the barge" *[The Passing of Arthur]*
"Maud—the Passion flower at the Gate" *[Maud]*

Titles are from inscriptions on the mounts of the photographs. These inscriptions vary from copy to copy; those given here are from the copies in the IMP/GEH collection (when inscriptions are lacking, assigned titles are given in parenthesis). Titles in brackets are of the Tennyson works illustrated.

The IMP/GEH copy of volume 1 lacks plate 3, "And Enid Sang," but the title is given here to make the list representative of the sequence in the *Illustrations*.

Albuquerque. *Likenesses: Portrait Photography in Europe 1850-1870.* University Art Museum, University of New Mexico, 1980. Text by Elizabeth Anne McCauley.

Altick, Richard. *The Shows of London.* Cambridge, MA, 1978.

Archer, Talbot. "A Famous Lady Photographer." *The International Annual of Anthony's Photographic Bulletin* 1 (1888): 3-5.

Aspin, Roy. "Remembering Julia Margaret..." *British Journal of Photography* 126 (January 26, 1979): 77-79.

Auerbach, Nina. *Woman and the Demon: The Life of a Victorian Myth.* Cambridge, MA, 1984.

Bartram, Michael. *The Pre-Raphaelite Camera: Aspects of Victorian Photography.* Boston, 1985.

Beach, Joseph Warren. *The Concept of Nature in Victorian Poetry.* New York, 1936.

Belloc, Marie A. "The Art of Photography. Interview with Mr. H. Hay Herschel (sic) Cameron." *The Woman at Home* 43 (April, 1897): 581-89.

Best, Geoffrey. *Mid-Victorian Britain, 1851-1875.* London, 1971.

Brookfield, Charles and Frances Brookfield. *Mrs. Brookfield and Her Circle.* 2 vols. London, 1905.

Cannon, W. F. "John Herschel and the Idea of Science." *Journal of the History of Ideas* 4 (1964): 56-88.

Caslin, Jean. "Mrs. Cameron Takes No Note of Time." *Views: the Journal of Photography in New England* 5 (Summer, 1984): 12-13.

Coburn, Alvin Langdon. "The Old Masters of Photography." *Century Magazine* 6 (October, 1915): 909-20.

Coe, Brian. *Cameras: From Daguerreotypes to Instant Pictures.* New York, 1978.

Czach, Marie. "Some Thoughts on Cameron's Ceylon Photographs." *Afterimage* 1 (September 1973): 2-3.

Edinburgh. *Van Dyck in Check Trousers: Fancy Dress in Art and Life 1700-1900.* Scottish National Portrait Gallery, 1978.

Emerson, P. H. "Julia Margaret Cameron." *Sun Artists* 5 (October, 1890): 33-41.

Evans, Frederick H. "Exhibition of Photographs by Julia Margaret Cameron, at 118, Westbourne Grove, W." *The Amateur Photographer* 40 (July 21, 1904): 43-44.

Fakoner, John. "Nineteenth Century Photography in Ceylon." *The Photographic Collector* 2 (Summer, 1981): 39-54.

Flukinger, Roy. *The Formative Decades: Photography in Great Britain, 1839-1920.* Austin, 1985.

Ford, Colin. *The Cameron Collection: An Album of Photographs by Julia Margaret Cameron.* Wokingham, England, 1975.

_____ . "Julia Margaret Cameron Centenary." *British Journal of Photography* 126 (January 26, 1979): 72-76.

_____ . "Rediscovering Mrs. Cameron—and Her First Photograph." *Camera* (May, 1979): 4, 13, 23-25.

Freund, J. Hellmut. "*Spiel um Tante Julia: Zwischennotiz.*" *Neue Rundschau* 91 (1981): 193-96.

Fuller, Hester Thackeray. *Three Freshwater Friends: Tennyson, Watts and Mrs. Cameron.* Newport, England, 1933.

Gernsheim, Helmut. *Julia Margaret Cameron: Her Life and Photographic Work.* rev. ed. Millerton, NY, 1975.

Gibbs-Smith, Charles Harvard. "Mrs. Julia Margaret Cameron, Victorian Photographer." In *One Hundred Years of Photographic History: Essays in Honor of Beaumont Newhall,* edited by Van Deren Coke. Albuquerque, 1975.

Gill, Arthur. "One Hundred Years Ago." *Photographic Journal* 104 (July, 1964): 209.

Ginsburg, Madeleine. *Victorian Dress in Photographs.* New York, 1983.

Girouard, Mark. *Return to Camelot: Chivalry and the English Gentleman.* New Haven, 1982.

Harker, Margaret. *Julia Margaret Cameron.* The Great Photographers. London, 1983.

Haworth-Booth, Mark, ed. *The Golden Age of British Photography: 1839-1900.* Millerton, NY, 1984.

Hill, Brian. *Julia Margaret Cameron: A Victorian Family Portrait*. New York, 1973.

Jenkyns, Richard. *The Victorians and Ancient Greece*. Cambridge, MA, 1980.

Keller, Ulrich F. "The Myth of Art Photography: A Sociological Analysis." *History of Photography* 8 (October-December, 1984): 249-75.

——————— . "The Myth of Art Photography: An Iconographic Analysis." *History of Photography* 9 (January-March, 1985): 16-26.

Kingslake, Rudolf. "Optics Design in Photography." Reprint of a series of articles published in *Image* between 1953-1977. *Image* 25 (September-December, 1982): 37-56.

Kirkpatrick, Diane. "Religious Photography in the Victorian Age." *Michigan Quarterly Review* 22 (Summer 1983): 335-50.

Knight, Hardwicke. "Anna Isabella Thackeray and Julia Margaret Cameron." *History of Photography* 7 (July-September 1983): 247-48.

Kühn, Heinrich. *"Die optischen Mittel für malerische Photographie."* *Camera* 2 (November, 1923): 85-87.

Lindquist-Cock, Elizabeth. "Stillman, Ruskin and Rossetti: The Struggle between Nature and Art." *History of Photography* 3 (January, 1979): 1-14.

London. *Mrs. Cameron's Exhibition of Photographs.* (French Gallery, 1865).

London. *George Frederick Watts, O.M., R.A. 1817-1904.* Tate Gallery, 1954.

London. *G. F. Watts: The Hall of Fame, Portraits of His Famous Contemporaries*. National Portrait Gallery, 1975.

Mann, Charles W., Jr. "The Poet's Pose." *History of Photography* 3 (April, 1979): 125-27.

——————— . "Your Loving Auntie & God Mama, Julia Cameron." *History of Photography* 7 (January, 1983): 73-74.

Martin, Edwin C. "Tennyson's Friendships." *McClure's Magazine* (December, 1893): 54-60.

Millard, Charles W. "Julia Margaret Cameron and Tennyson's *Idylls of the King.*" *Harvard Library Bulletin* 21 (April, 1973): 187-201.

Minneapolis. *Victorian High Renaissance*. Minneapolis Institute of Art, 1978.

Mozley, Anita Ventura. "'The Priestess of the Sun' and the Historian of Photography." *Afterimage* 3 (November, 1975): 6-7, 13.

"Mrs. Cameron's Photographs." *The Queen, the Lady's Newspaper* 43 (February 1, 1868): 83.

New Haven. *The Substance or the Shadow: Images of Victorian Womenhood*. Yale Center for British Art, 1982. Text by Susan P. Casteras.

O'Connor, V. C. Scott. "Tennyson and His Friends at Freshwater." *The Century Magazine* (November, 1897): 240-68.

Ovenden, Graham, ed. *A Victorian Album: Julia Margaret Cameron and Her Circle*. New York, 1975.

Parker, Rozsika and Griselda Pollock. *Old Mistresses: Women, Art and Ideology*. New York, 1981.

(Patmore, Coventry). "Mrs. Cameron's Photographs." *Macmillan's Magazine* 13 (January, 1866): 230-31.

"Photographic Portraiture: An Interview with Mr. H. Hay Cameron." *The Studio: an Illustrated Magazine of Fine and Applied Art* 2 (December, 1893): 84-89.

Pinhorn, Malcolm. "A Photographer in the Family." *Genealogist Magazine* 19 (1977): 135-38.

Poston, Lawrence. "Wordsworth among the Victorians: The Case of Sir Henry Taylor." *Studies in Romanticism* 17 (Summer, 1978): 293-305.

Providence. *Ladies of Shalott: A Victorian Masterpiece and Its Contexts*. Bell Gallery, Brown University, 1985.

Rossetti, William Michael. "Mr. Palgrave and Unprofessional Criticisms on Art." Reprinted in *Fine Art, Chiefly Contemporary*. London, 1867.

——————— . *Some Reminiscences of W. M. Rossetti*. 2 vols. New York, 1906

——————— . **ed.** *Rossetti Papers 1862-1870*. London, 1903.

Rouillé, André. *L'Empire de la Photographie: Photographie et pouvoir bourgeois*. Paris, 1982.

Schwarz, Heinrich. "Julia Margaret Cameron." *The Complete Photographer* 2 (1941): 593-95.

——————— . *"Kunst und Photographie: Ein Vortrag von 1932."* *Fotogeschichte: Beiträge zur Geschichte und Asthetick der Fotografie* (1984): 5-18.

Smaills, Helen. "A Gentleman's Exercise: Ronald Leslie Melville, 11th Earl of Leven, and the Amateur Photographic Association." *The Photographic Collector* 3 (Winter, 1982): 262-93.

Solomon-Godeau, Abigail. "Photography and Industrialization: John Ruskin and the Moral Dimensions of Photography." *Exposure* 21 (2):10-14.

Soulages, François. *"Le théâtre photographique de Julia Margaret Cameron."* *Les Cahiers de la Photographie* 2 (1981): 24-32.

Stanford. *"Mrs. Cameron's Photographs from the Life."* Stanford University Museum of Art, 1974. Text by Anita Ventura Mozley.

Symmes, Marilyn F. "Important Photographs by Women." *Bulletin of the Detroit Institute of Arts* 56 (1978): 141-52.

Thackeray, Anne. *Toilers and Spinners and Other Essays*. London, 1874.

Thomas, G. "Bogawantalawa, the Final Resting Place of Julia Margaret Cameron." *History of Photography* 5 (April, 1981): 103-4.

Wall, A. H. "Practical Art Hints: A Critical Review of Artistic Progress in the Domain of Photographic Portraiture." *British Journal of Photography* 12 (November 3, 1865): 557-59.

Watson, R. N. "Art, Photography and John Ruskin." *British Journal of Photography* 91 (March 10, 1949, March 24, 1949, April 7, 1949): 82-83; 100-101; 118-119.

Watts, Mary Seton. *George Frederick Watts: The Annals of An Artist's Life*. 3 vols. New York, 1912.

Weaver, Mike. "The Hard and Soft in British Photography." *The Photographic Collector* 4 (Autumn, 1983): 195-97.

——————— . *Julia Margaret Cameron: 1815-1879*. New York, 1984.

Weaver, Mike and Marina Miraglia. *Julia Margaret Cameron, 1815-1879*. Rome, 1985. Translation and expanded version of Mike Weaver, *Julia Margaret Cameron 1815-1879*, New York, 1984.

Wiegand, Wilfried. *"Die Porträtkunst der Julia Margaret Cameron."* *Neue Rundschau* 91 (1981): 203-8.

Williams, Val. "Only Connecting: Julia Margaret Cameron and Bloomsbury." *The Photographic Collector* 4 (Spring, 1983): 40-49.

Wilsher, Ann and Benjamin Spear. "'A Dream of Fair Ladies' Mrs. Cameron Disguised." *History of Photography* 7 (April-June 1983): 118-20.

Wollheim, Peter. "Julia Margaret Cameron: A Victorian Soul." *Photo Communique* 4 (Winter, 1982/83): 12-17.

Woolf, Virginia. *Freshwater: a Comedy*. Edited and with a preface by Lucio P. Ruotolo. New York, 1976.

——————— . "Freshwater." *Neue Rundschau* 91 (1981): 163 181. German translation by Gustav K. Kemperdick.

Yeldham, Charlotte. *Woman Artists in the Nineteenth Century, France and England*. 2 vols. New York, 1983.